Oil Painting
Step-by-Step

D0189224

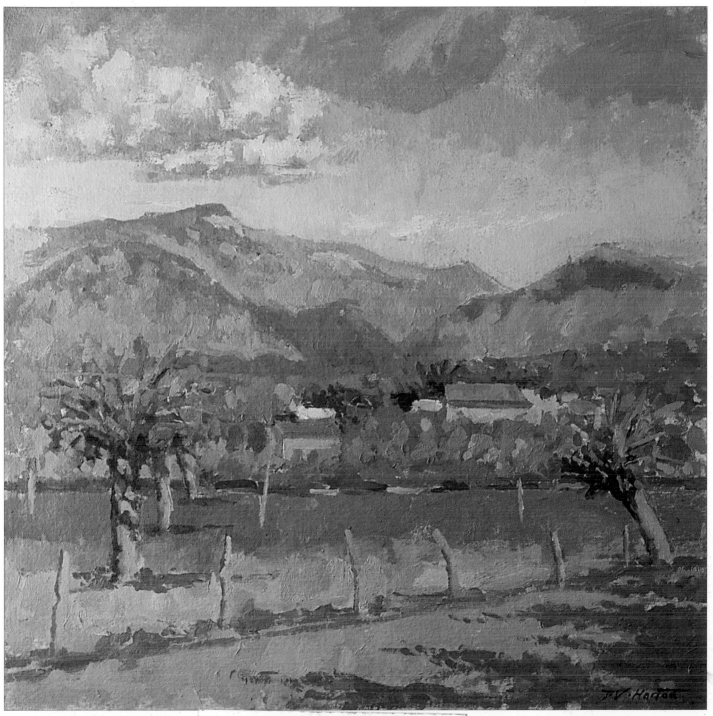

WALTHAM FOREST LIBRARIES

904 000 00259544

First published in Great Britain 2011

Search Press Limited
Wellwood, North Farm Road,
Tunbridge Wells, Kent TN2 3DR

Reprinted 2012

Based on the following books published by Search Press:

Step-by-Step Leisure Arts series:
Painting with Oils by Noel Gregory, 2000
Flowers in Oils by Noel Gregory, 2000
Landscapes in Oils by Michael Sanders, 2003
Water Mixable Oils by Michael Sanders, 2003

Oil Painting Tips and Techniques series:
Instant Oil Painting by Noel Gregory, 2006
Painting Landscapes in Oils by James Horton, 2007

and on *Roy Lang's Sea & Sky in Oils*, 2007

Text copyright © Noel Gregory, James Horton, Roy Lang and
Michael Sanders, 2011

Photographs by Charlotte de la Bédoyère and Steve Crispe,
Search Press Studios and by Roddy Paine Photographic Studios

Photographs and design copyright © Search Press Ltd. 2011

All rights reserved. No part of this book, text, photographs or
illustrations may be reproduced or transmitted in any form
or by any means by print, photoprint, microfilm, microfiche,
photocopier, internet or in any way known or as yet unknown, or
stored in a retrieval system, without written permission obtained
beforehand from Search Press.

ISBN: 978-1-84448-665-6

The Publishers and author can accept no responsibility for any
consequences arising from the information, advice or instructions
given in this publication.

Readers are permitted to reproduce any of the paintings in this
book for their personal use, or for the purposes of selling for
charity, free of charge and without the prior permission of the
Publishers. Any use of the paintings for commercial purposes is
not permitted without the prior permission of the Publishers.

Suppliers
If you have any difficulty obtaining any of the materials
and equipment mentioned in this book, please visit the
Search Press website: www.searchpress.com

Printed in Malaysia

**Waltham Forest
Libraries**

904 000 00259544

Askews & Holts	15-Mar-2013
751.45	£12.99
3821768	

Cover
Ocean Spray by Roy Lang
56 x 40.5cm (22 x 16in)

Page 1
**Bright and Windy Day, Can-Xenet, Majorca
by James Horton**
45.7 x 38cm (18 x 15in)

Pages 2–3
Poppy Path by Noel Gregory
96.5 x 76cm (38 x 30in)

*This is a picture that developed gradually, rather like
completing a crossword puzzle. It started when I found the
blue cornflower, which for some reason is not as common as
it once was. I painted this on a large canvas, then added the
poppies around it from life. I then developed the picture by
adding more and more flowers and the path. I only stopped
building up the composition when it seemed to be well
balanced. This is not the easiest way to go about painting
pictures, but it is great fun.*

Pages 4–5
Time to Reflect by Roy Lang
56 x 40.5cm (22 x 16in)
*The colours, tones and softened edges convey a feeling of
relaxation and contemplation at the end of the day.*

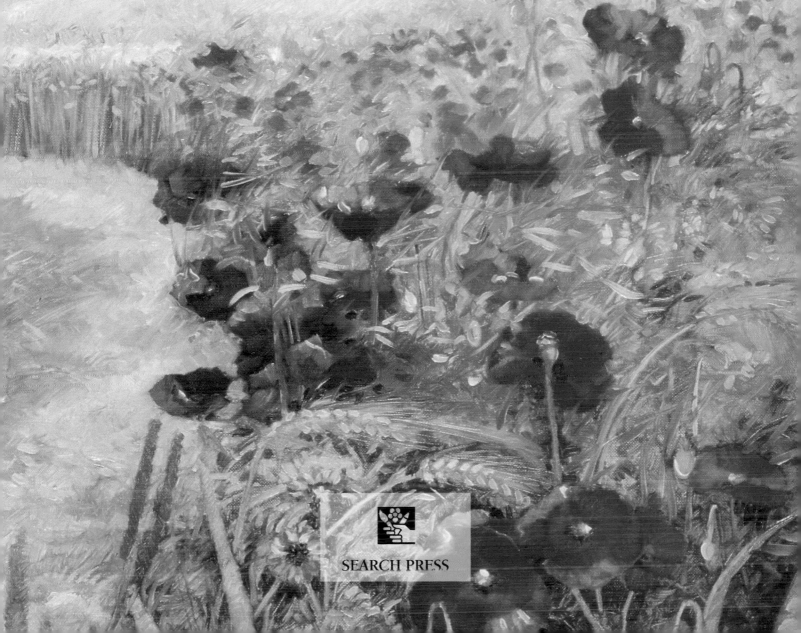

Oil Painting
Step-by-Step

NOEL GREGORY, JAMES HORTON, ROY LANG AND MICHAEL SANDERS

SEARCH PRESS

Contents

Materials

Paints

Oils are the preferred medium of many artists, partly because of the strength of colour and texture they can produce, and also because of the ease with which corrections can be made. They can be worked wet into wet over long periods and blended to soften areas where required. They are made from colour pigments mixed with a binder (usually linseed, poppy or safflower oil). Mineral or vegetable pigments were traditionally used, and synthetic pigments were introduced in the 1950s. Oil paints come in two qualities: artists' quality paints are the best – they are the most expensive, but they contain the highest grade and greatest quantity of pigments. Students' quality colours are also very good, and are more than adequate for anyone starting to paint.

Artists' quality oil paints.

Most artists recommend buying a limited palette of colours and learning how to mix further colours from these. This both simplifies the colour mixing process and helps to keep individual paintings harmonious. The artists featured in this book each recommend a limited palette of colours that best suits their style and subject matter.

Traditional oil paints require the use of solvents such as turpentine or white spirit to thin the paint and to clean the brushes. The exception are water mixable oils, which are genuine oil paints made with linseed or safflower oil, yet which can be thinned and cleaned up with water. The advantages of water mixable oils are obvious: no more smelly rags or bottles of spirit; just soap, water and paper towels.

Water mixable oil paints.

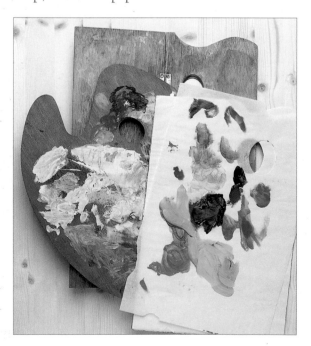

Palettes

Any flat, non-absorbent surface can be used to hold and mix oil paints: plastic, greaseproof paper, even glass. Many artists prefer a traditional wooden artist's palette. The large kidney-shaped ones are the most comfortable to use, and the warm, neutral tone of the wood makes colour judgement easier.

Disposable paper palettes with tear-off sheets are also useful. When you have finished painting, tear the page off, fold it and throw it away.

Many artists like to lay out their colours on the palette in a particular order to make choosing and mixing colours easier.

Mediums and solvents

Mediums are added to oil paints for a number of reasons, most commonly to make the paint flow better and to affect drying times. You will need linseed oil initially, and you can add to your collection later if necessary, bearing in mind the following properties.

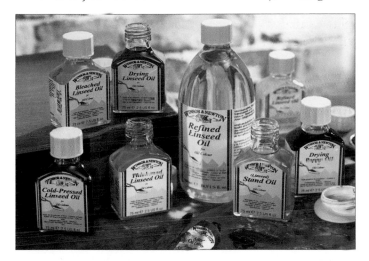

Artists' gloss varnish is a ketone resin and wax blend with white spirit. It is quick-drying and durable. **Artists' matt varnish** has the same properties as gloss varnish, but it dries with a matt finish. **Refined linseed oil** is one of the most popular of the painting mediums. It slows the drying time, which is ideal for the wet-into-wet painting technique. **Bleached linseed oil** produces a paler oil with a faster drying rate and improved flow. **Cold-pressed linseed oil** reduces the consistency of brush marks and increases transparency and gloss. **Drying linseed oil** contains manganese driers that reduce drying time. **Drying poppy oil** is a pale yellow resisting oil which reduces consistency and increases drying time. **Stand oil** is a non-yellowing retarder for pigment; it imparts a flexible, durable finish to oil paint. **Thickened linseed oil** is faster drying than unprocessed oil paint, and improves paint flow. **Wingel** is a free-flowing liquid, which is suitable for building up glazes.

James Horton mixes his own medium from equal measures of dammar varnish and linseed oil combined with two measures of turpentine.

Solvents are used to thin down paint and to clean brushes. A distillate of pine resin, **turpentine** has good wetting properties and is used to dilute oil colours. **White spirit** makes for a cheaper alternative solvent for thinning paint and cleaning. Dry brushes after cleaning on rags to avoid white spirit remaining and getting in your paints. If you leave used white spirit undisturbed for a few days, the sludge will sink to the bottom and the liquid on top will be usable again.

Make sure you work in a well ventilated area when using solvents, as they can be unhealthy if breathed in. Low odour alternatives may be more suitable for some of you.

Brushes and knives

The traditional oil painting brush is long-handled and made of hog bristle. These days, there are some excellent synthetic equivalents. It is best to get a selection; you will gradually develop favourites that suit your style.

There are three basic brush shapes: flat, round and filbert with either a regular or long length of bristle. The flat brush is chisel shaped, the round is tapered almost to a point and the filbert starts like a flat then gently tapers towards the tip. A fan brush is a useful addition for gently blending one colour into another. Brights are short, flat hog-hair brushes.

Brush sizes are usually denoted by numerals, the larger the number, the bigger the brush. It is best to have a range, with at least a couple of large brushes for covering large areas. Very small brushes should be used only for a few highlights, applied when finishing a painting.

Knives also have many uses in oil painting: for mixing paint; scraping off the occasional error; applying paint, both with the edge or the flat of the knife; and using the tip of the knife to scratch out fine lines in wet paint. Knives with bent handles, known as painting knives, are most useful.

Surfaces

Many artists prefer to paint on stretched canvas. A good quality linen support with a fine tooth is best, for it provides movement and allows for subtle paint strokes. Linen, woven from flax, is versatile and extremely resistant to decay, so a high quality fine grain handmade canvas, made from 100 per cent linen, is the best surface to paint on. Synthetic canvases are available, but paint adheres less readily to some kinds of synthetic materials.

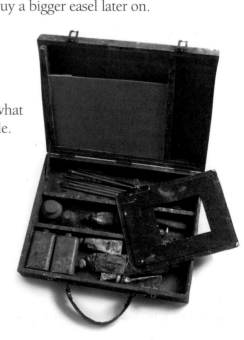

The fabric is stretched on to wooden stretcher pieces to form a support for the painting, and then prepared with acrylic primer. The cheapest way to buy a canvas is to stretch it yourself. However, this takes time and a little skill, so you might prefer to buy a ready-made canvas from your art supplier.

Canvas boards are also available. Acrylic primed fabric is laminated on to stable, high quality boards, providing a firm base for painting. These boards are less expensive, they can be cut down to fit existing frames and they can be stored easily.

Oil colour papers with a traditional canvas-textured surface, are available in pads. They are ideal for oil painting and for outdoor sketching.

Hardboard can be used, but make sure that you use the smooth side. It should be primed with two coats of acrylic primer before you start to paint.

Easels

Canvases are usually painted upright, and you therefore need an easel when using oils. There is a huge range available, ranging from large studio easels with a box for paints and brushes, to lightweight sketching supports. Aluminium easels are light and easy to carry and erect. Adjustable wooden sketching easels are also very good and have the same qualities. It might be best to buy one of these initially; you can always buy a bigger easel later on.

Materials for painting outdoors

Portability is important when painting outdoors, so one must learn to take only what is essential for the job and perhaps discard many of the extras that one uses inside.

Transporting a wet painting back home is one of the biggest headaches for an outdoor painter. This is where the box easel is a wonderful option. Alternatively, smaller paintings can be stored in the lid of a standard paintbox.

Standing still or sitting for long periods can make you cold, even in summer if there is a breeze, so always take plenty of warm clothing.

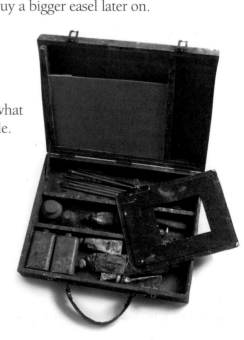

A paintbox like this can hold two painting boards. You can also close the lid on the palette, keeping everything in place while you are moving. This box can be used while sitting down, resting on your knees with the painting contained within the lid. A viewfinder with one adjustable side is a very useful tool for deciding on compositions.

Other equipment

There are a few other items that make life easier, and I always like to have these with me when I paint. The most important, even before you open a tube of paint, is a plentiful supply of kitchen paper or clean, lint-free rags, which some artists make from old shirts. You will need at least two screw-top jars for clean and dirty thinners, and some pens, pencils and sketch pads for thumbnail sketches. Some artists use sponges and scraps of paper and card to add texture to their work, and a cocktail stick can be used for the sgraffito technique.

Then, at the end of a painting session, brushes have to be cleaned. Most artists use white spirit for this, and some then use brush soap. Use a back-and-forth painting action on the soap until no further colour comes out, then rinse the brush in water. Apply a little clean soap to the clean brush and allow it to dry; this will help the brush keep its shape.

Cleaning a brush with brush soap after using white spirit.

Pencils and pens for drawing and for sketching thumbnails, paper and natural sponges for applying texture and kitchen paper for cleaning up.

Surfaces for oil painting need to be primed so that the paint sits on the surface with good adhesion and doesn't sink in. You can use a good quality acrylic gesso for this, which can be tinted with a little acrylic paint if you want a coloured background. Michael Sanders recommends using an enamel plate to mix acrylic gesso with acrylic paint, and an old household paintbrush to apply it.

PAINTING WITH OILS

by Noel Gregory

To my mind, oil paint is the most versatile of all painting mediums. You can develop the painting as you work, moving colours about on the canvas to refine shape, tone and texture, and you do not have to worry about your drawing skills as you can paint over mistakes. There will be days when you may feel like painting thick, heavily-textured images, and others when you want to create a soft, smooth effect using thin colours. You may want to paint in great detail or perhaps just work up a sketch on the spot. However you want to paint, it is a wonderful medium to work with.

Many people think of watercolours as the perfect medium for beginners, and this may have something to do with their first experience of poster colour and powder paint at school. However, anyone starting to paint will soon discover that oils are so much easier to use.

Many beginners find a blank canvas intimidating. An artist friend of mine was demonstrating his superb talent for drawing birds from memory at an exhibition and was surrounded by interested observers. One couple watched him in silence for many minutes. Suddenly, the woman smiled and said to her partner, 'I can do that'. It had taken the artist most of his life to master his technique, and he was about to comment when she went on to say, 'but I do not know where to put the lines'. This is a common response from people who would like to paint, but lack the confidence to start. However, if you work with oils, starting with a blank canvas is easier. You only have to concern yourself with basic outlines, before you can start creating your first masterpiece.

This section takes you through the basic principles of painting with oils. The step-by-step sequences are designed to help build up confidence and develop skills. The finished paintings will inspire you to create your own pictures. As you gain more confidence, you will gradually develop your own style of painting and soon afterwards you will be able to say, 'I now know where to put the lines'.

Opposite
Lazy River
40.5 x 51cm (16 x 20in)

Subjects can often be found in the most unexpected places. Simple everyday scenes can be perfect – you do not have to travel far to find inspiration. This tranquil scene is actually near a built-up industrial area and close to a very busy road. Even if it had included an ugly building, I could have omitted it and replaced it with, say, a nearby tree. You can easily leave something out of a composition if you feel like it.

I love painting scenes like this – a day out, sketching on the spot, with just a small canvas, some paints and a picnic. What a wonderful way to make a living; I am very fortunate.

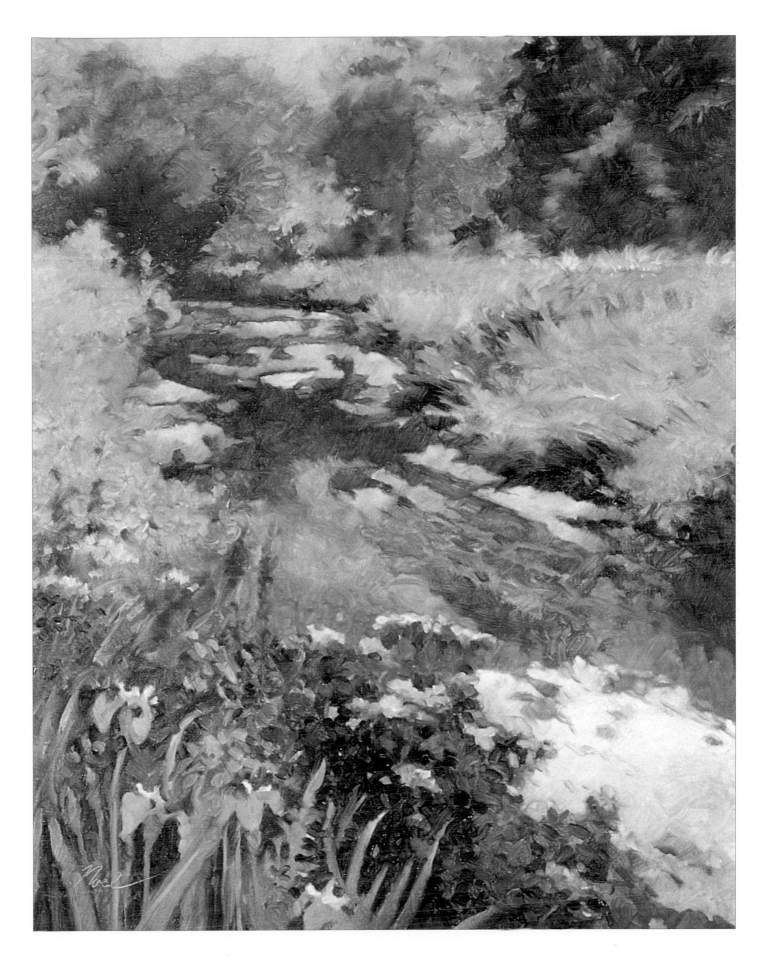

Understanding tone

Painting is about confidence and this can be developed in many ways. One way is to study tone, or degrees of light and dark. A look at Rembrandt's work shows us how important tone is. It has been said that if you can master this fundamental technique, there is little left to learn, and I thoroughly agree with this sentiment. I would go further and say that you could, perhaps, get away with poor drawing and colour, but if you do not understand the tonal structure of a painting, you will always create weak images.

One way to appreciate tone is to look at a subject through half-closed eyes. Restricting your vision in this way eliminates all detail except for the bright highlights and dark shadows.

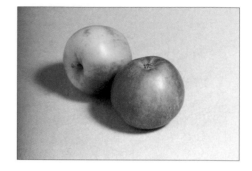

A simple, still-life composition is perfect for practising the techniques of tonal structure. Light it from one side to create a strong tonal contrast.

Apples

Still-life subjects like this simple composition, provide a very good opportunity for experimenting with tonal values. Apples have an interesting form, and lighting them from one side creates good highlights and strong shadows. Their shape and form are created with intermediate tones.

This demonstration is painted on a 25.5 x 20.5cm (10 x 8in) canvas, using titanium white and ivory black (mixed with a touch of burnt sienna). The burnt sienna softens the black, which is too harsh when used on its own.

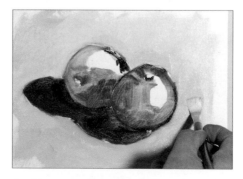

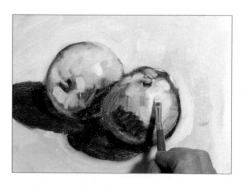

1. Dilute ivory black with linseed oil, then add a touch of burnt sienna. Use a small, round sable brush to loosely sketch in the outlines of the two apples and their shadows.

2. Use a medium bright brush and various strengths of the black mix to wash in the large areas of intermediate tones, and the dark shadows. Paint the background using titanium white with touches of the black mix.

3. Now add highlights and start to develop the 'tonal shape' of the apples. Use a small bright brush to build up the paint, making curved and straight strokes that follow the contours of the apples.

4. Use a dry medium bright brush to blend the paint and soften the edges of the images. If you leave the painting to dry slightly – say overnight – you will find it easier to blend the colours.

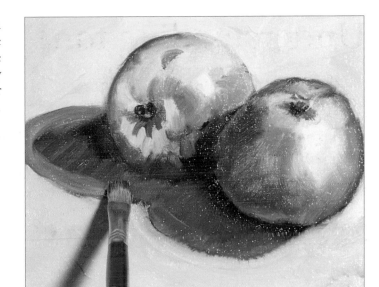

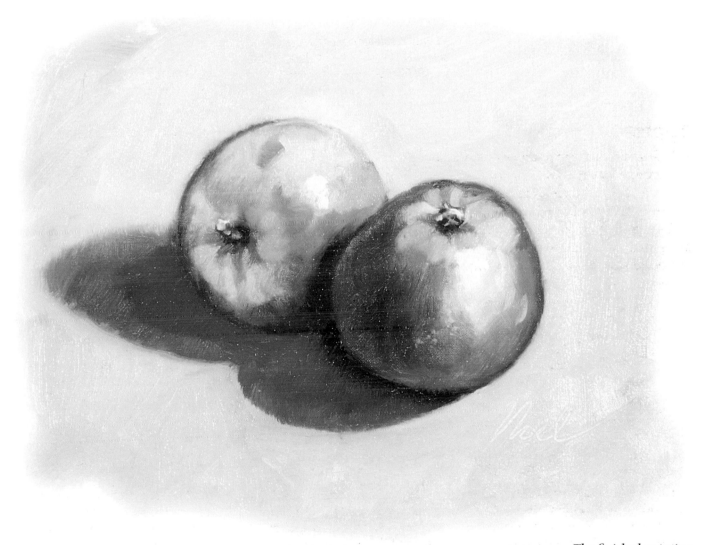

The finished painting

Fine details have been added and the paint layers strengthened slightly. Final touches of pure titanium white have been used to create the brightest highlights.

Using a limited palette

You can continue to build up your confidence by adding a few more colours (from the same part of the colour spectrum) to your palette. Painting with a limited palette will help you concentrate on creating good three-dimensional images without having to worry about 'seeing' and mixing too many colours. Obviously it is easier if you choose a subject with a limited colour range, as I have here.

Mushrooms

These mushrooms are comprised of tones of brown at the warm end of the spectrum, so I have added just two primary colours (cadmium red and chrome yellow hue) and Vandyke brown, to the black, white and burnt sienna used for the tonal study on pages 12–13. The picture is painted on a 25.5 x 20.5cm (10 x 8in) canvas.

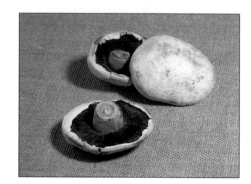

Side lighting this simple composition produces good tonal qualities.

Look at the shapes of the mushrooms as simple blocks of colour. Start with the largest blocks, then gradually paint progressively smaller blocks, leaving the fine details until the last possible moment. Try to think of details as just tiny blocks of colour that sit on the surface of larger ones. With these mushrooms, for example, it is not necessary to paint in every individual gill, you just need to create shapes that indicate the form of their mass.

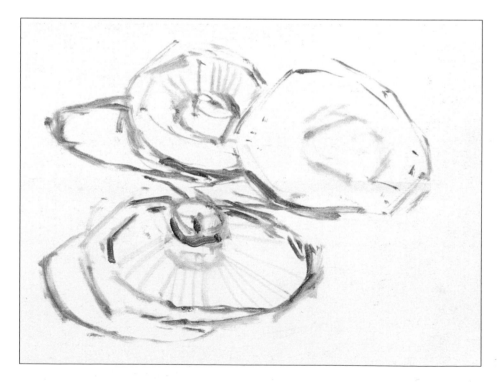

1. Mix a wash of linseed oil and burnt sienna, then quickly draw the outlines of the mushrooms, using a small round sable and firm strokes to capture their shapes.

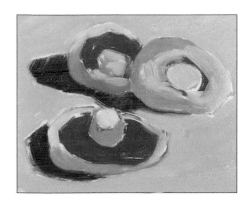

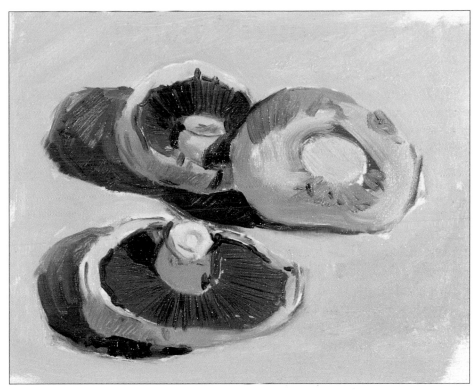

2. Use a medium bright brush and a mix of red, yellow and white to block in the background. Mix the brown with a touch of white and black, then paint in the darker areas. Remember to constantly look at the subject through half-closed eyes to discover where the darkest areas lie, then look at the lightest areas and add these as simply as possible.

3. Now use a small bright brush to build up the tone, painting in the darker areas and developing the form and details of the mushrooms.

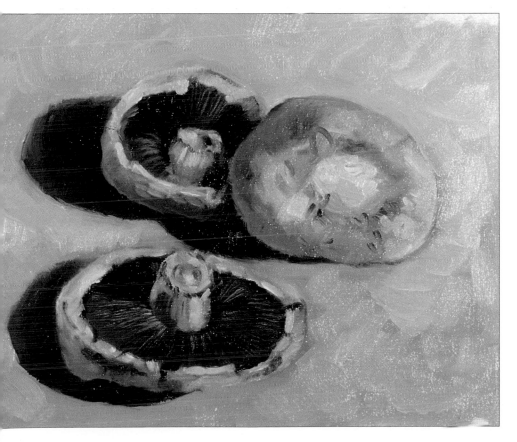

The finished painting
More details have been added using a small sable brush. The brightest highlights and the darkest darks are the last to be applied.

Painting outdoors

Painting still-life images in the studio is fine, but for many, working outdoors is the ultimate challenge. The most difficult problem is getting the right perspective. How do you create a three-dimensional image in just two dimensions?

Perspective is as complex a subject as art itself – it has been refined and changed throughout history, but, in simple terms, it is just a formula for size and proportion. Objects of similar size appear smaller the further they are from the ground line, and parallel lines appear to vanish to points on the horizon.

One simple way of achieving the right scale and the correct angles is to sight-size major parts of the scene, using the handle of your brush and your thumb as a ruler to scale selected objects. Hold the brush at arm's length, close one eye, align the tip of the brush at one end of an object, then move your thumb along the brush until it aligns with the other end of the object. Transfer this measurement on to your canvas. You can use the same technique to record the angles of the various elements of the scene.

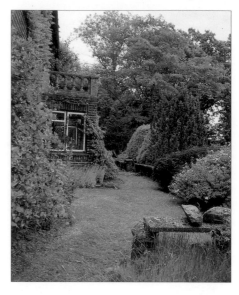

This garden scene is an ideal subject to practise the sight-sizing method of creating an initial sketch.

When sight-sizing, stand close to your easel so that you can transfer scaled measurements without moving your position. Always hold your arm straight out in front of you, and always use the same eye to view the object being scaled.

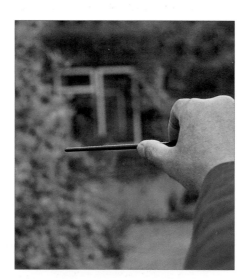

1. Start by scaling simple shapes such as this window. Hold the brush parallel to the bottom edge of the window with its tip aligned with the left-hand side. Then, without moving your arm, slide your thumb along the brush until it aligns with the right-hand side of the window.

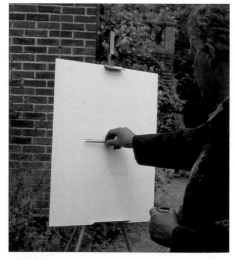

2. Without moving your feet, swing round to face the easel and transfer the scaled measurement to the canvas. You may find that the objects you are measuring are smaller than you first imagined.

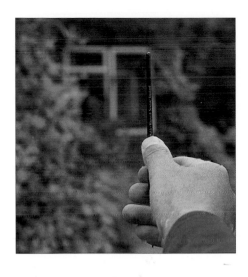

3. Now hold the brush parallel to the side of the window. Align its tip with the top edge and use your thumb to scale the height of the window.

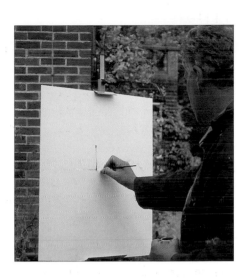

4. Swing round and transfer this measurement to the canvas. Continue sight-sizing the outlines of the building and transferring them to the sketch.

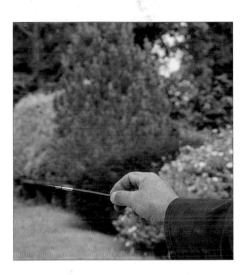

5. Use a similar technique to sight-size angles, for example, the angle of the low garden wall. Hold the brush square to the ground line, and angle it so that it aligns with the top of the wall.

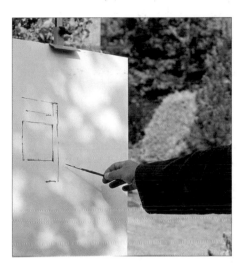

6. Again, swing round and transfer this angle on to the sketch. Continue to sight-size the other major elements of the scene in a similar manner.

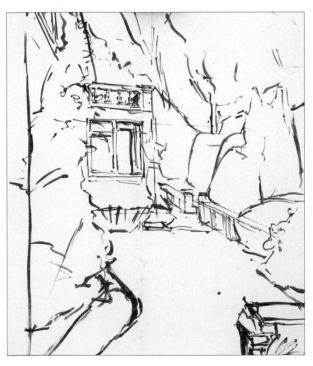

The completed sketch

Once the main elements and angles have been sketched in, it only takes a few minutes to link them all together. It is not necessary to produce a finely detailed sketch at this stage – indeed, if the drawing looks too good, you may be tempted not to spoil it by painting it.

I distinctly remember the first time that I used sight-sizing. I was a second-year art student and the subject was a road, a fence and a few houses. Sight-sizing showed me the scale of background objects relative to those in the foreground. It also helped me to understand how the sides of the road appeared to taper. Suddenly, the whole composition became three dimensional, with a real impression of distance. This was something I had found hard to master before, and that day was one of the most exciting of my artistic career. I still have the painting at home.

Using photographs

A century ago, artists had no choice but to record images in a sketchbook. Nowadays, you do not have to worry about rain, or having to wait until the sun is in the right place because you can simply take a few photographs at the right time, then recreate the scene at home. Do not be afraid of photographs. I know of few professional artists who have not used them at some time in their life, and I rarely go anywhere without a camera. Whenever you see something of interest, take a few photographs and keep them for future reference.

Foxglove Lane

This painting is composed entirely from photographs. The actual scene had lots of interesting areas, but the width of the road set them apart. I cut out the best parts from each photograph, then reassembled them to create a more interesting composition – here, for example, I turned the wide road into a narrow winding lane.

1. Cut the photographs to leave just the most interesting images and features.

2. Arrange the pieces together, overlapping them as necessary, until you like the composition.

3. Glue the pieces down on to a sheet of paper. Then, if necessary, enlarge the completed scene on a colour photocopier.

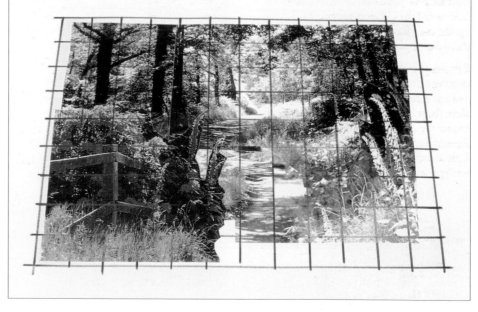

4. Sometimes, I find it useful to draw a grid on the photograph or photocopy. I then draw a similar, but larger, grid on the canvas and transfer the different elements on to the surface.

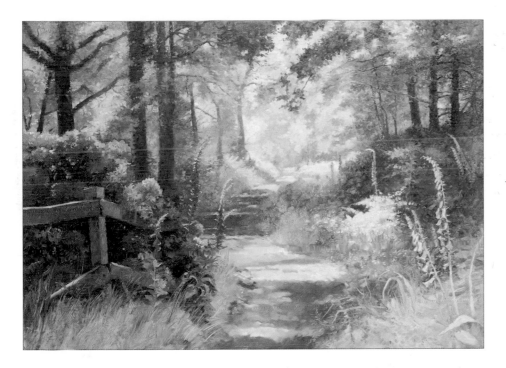

The finished painting
101.5 x 76cm (40 x 30in)

The original road has been transformed into a winding lane simply by moving the rhododendron and fence to the right. When rearranging scenes in this way, you must watch out for uniformity of scale, tone and shadow. You must also be aware of the seasonal changes. For example, you need to know that rhododendrons and foxgloves flower at the same time of year.

Rhododendron Garden
91.5 x 76cm (36 x 30in)

This canvas was composed entirely from reference sources. The background, with the sunlight gleaming through the arch in the hedge, was taken from a greetings card and the plants on the right hand side were taken from photographs. I cut up the individual pictures and rearranged them into a pleasing composition.

For this painting, I wanted a large rhododendron bloom in the foreground, so I cut a couple of stems and painted them from life. I lit them with a spotlight to give the appearance of sunlight. Remember to arrange the position of the light source to correspond to that of the background images.

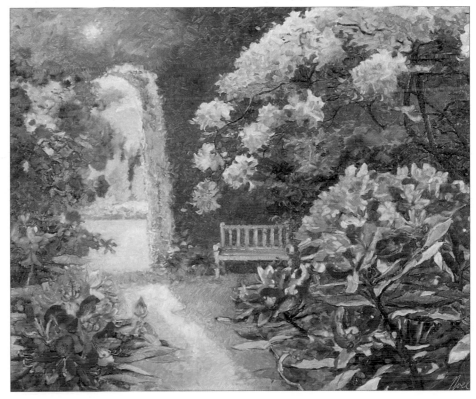

Country Lane

Beginners often choose to paint landscapes. Wherever you live, whether it be in a town or in the countryside, we are surrounded by ever-changing seasons and subjects. Most landscapes can be quite a challenge, so it is better to find an easy subject to start with. A simple scene with a tree and a path is all you need to help develop your confidence in capturing perspective, colour and tone.

At first glance, this landscape may seem quite complicated, but when you use the sight-sizing technique to compose the initial sketch (see pages 16–17) it becomes a simple arrangement of different elements. You just have to fill these elements with blocks of colour, then add the detail.

You will need

61 x 46cm (24 x 18in) canvas

Brushes: small and medium short, flat hog-hair brights and a small round sable

Colours: Vandyke brown, permanent green light, titanium white, cerulean blue, cadmium red

Linseed oil

It is always worthwhile taking a photograph, in case you have to finish your painting in the studio.

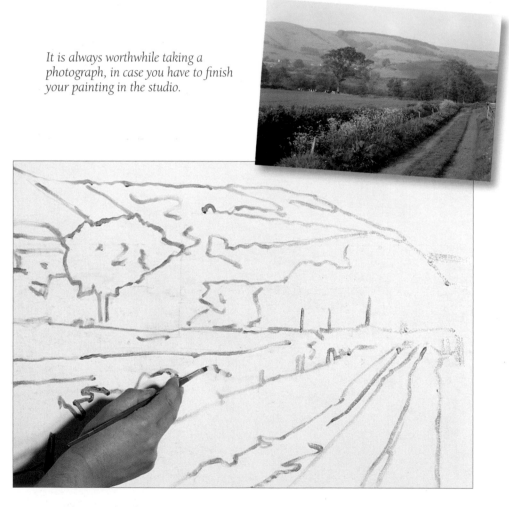

1. Mix a thin wash of Vandyke brown and linseed oil, then use a small round sable to draw the basic elements of the scene on to the canvas. The most important lines are those that create the perspective of the lane and the hedge. Sight-size these angles, transfer them on to the canvas, then mark in the horizon. Scale the middle distance trees, then gradually add the shapes of the distant fields. Try not to overdo the detail on this initial sketch – the paint will do the 'real' drawing as the picture develops.

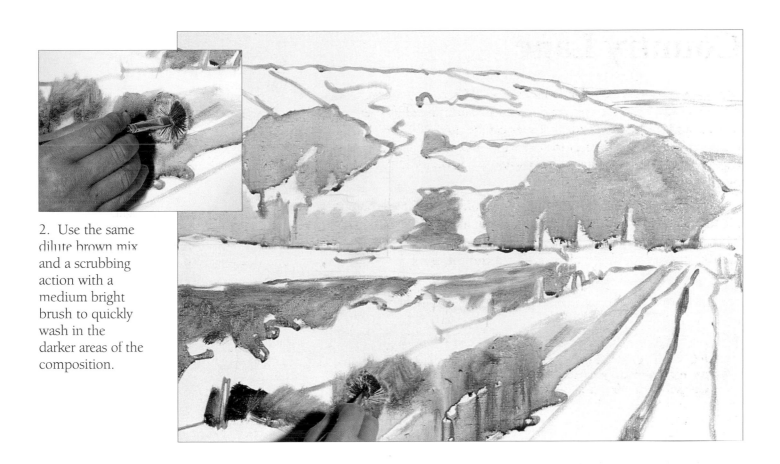

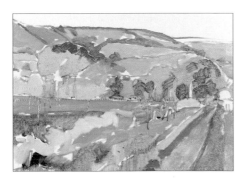

2. Use the same dilute brown mix and a scrubbing action with a medium bright brush to quickly wash in the darker areas of the composition.

3. Block in the foreground areas with a mix of permanent green light and titanium white. Add touches of cerulean blue to the green mix and block in the middle distance areas. Then, as the soil colours in this particular scene are so hot, add a touch of cadmium red to the mix, and paint in the distant hills.

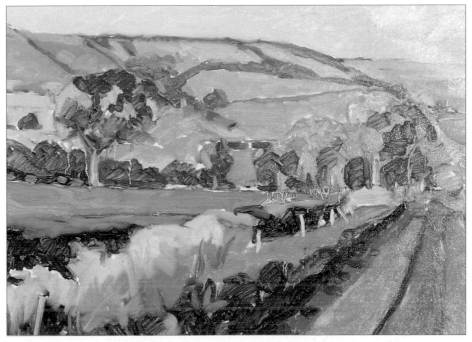

4. Continue blocking in the landscape and sky, gradually adding smaller shapes, until the whole canvas is covered with colour.

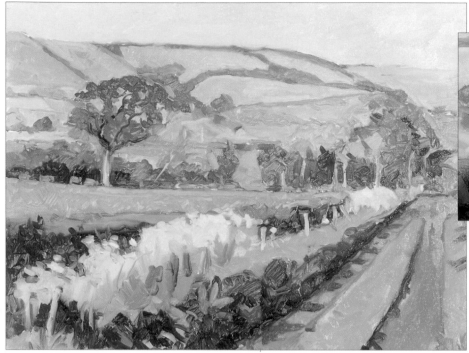

5. Start to build up the tones. Keep developing the painting by adding further foreground and middle distance details, by defining shapes, by adding highlights and by deepening shadows.

6. Use a clean, dry, medium bright brush to move the paint around and soften each area. Work over the whole painting, wiping the brush clean regularly to retain the freshness of the colours on the canvas.

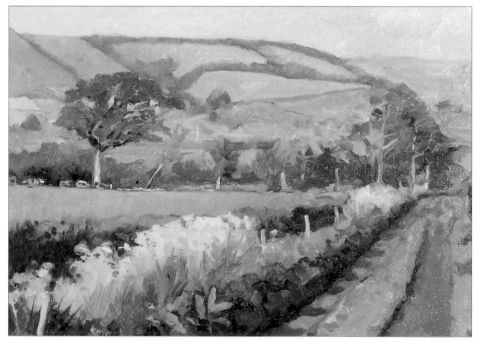

7. Continue developing the canvas, building up and moving the paint around on the surface, letting the brush strokes produce interesting textures. Do not worry about what brush to use, experimentation will provide the answer. Similarly, you do not have to mix every colour on the palette – you can change and mix colours on the canvas during painting. For example, if a green area is too blue, add some yellow on top, then move the paint about until you achieve the desired colour.

8. Develop specific parts of the painting by adding fine detail. A small round sable brush is useful when painting lines such as this wire fence. It also creates the smallest brush strokes, making it ideal for painting foliage and tiny bright highlights.

The finished painting

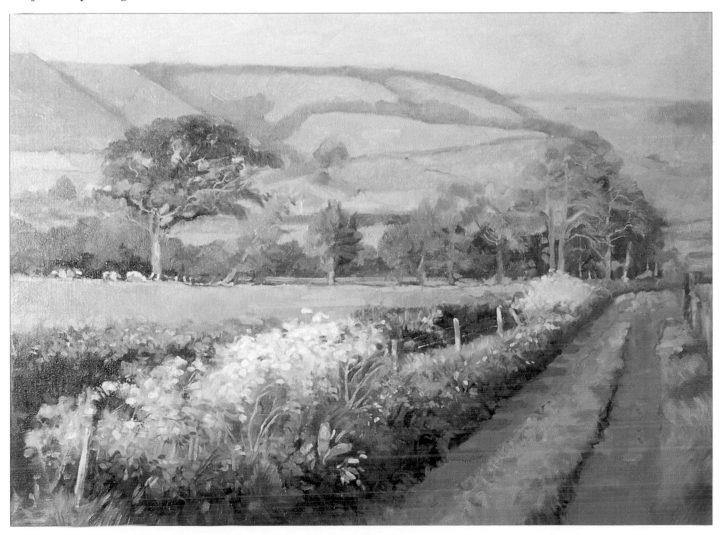

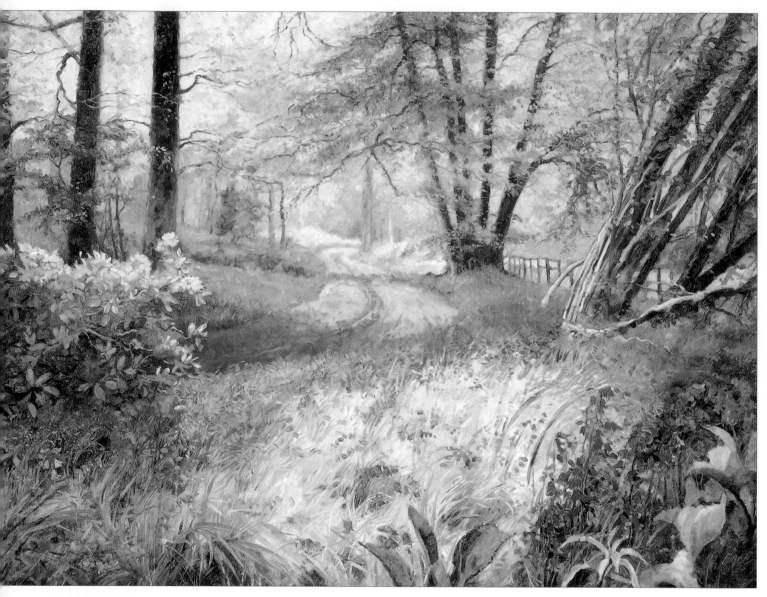

Bluebell Wood
101.5 x 76cm (40 x 30in)

Both this painting and the one opposite are examples of interesting landscapes. I painted them on the spot, and worked for approximately one week on each painting. Both were started in exactly the same way as the landscape demonstration on pages 20–23. In the painting above, a strong feeling of perspective is created by a simple path leading the eye into the far distance. I took foliage back to the studio to complete the foreground.

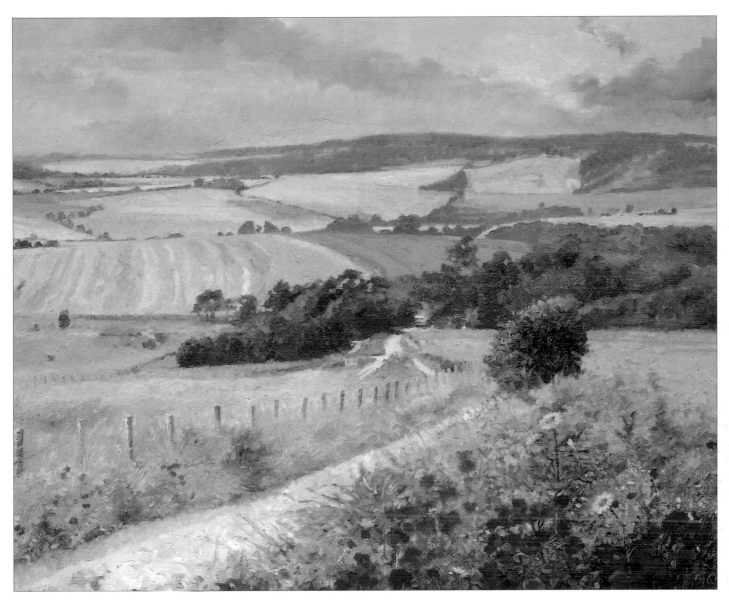

Poppies
76 x 61cm (30 x 24in)

Sunlight has a great deal to do with the impact of this painting, and the heavy clouds give it a more dramatic effect than would a clear blue sky. The path leading down to the trees in the middle distance takes the viewer past the colourful summer fields. There is a wonderful feeling of space and perspective which is heightened by the red poppies in the foreground and the blue misty hills in the distance.

LANDSCAPES IN OILS

by Michael Sanders

Oil paint is one of the most expressive and versatile of mediums. With its smooth, buttery consistency, you can create blended areas of colour with soft edges, heavily textural ridges of paint or pin-sharp highlights of brightness.

For centuries, oils have been the first choice of artists wishing to capture the myriad moods and colours of the great outdoors. Landscapes are a timeless source of inspiration. Each season brings different colours and textures, and the sky illuminates the scenes with different types of light that create a marvellous variety of atmospheres.

As with any subject, the way to begin painting a landscape is to learn to really 'see' it, and you should get into the habit of studying the world around you every time you leave home. Compare tones in the distance with those up close, and notice how distant objects appear pale, hazy and bluish. Look at the sky and see how many colours there are, and note how water reflects those colours. Watch cloud formations, and observe how they catch the sun and cast shadows. Compare the colours at the top of a tree with those in the shade at the bottom. It does not matter if you have never painted before – looking, seeing and comparing colours and tones will get you well on your way.

In this section, I will take you, stage by stage, through landscape painting techniques, as I build an image up, colour by colour and stroke by stroke. Follow me through the demonstration, then, using your new-found skills you will be ready to create paintings of your own – works of art that you can be proud of.

As you paint, you will feel attracted towards particular colours and techniques, or your creativity will lead you to try different techniques and maybe invent some of your own! Be bold, do not be afraid of colour or texture, do not worry about the occasional mistake and, above all, have fun!

Opposite
Working the Land
Size: 30 x 40cm (11¾ x 15¾in)

A lot of the work on small market gardens in the part of Cornwall where I live is still carried out by hand because of the steeply sloping terrain. There is an air of gentle dereliction about this image; the buildings show signs of neglect while the old man carefully tills the soil. I chose the colours to impart a warm nostalgic atmosphere. The washing hanging out to dry lends a mood of domesticity.

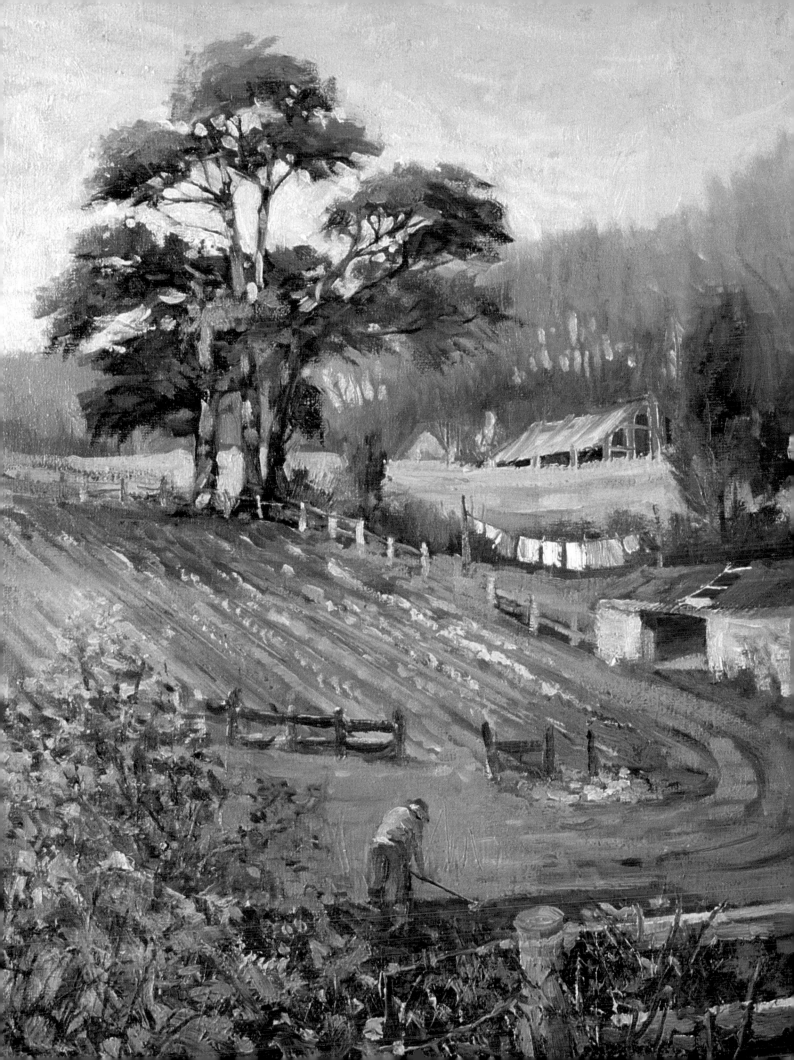

Understanding colour

Colour is a subject I am frequently asked about. How do you avoid colours that clash or look muddy? How do you create depth in a painting? It is true that, no matter how interesting, or how well-drawn a composition is, poor or indifferent colours can spoil an otherwise successful painting.

To me, one of the most important requirements is an understanding of colour temperature. All colours can be considered as warm or cool. Red is often regarded as a 'hot' colour, but permanent rose, for example, is a cool blue-red, whereas cadmium red is a warm yellow-red. Blue, on the other hand, could be seen as a cold colour, but it can be a warm ultramarine, or a cool phthalo blue. Similarly, Winsor lemon is a cool yellow while cadmium yellow deep is a warm red-yellow.

In a painting, warm colours (browns, brown-greens, reds and oranges) appear to be close to the viewer, while cool colours (blues, violets and blue-greens) imply distance. So, in the context of a landscape, it makes sense to include cool colours in middle and distant parts of a composition, and warm ones in the foreground.

In order to fully appreciate how colours work, I suggest you paint a colour wheel (see below), on a piece of white canvas board or primed cardboard. If you have not used oils before, it will give you a chance to get used to the feel of them and how they mix. Do not thin the paint, and scoop it off the palette rather than dipping into it. Clean your brush at regular intervals to avoid muddying the colours.

Colours that are opposite each other on the wheel are known as complementary colours – yellow and purple, orange and blue, red and green – and these

permanent rose

purples

reds

cadmium red

ultramarine (green shade)

oranges

blues

phthalo blue

cadmium yellow deep

greens

yellows

Winsor lemon

28

can also work well in the compositional sense. A painting with a lot of greens, for example, will be enlivened considerably by a touch of red and so on. Another use of complementary colours is to subdue or tone-down vibrant colours. So, if your trees are too green, a touch of red can often subdue the colour enough to make it look more natural.

Painting a colour wheel

Lay out a white and a warm and cool version of the three primary colours on a palette. For this wheel, I used the following colours: titanium white; Winsor lemon, a cool yellow; cadmium yellow deep, a warm yellow; cadmium red, a warm red; permanent rose, a cool red; ultramarine (green shade), a warm blue; and phthalo blue, a cool blue.

Start the basic colour wheel (the inner of the three circles) at about the seven o'clock position with a small block of cool yellow. Then, working clockwise, gradually mix touches of warm yellow to the cool yellow and add more blocks until you have a block of pure warm yellow. Now mix tiny touches of warm red to pure warm yellow and lay in more blocks of colour until you have a block of pure warm red. Cadmium red is quite strong, so be careful with the mixes. Complete the warm side of the wheel by mixing touches of cool red to the warm one and adding blocks of colour to the wheel until you have a block of pure cool red. Permanent rose is fairly weak so you will need a lot for it to have an effect.

Work round the cool side of the wheel, introducing the warm blue to the cool red, the cool blue to the warm one, then the cool yellow to the cool blue. For this wheel, I mixed my blues, ultramarine (green shade) and phthalo blue with titanium white to create warm and cool mid-blues.

When the basic wheel is complete, the yellows should be opposite the purples, the oranges opposite the blues and the reds opposite the greens. These are the complementary pairs of colours referred to earlier, and they can be mixed to produce the wide range of brownish colours (the spokes of the colour wheel).

In this example, I developed the wheel further to show a range of tints. I lay in an outer band of pure white, keeping it slightly away from the basic colour wheel, then dragged the colours from the basic wheel across half the width of the white. I then dragged these tints across the remaining width of white to produce paler hues of each colour.

Autumn on Dartmoor
Size: 40 x 30cm (15¾ x 11¾ in)

This atmospheric composition makes good use of complementary colours – the warm orange-browns of the tree and foreground foliage, and the cool hazy blue of the distant hill.

Mixing your own greens

It is possible to use a ready-made mid green (say sap green) and modify it with Winsor lemon or Naples yellow to create lighter tones, and ultramarine (green shade) or burnt sienna to make darker ones. Making your own greens, however, should be the aim of every landscape artist. It is not difficult to mix attractive greens, and once you have mastered the technique, you will never be stuck for the correct tone or shade.

For my basic green, I use Winsor lemon – a clean coolish yellow – and ultramarine (green shade), a cooler version of the traditional ultramarine blue. For darker shades, I add more ultramarine (green shade) or burnt sienna. To lighten these greens, I add Naples yellow for warm shades or titanium white for cooler, receding greens.

Try out these mixes or experiment with your own colours. There are two important points to remember: natural looking greens often have a lot of brown or yellow in them, especially those in the foreground; and distant greens are best made paler and bluer.

Sometimes, we are faced with the problem of distant greens that are quite dark. A good way of dealing with this is to make the colour more blue than green, so that they still appear to recede. Phthalo blue is a good blue to use; add a little Winsor lemon to make it greenish and some titanium white to achieve the correct tone. Be careful when using this blue; it is very strong so use it sparingly.

1 – Winsor lemon and ultramarine (green shade)

4 – mix 1 with a touch more ultramarine (green shade)

7 – mix 1 with some burnt sienna

2 – mix 1 with a little Naples yellow

5 – mix 4 with a little titanium white

8 – mix 7 with a little Naples yellow

3 – mix 2 with a touch more Naples yellow

6 – mix 5 with a touch more titanium white

9 – mix 8 with a touch more Naples yellow

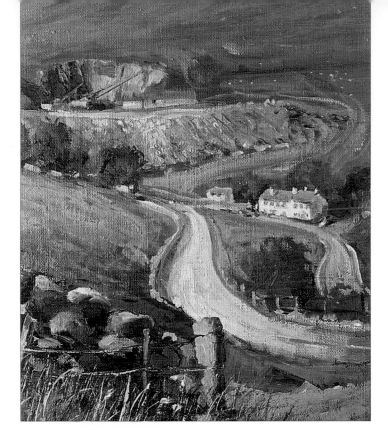

Merrivale Quarry
Size: 24 x 30cm (9½ x 11¾in)

A moorland setting like this enables me to use a wide variety of warm and cool greens. I painted this image on site, in one session. I chose an orange-tinted board to work on, and allowed some of the colour to show through here and there to unify the painting. Orange or red can work well as a background colour for greens as it tends to soften and modify them.

10 – Winsor lemon and
Naples yellow

13 – A lot of Winsor lemon with
a little ultramarine (green shade)

16 – Winsor lemon with a
tiny amount of phthalo blue

11 – mix 10 with a little
titanium white

14 – mix 13 with a little more
Winsor lemon and some titanium white

17 – mix 16 with a little
titanium white

12 – mix 11 with a touch more
titanium white

15 – mix 14 with more touches of
Winsor lemon and titanium white

18 – mix 17 with a touch more
titanium white

Painting techniques

Oil paint is the most versatile of all painting mediums. It is possible to adopt many techniques and, due to the slow drying time, oils can be superimposed on one another or scraped back to show the original colours. Sponges, rollers, stamps, fingers, and even bicycle tyres and plastic cutlery have been used to produce works of art in oils! Try some of these more traditional methods, then maybe invent some exciting ones of your own.

Wet on wet

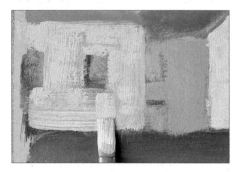

This is the most immediate and simplest technique. Colours are brushed on with little or no dilution and the painting is built up with brush strokes which remain visible.

When working wet on wet, the application of paint is likely to lift off some of the colour already applied. This can result in muddy colours, especially when putting light on to dark or *vice versa*. To keep colours fresh and clean, get into the habit of wiping the brush with a paper towel or clean rag every few strokes, then recharging it with clean colour.

The demonstration in this section was painted wet on wet.

The easiest way to get started is to begin on a tinted canvas or board, allowing some of this background colour to show through here and there, to unify the painting.

Wet on dry

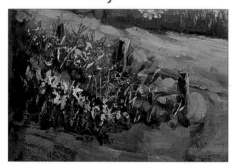

This is a very traditional oil painting technique, where the painting is allowed to dry thoroughly between layers. It is not for the impatient – one to two weeks should be left between stages – although this time can be reduced to a few days by using a fast drying medium.

The one important rule in oils – 'fat over lean' – must be followed to ensure good adhesion between coats of paint. This means that you should always put thicker paint over thinned paint. When working on a dry painting (except the primer coat on the board or canvas), any dilution of paint must be made with linseed oil or a medium, not turpentine or white spirit.

Wet on dry is a very good technique for building up intricate, fine detail over a period of time.

Scumbling

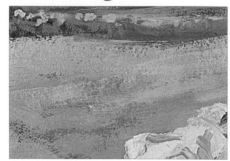

Scumbling is a classic, broken-colour technique which creates a lively, textured appearance. It is particularly useful for masses of foliage, clouds, moorland or mountains, rough-textured walls and old buildings. It can be used wet on wet or wet on dry, but do allow the colours underneath to show through here and there. Although it is possible to scumble several colours in one area, it is better to use similar tones or the effect can look clumsy.

Scumbling can be a very useful technique for rescuing a bland area of a painting, where a flat area has become uninteresting – simply mix a colour, similar in tone but slightly different in colour, and apply loosely with a big brush, making sure to leave plenty of gaps between brush strokes. A very satisfying effect can be achieved this way.

Dry brush

In oils, unlike watercolour, the highlights are applied last, on top of a darker colour. To achieve an effect like sparkling water, or of light rippling on a cornfield, the pale vibrant colour must be dragged across the surface so that the brush stroke breaks up in an interesting, irregular way.

The brush should be held lightly, well back on the handle, with the handle parallel to, and almost touching, the surface. Very little pressure is applied and the paint is literally dragged off the brush. This technique can be wet on wet or wet on dry.

Sgraffito

This technique entails scraping back through wet colour to show a different colour underneath. You can use any pointed object: the tip of a painting knife, a wooden skewer or cocktail stick, or even the sharpened handle of a paint brush.

For most of my paintings, the undercolour is the primed board or canvas, so I choose a primer colour to suit the subject. For best results, the undercolour should be a different tone to the layer being scraped through.

Sgraffito is excellent for detail where clean, crisp lines are required: grasses, hair, fence posts, gates, masts, ropes, stems of flowers and branches.

Impasto

This is a technique which in extreme cases can become almost sculptural. Heavy layers of paint are built up to create a rough, textural surface that adds a further dimension to the painting. Stiff brushes and knives are best used for impasto work, with no attempt at hiding the strokes. A very directional appearance can be achieved with impasto, to imply the slope of a hill, the movement of water, or light through trees. The effect tends to dominate a painting and is best restricted to the foreground or middle distance.

If you want a really heavy, more textured impasto, use an impasto medium to bulk out the paint.

Glazing (see also pages 140–141)

A glaze is a coloured, transparent varnish used to change colours in a painting without losing any of the detail underneath. Always mix colours with a glazing medium, not linseed oil or turpentine. Most glazing mediums dry in a day or two, and it is best to allow the glaze to become completely dry before working subsequent layers, or parts of it could be smudged and the glaze made muddy. The best colours to use are those listed in manufacturers' colour charts as transparent or semi-opaque. Opaque colours will look muddy.

I sometimes use a glaze to add shadows or form, or to modify part of a painting that has not worked. Some artists work almost exclusively in thin glazes, carefully building up the desired effect. A good way of using a glaze is to put a complementary colour on top of one that appears too vibrant or bright – while still allowing some of the bright colour to show through here and there.

Quiet River

The tonal sketch of this peaceful village scene was done without colour notes or indication of time of day. By choosing pale, warm colours for the buildings, and purple and blue shadows, I have created an evening setting for this demonstration.

I felt that the boat, as portrayed in the tonal sketch, was too horizontal and made the composition rather static, so I decided to change it. I found a photograph of a similar boat in my reference collection, and made a pencil study of it by the side of the original tonal sketch in order to establish the shadows. I also sketched a small outline of the revised composition. As I developed the painting, I decided the oars were a distraction, so I left them out.

You will need

30cm (12in) square of 3mm (1/8in) cardboard, primed with acrylic gesso mixed with a little cadmium red acrylic paint

Nos 2, 6, 10 and 12 long flat brushes

Colours:
 Ultramarine (green shade)
 Permanent rose
 Cadmium red
 Winsor lemon
 Naples yellow
 Titanium white
 Burnt sienna

This photograph and the sketches below were used as the reference material for this step-by-step demonstration.

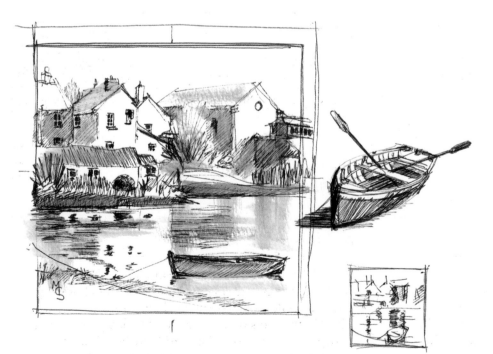

1. Mix shades of purple from ultramarine (green shade), permanent rose and tiny touches of Naples yellow. Thin the colours, then, referring to the sketch opposite, use the No 10 brush to draw in the outlines. When you are happy with the composition, use the purples to block in the dark windows and shadowed areas, creating a tonal range that will be maintained through to the finished painting.

2. Mix titanium white with touches of permanent rose and Winsor lemon, then block in the base layer of the sky. Work the brush vigorously to create a thin layer of colours. In this scene, I wanted to achieve the warm glow of a summer evening, so the sky required hints of yellow and violet.

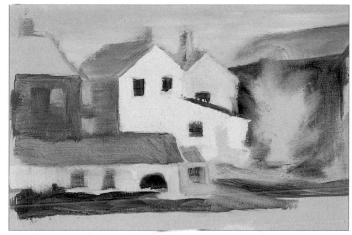

3. Use titanium white with a touch of Naples yellow to block in the front of the middle cottage (notice that I left space for another window to be added later). Add touches of ultramarine (green shade) to the mix and block in the next door cottage and the foreground building.

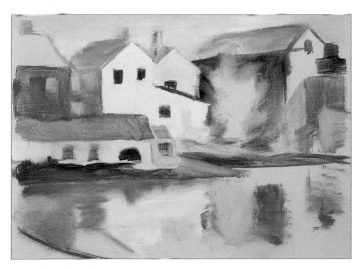

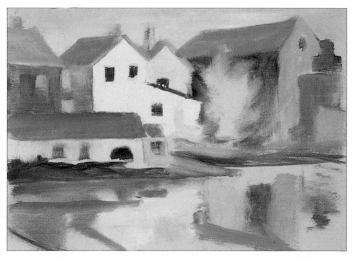

4. Use the same colours to block in the reflections, remembering that they must align vertically with the objects being reflected. Use the existing greys on the palette to add reflections of the dark sides of the buildings. Use a dry brush to soften and merge the edges of all reflections.

5. Mix a pale orange (Naples yellow and cadmium red), then block in the front faces of the right-hand buildings and their reflections. Add a touch of burnt sienna and block in the roofs of the foreground building, the middle cottage, and their reflections. Add touches of titanium white, then block in the roofs of the other buildings.

35

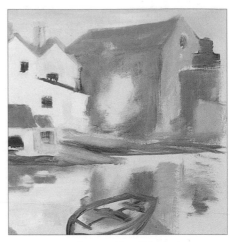

6. Use a thin mix of burnt sienna and ultramarine (green shade) to draw in the outlines of the boat.

7. Weaken the purples on the palette with titanium white, then block in the side of the middle cottage. Add more white and some Naples yellow, then block in the fronts of the left-hand and foreground buildings. Add these colours to the reflections.

8. Mix burnt sienna and Naples yellow with a touch of ultramarine (green shade), then overpaint the purples on the side of the large building, leaving some of the undercolour showing. Scrub some of this green into the reflections.

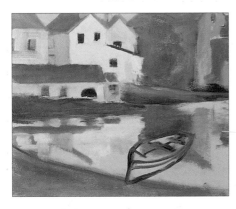

9. Mix dark greens from Winsor lemon, ultramarine (green shade) and burnt sienna, then block in the foliage. Use the brush strokes to show the direction of growth. Add more Winsor lemon to work the mid tones (detail and lights and darks will come later). Use a slightly darker tone (more burnt sienna and ultramarine (green shade) and horizontal strokes for the reflections. The reflection of the tree gives a good dark behind the boat. Add a touch of titanium white for the foreground.

10. Mix a pale orange (cadmium red and Winsor lemon), then use loose irregular brush strokes to develop the sky. Start from the left-hand side, adding touches of titanium white as you work across to the right-hand side. Allow some of the undercolour to show through, and take the colour across the chimneys which will be reinstated later.

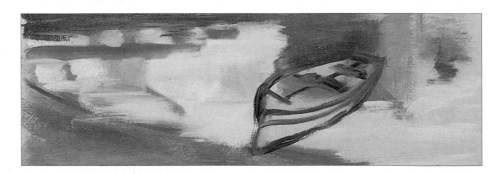

11. Use slightly paler tones for the sky reflection.

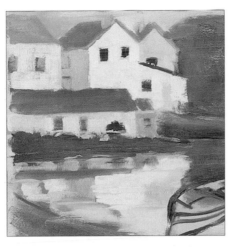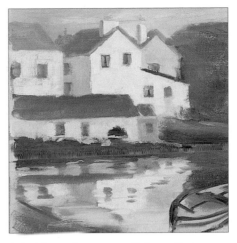

12. Mix Winsor lemon and titanium white, then use the No 6 brush to overpaint the front of the left-hand cottage. Use short strokes to build up a rough stone texture on the wall. Again allow undercolours to show through.

13. Add more titanium white, then paint the front of the middle cottage. Add burnt sienna to make a slightly darker mix to paint the foreground building. Use all these tones to add reflections. Overlap colours to imply ripples on the surface of the water.

14. Use paler tones of the yellows to redefine the chimneys. Mix purple-greys from ultramarine (green shade), Naples yellow and permanent rose, then use the edge of the No 2 brush to adjust the windows and the shadowed side of the chimneys, and to add a distant roof and chimney. Use these tones to paint the reflections.

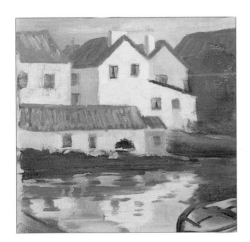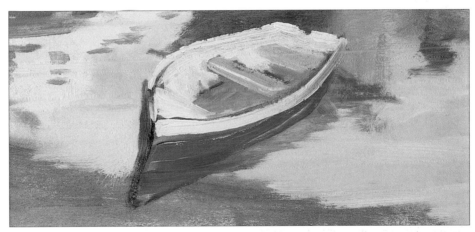

15. Use a mix of burnt sienna, Naples yellow, and a touch of cadmium red to adjust the roofs, angling the brush strokes to follow their slopes. Use short strokes of paler colours to suggest roof tiles. Again add touches of these colours in the reflections.

16. Use ultramarine (green shade) with a touch of permanent rose to block in the side of the boat. Use a weaker tone (add a touch of titanium white) for its reflection in the water, and a deeper tone (more blue) for the shadowed side. Use Winsor lemon with tiny touches of cadmium red and titanium white to block in the insides of the boat; add burnt sienna to the mix and paint the bottom, and cadmium red and more white for the seats. Paint the gunwales and foredeck with titanium white mixed with just a hint of Winsor lemon.

Tip *Turn the painting upside down to work the nearside curves of the boat.*

37

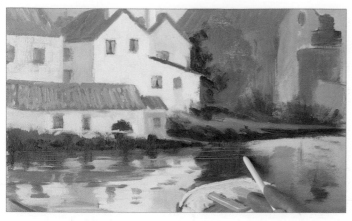

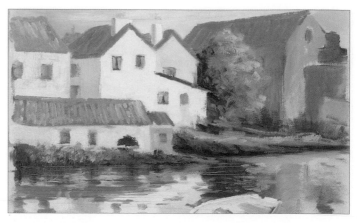

17. Mix a dark green from ultramarine (green shade), Winsor lemon and burnt sienna, then use the No 2 brush and short, upwards strokes to paint the shadowed parts of the tree and the foliage on the far bank, and to define the edges of the buildings and the river. Pull some of the darks down into the water, then use the handle of the brush to make horizontal strokes through these reflections.

18. Mix a pale green from ultramarine (green shade), Winsor lemon and touches of Naples yellow, then work up the highlights on the tree and foliage. Again introduce these colours into the reflections. Use the handle of the brush to scratch out the indication of a few branches and part of the tree trunk.

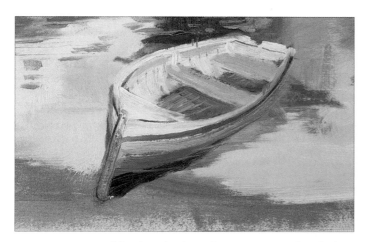

19. Having stood back to look at the painting, I decided to widen the boat slightly. Working upside down, I redefined the gunwales, foredeck and seats, then added shadows in the bottom of the boat. I used the brush handle and the sgrafitto technique to define the planking and other edges and shapes inside of the boat. I completed the detail and highlights with an off-white mix of titanium white and Naples yellow.

20. Mix an off-white (titanium white with touch of Naples yellow) and pick it up on the straight edge of a small piece of paper. Touch this on to the windows to define the bars. Mix a pale grey from Naples yellow, ultramarine (green shade), burnt sienna, titanium white, then use the edge of the No 2 flat brush to create the window recesses and the shadows under the window sills.

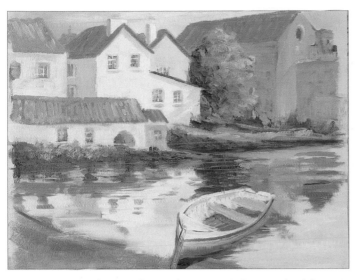

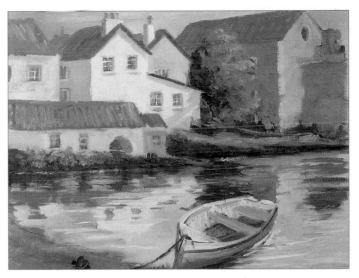

21. Mix a purple-grey from ultramarine (green shade), permanent rose, Naples yellow and titanium white. Scumble this on the side wall of the right-hand building, then add a few holes in the adjacent tree and adjust the shape of the window. Add a touch more white, then paint cast shadows under the eaves of the cottages. Use the greys on the palette to add detail to the shapes at the right-hand side and the reflections.

22. Having stood back to view the composition, I was not happy with the right-hand side so I decided to amend it. I overpainted the cast shadow on the large building and made its end wall slightly wider. This created a much better reflection to contrast with the stern of the boat. I also used titanium white with a hint of grey from the palette to create ripples to the left and right of the boat.

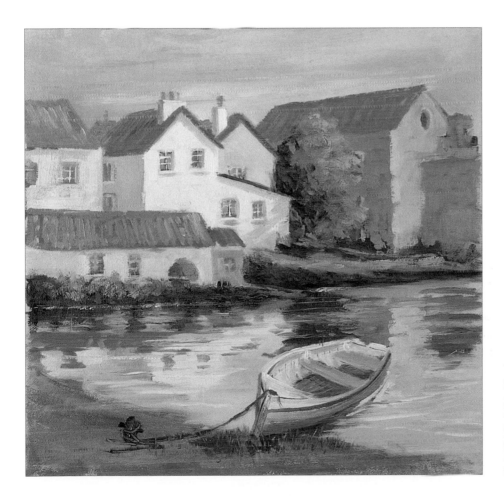

The finished painting. To complete the painting, I modified the foreground grasses to include the shadow of the boat and added a mooring rope. I also modified the reflections of the large building at the right-hand side, then dry brushed a pale mix of Winsor lemon and titanium through the reflections.

ELEMENTS OF THE LANDCAPE

by James Horton

One might say that the birth of modern landscape painting began with Turner and Constable and then proceeded to accelerate in development throughout the rest of the nineteenth century; so in terms of western art as a whole, landscape painting is still in its infancy. At the start of the twenty-first century it might be easy to think that there is nothing much left to do in the wake of such wonderful painters as the Impressionists and many others since. However, all artists have worked with the achievements of their predecessors looming large behind them and still gone on to find new challenges.

The fact is that we are surrounded by the landscape and can turn to it as a permanent source of inspiration, and as long as there are individual painters working with an independent eye, we can always enjoy looking at, and creating, landscape paintings.

To try and teach painting comprehensively through the medium of a book is no more possible than teaching cabinet-making or any other subject where practical experience is necessary. However, what I hope to do in this section is to lay the foundations of a solid technique that will enable the enthusiast to embrace any part of the subject without fear or intimidation and approach the landscape with reasonable expectations of achieving decent results.

When I am teaching, I often hear a student say that they chose a particular view because they felt it more approachable or easier than another. My feeling is that subjects that inspire you are the ones you really want to paint. In reality, there is not really any subject that is intrinsically more difficult than any other. There may be complexities or intricate aspects to a particular subject, but the actual business of simplifying and turning the literal into a painterly language will always remain the same. Any subject is possible; all that is required is to find the means to tackle it. Most important is to approach your subject in a positive way, which means not making a compromise before the painting actually starts!

The challenge of pitting your wits against the view in front of you and trying to turn it all into a picture is the most exciting thing in painting, in my opinion. In addition, let us not forget that when working outdoors the challenge is not always intellectual. A whole multitude of events can test your resolve; from inclement weather, things that block your view, to people who insist on holding a conversation. Hopefully I can help you to create a technique capable of dealing with the painterly problems by sharing with you my own approach and enthusiasm for landscape painting.

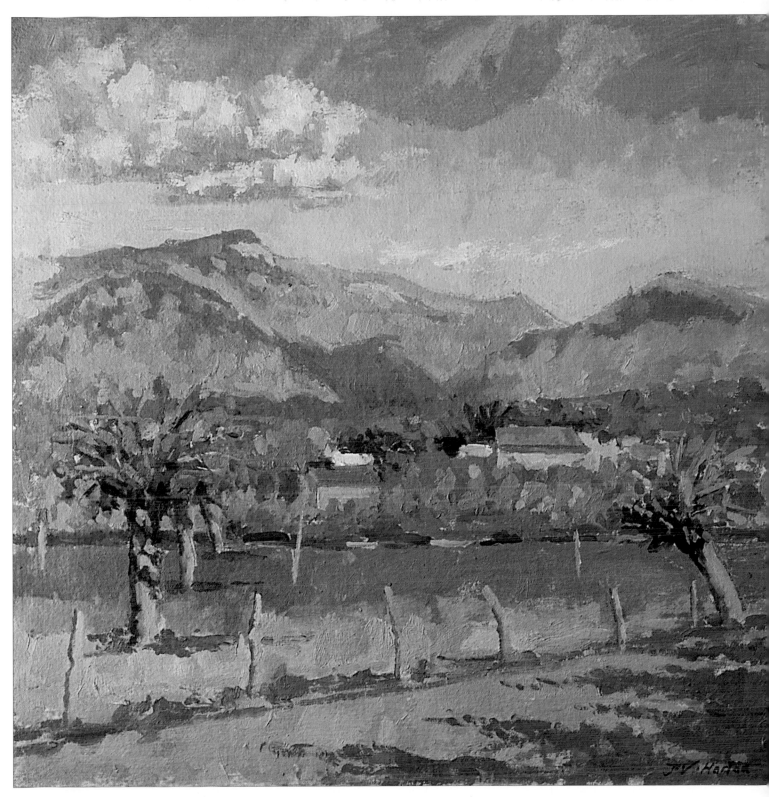

Bright and Windy Day, Can-Xenet, Majorca
45.7 x 38cm (18 x 15in)

The great challenge in this painting was to capture the fleeting clouds and resulting shadows on the hills. The ability to 'freeze frame' at any one point within your mind's eye is essential at times like this.

Aerial perspective

The term 'aerial perspective' is used to describe how colours become less intense as they recede into the distance. This often results in a bluish or purple quality in objects that are very far away.

As a painter I am very concerned with colour, and in particular spatial colour. As a consequence, most of the paintings in this section will show aerial perspective to a greater or lesser degree (see the painting on the right for a particularly striking example).

As painters, we should always be objective when considering colour values – the way one colour looks against another; whether it is brighter or more subdued; darker or lighter. The more you compare colour within your subject, the better the 'fix' will be in relation to pitch. In relation to aerial perspective this means that if the tones and colours in the landscape you are painting are correctly observed, you will automatically establish a degree of aerial perspective.

Note that just as parallel lines appear to converge as they recede from the eye, so too will colour alter in relation to the effects of ordinary, or 'linear' perspective. Generally speaking, colours tend to become greyer and less intense and often acquire a blue or purple hue as they recede. This is worth remembering if you have to work on pictures away from the spot.

View from the Villa del Monte, Rufina, Tuscany
28 x 35.5cm (11 x 14in)

Notice how aerial perspective is used in this scene.

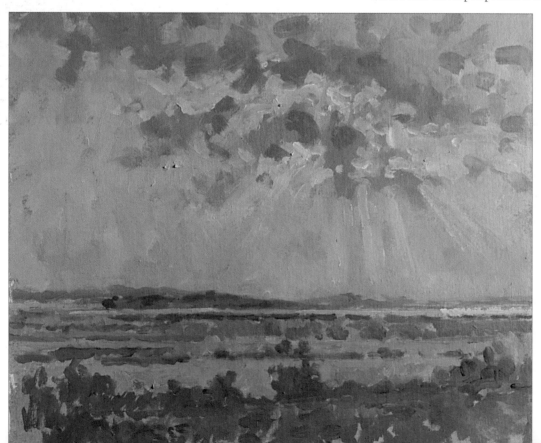

Late Afternoon Looking Toward Wells from Blakeney
30.5 x 25.5cm (12 x 10in)

This painting has been developed in quite a high key (i.e. lighter tones), and a muted range of colour. The bluish character of the distance helps to create space, distance and recession. Even in full daylight, objects and areas in the distance tend towards blue, but the more the light begins to dwindle, the greater the blue-grey effect.

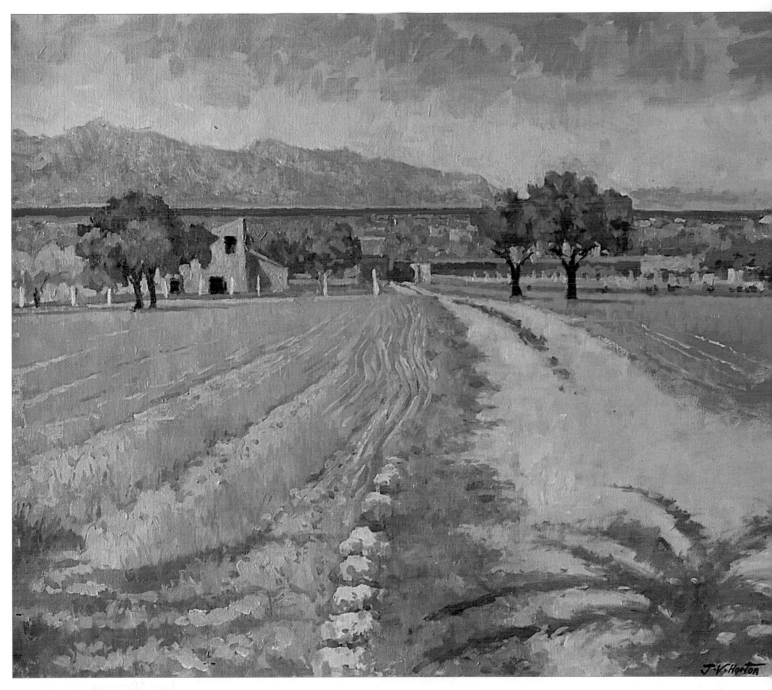

The Drive at Can-Xenet, Majorca
26 x 22cm (10¼ x 8¾in)

As well as the use of typical aerial perspective, this picture also uses linear perspective to aid a sense of recession. Notice how the cast shadows help to create a foreground.

Composition

Composition in painting is a rather difficult thing to define. The further one goes back into history, the easier it becomes to distinguish a good composition from a bad one. The 'rules' were much clearer and better defined in the past. In modern times, particularly with the ever-present influence of photography, it is much more difficult for a painter to know what is expected of him or her.

Although one might be reluctant to define a good or bad composition, I think it is possible to identify one that is interesting, complex and well thought out. If a composition satisfies all these criteria and the artist can honestly say that it does all the things he wanted it to, then it would be fair to say that such a composition is successful.

I often feel that the shape and proportion of the canvas (e.g. long and thin, square etc.) will have a character that can suggest certain ideas about geometry, tension and negative shapes and is similar to that of a key for a composer in music – some artists will like a certain shape, just as a musician will like a certain sound. Regardless of the shape of the canvas and what is being painted, the important thing to remember is that a composition must adequately fill the whole space of the canvas and have the feeling that the content belongs there and is held there by its own geometry and armature.

Note

Positive shapes are objects such as trees, buildings and people. Negative shapes are the shapes made by the space left around positive shapes.

Using a viewfinder

Very often landscape painters will use a viewfinder. This is an excellent way of seeing how your composition will look within your chosen format. The essential thing to remember is that the shape of the window in the viewfinder must be the same proportion as the canvas. This is why it is important to have an adjustable viewfinder.

A viewfinder is made up of two rectangles of cardboard held together with a bulldog clip. Each piece of cardboard has a rectangular hole cut in it, so by moving one in relation to the other you can change the shape of what is visible through the viewing hole.

The following photographs show how a viewfinder is used. Simply hold it a comfortable distance away from yourself and move it until you are happy with the scene you can see through it.

If you move your viewfinder near to or further from the eye, you increase or decrease the amount observed.

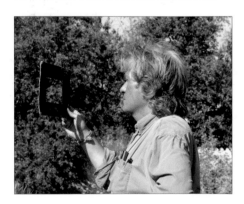

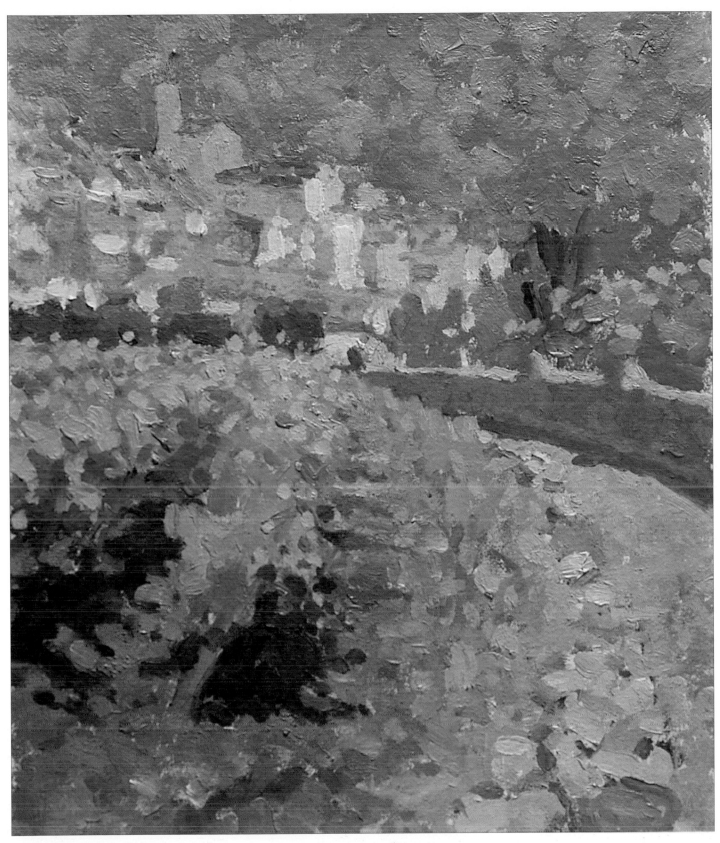

Roquebrun, France
20.2 x 25.5cm (8 x 10in)

This picture uses the classic motif of parallel lines. The vines, road and wall all align and lead the eye
into the composition. Notice how the eye level is set quite high to make the most of the foreground.

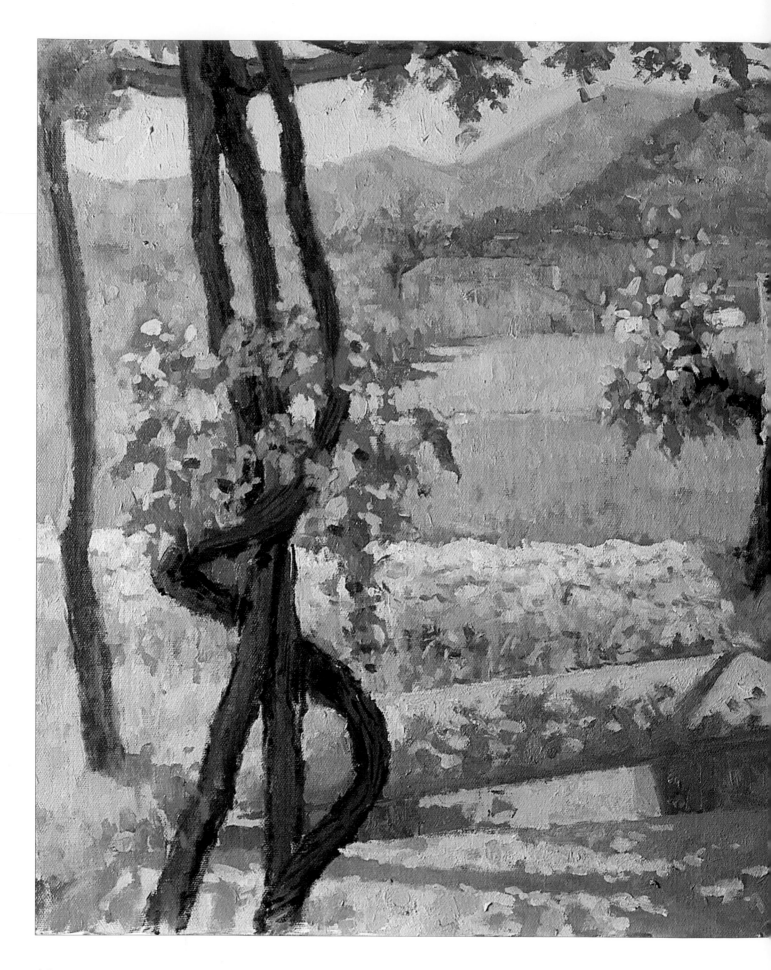

The View of the Mountains through the Pergola, Can-Xenet
56 x 45.7cm (22 x 18in)

This composition uses a 'frame within a frame' technique to enhance the space between the foreground and the distant mountains. By playing off the horizontals of the distant fields, wall and benches with the verticals of the vine and pergola, it creates an abstract effect almost like that of Mondrian and Ben Nicholson.

Observation & colour values

One of the most exciting, but also frustrating, aspects of painting outdoors is the changing light. In a country like England, stability within the weather during a working session is very rare. How often painters have longed for the long, sunny days that the Impressionists enjoyed in the south of France.

The key to coping with changing light is not to chase the light by altering the picture every time the light alters. Instead, try to observe the key points each time the light returns to where you want it and maintain a consistency of observation. Some parts of a scene will remain more constant than others, and these are the parts you can work on while waiting for the key elements to stabilise.

Secondly, it is never advisable to work too long on the same picture even if the light is stable, because the quality of light will alter as the day moves on. Two to three hours is the ideal time for working straight from life. If you cannot complete your painting in one session, try to return at the same time the following day.

One of the most important factors in establishing a good working pitch as early as possible is to compare and contrast different parts of a scene and work uniformly all over the canvas, rather than completing one detail of the composition before moving on. You will see this procedure in use in most of the projects. Although it is possible to alter anything at any time in oil painting, it is such a good feeling if the painting starts well and progresses smoothly without too much struggle to develop the basics.

The Creek at Morston, Norfolk
61 x 40.5cm (24 x 16in)

The light was very changeable during this painting and I had to be careful to keep my observations consistent, particularly in relation to the distant Blakeney Point where the sun lit up different parts of the landscape at different times.

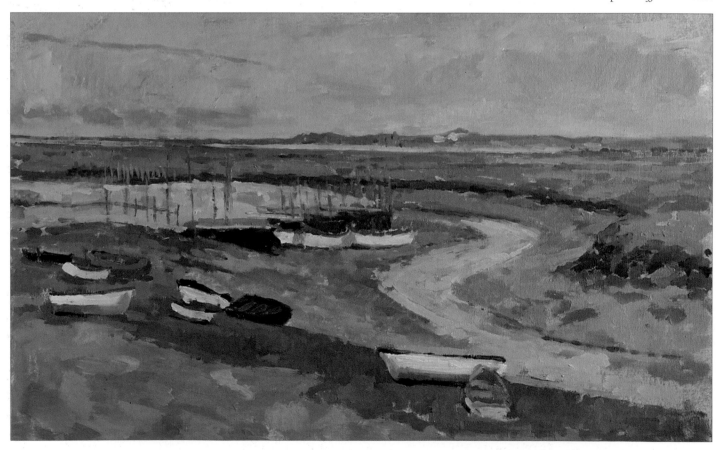

The Long and Winding Road
25.5 x 15.2cm (10 x 6in)

This painting was done in mid-winter on a bleak road in the Fens. The sky at first seemed a leaden grey, but after a while the eye becomes very alert to the subtle differences of pearly greys.

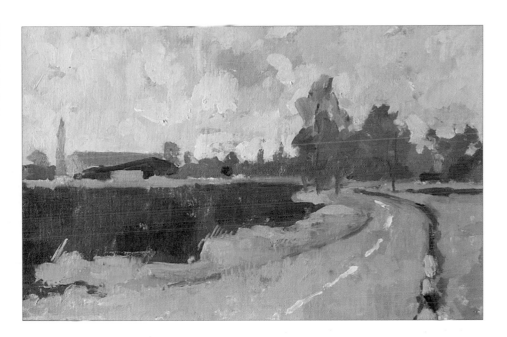

Beach Huts at Walberswick
91.5 x 76cm (36 x 30in)

Despite its size, this picture was painted entirely on the spot. I had several days of constant light – very important for the shadows – and was able to achieve a freedom and fluidity of brushstrokes quite different from that possible on a smaller canvas. A painting of this size enables you to resolve areas more thoroughly into greater detail.

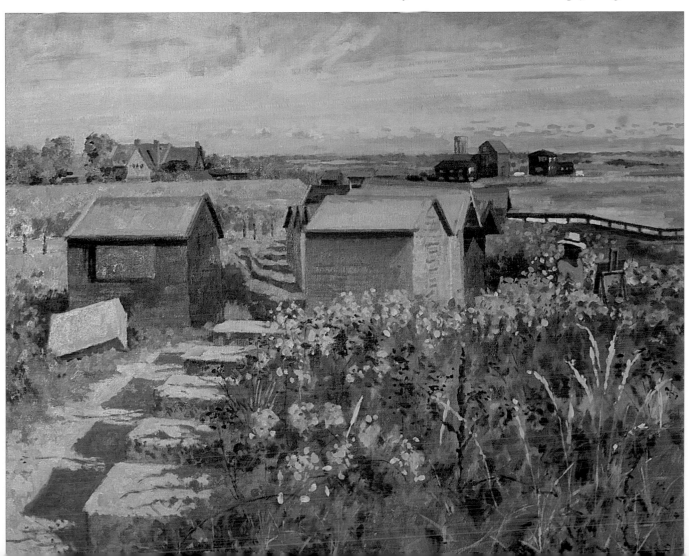

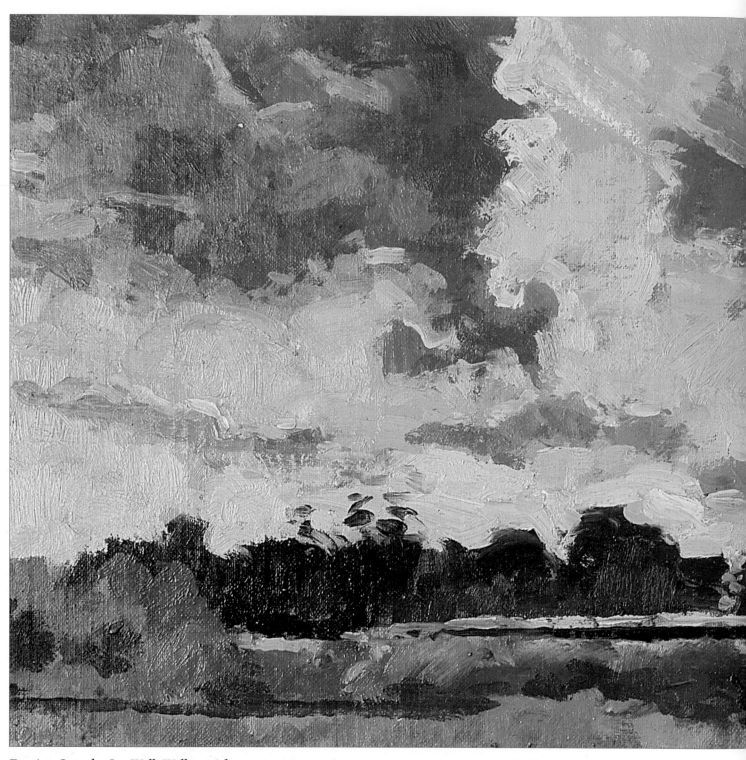

Evening Over the Sea Wall, Walberswick
25.5 x 20.2cm (10 x 8in)

This is, in effect, a pure sky study as the landscape below does little more than to anchor the sky.
However, without the landscape the picture would have been far less interesting.

Skies

John Constable once said that the sky was the chief organ of sentiment in any picture. Painting in East Anglia, where one sees so much sky, he was only too aware of the importance it has in a painting.

The sky plays an important part in all our lives, and whether it is filled with thunderclouds or a stunning sunset, we are continually aware of it. As landscape painters it is always a challenge to try and capture a particular sky in all its subtlety. There is also the added challenge of movement in the sky – sometimes very rapid movement.

Constable was the son of a miller and grew up in the country. Consequently, he observed the sky day after day. He was probably the first artist to make serious studies of clouds and skies to try and gain extra authenticity in his paintings. I remember once looking at the paintings of Sir Peter Scott, the bird artist, and thinking how wonderfully plausible his skies were. Once again, he was a man who spent a great deal of time outside observing.

Like Constable, I feel that we should all make little sky studies of cloud structures, colour formations and so forth to improve our knowledge of how skies work.

Late Afternoon Rooftops, Marrakech
30.5 x 25.5cm (12 x 10in)

This was painted from the roof of the riad I was staying in. It is good to give the sky an anchor: even though the rooftop, trees and tower are loosely suggested, that is all that was needed.

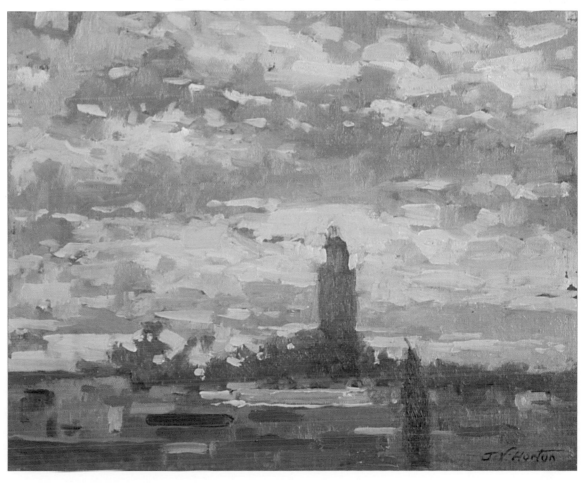

Clouds Over the Quarry

This is an exercise in creating cloud structures with relatively few colours, and also achieving solidity with simple, broad brushstrokes.

Useful mixes on the palette

Warm field mix ——————————

Cloud mix ——————————

Cool field mix ——————————

Sky mix ——————————

Sky highlight mix ——————————

You will need

Canvas, 30.5 x 25.5cm
 (12 x 10in)
Medium mix (see page 7)
 or ready-made medium
Brushes: size 2 round,
 size 4 flat
Colours:
 French ultramarine, ivory black,
 phthalo blue, cobalt violet,
 permanent rose, cadmium red,
 yellow ochre, Venetian red,
 cadmium yellow, lemon yellow,
 titanium white
Medium painting knife
Clean rag

1. Sketch out the rough shapes of the landscape and cloud formations with a size 2 round brush and French ultramarine.

2. Mix titanium white and cobalt violet into the French ultramarine on your palette, and use this mix with a size 4 flat brush to block in the area of sky at the top of the painting. Vary the tones by adding more French ultramarine and a touch of ivory black for the very darkest shades at the top right. Paint the sky above the horizon in a lighter tint by adding lemon yellow to the original French ultramarine, titanium white and cobalt violet mix.

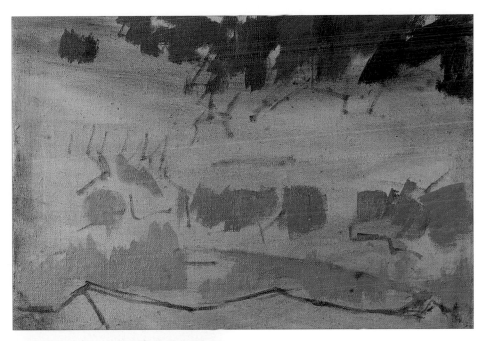

3. Still using a size 4 flat brush, begin painting the clouds with a titanium white and yellow ochre mix. Continue varying the sky by adding phthalo blue to the sky mixes you have on your palette. To incorporate the colours of the clouds into the sky, add yellow ochre to the sky mixes.

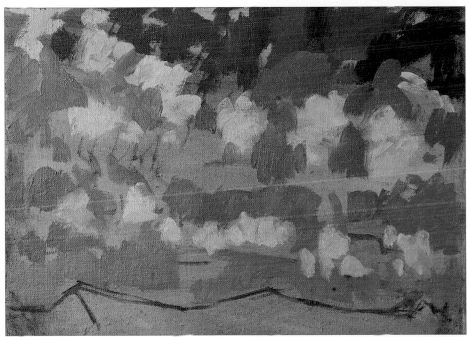

Tip

If you want to portray a faster-moving sky, then it is not necessary to sketch out the clouds beforehand, since they will be unrecognisable later on.

4. Continue filling in the sky, continually varying the main sky mix with the addition of phthalo blue and touches of yellow ochre and ivory black. Switch to the size 2 round brush and use a mix of cadmium red, titanium white and yellow ochre to block in the quarry on the lower left of the painting. Add some of the darkest shades used in the sky to this mix for the shadow of the quarry.

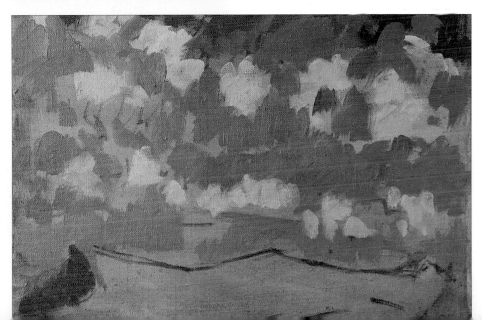

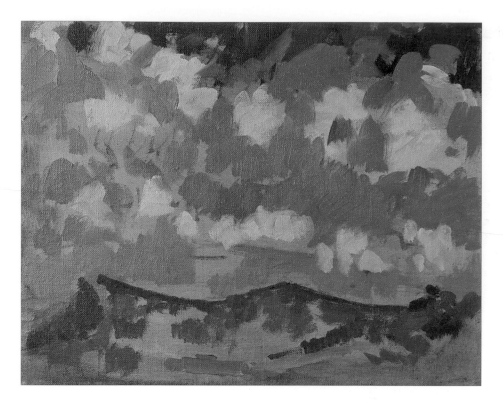

5. Block in the main colours on the ground using a size 4 flat brush and a mix of lemon yellow and ivory black, varied with the addition of phthalo blue and titanium white. Add Venetian red to this ground mix and use this shade to add in a darker line on the horizon and add shadows and texture to the ground, paying particular attention to the darker hillsides. Drop in the foreground fields with a mix of cadmium yellow, cadmium red and yellow ochre.

Tip

Keeping your brushes and medium clean is essential for a fresh finish, so rinse and dry the brushes thoroughly before using them with a different colour of paint. Alternatively, have a number of brushes on hand for different colours.

6. Using the same mixes as for the ground in the previous step, add touches of French ultramarine and yellow ochre, and refine the landscape. Begin comparing the tones of the sky and the ground and ensure the painting as a whole works harmoniously, lightening or darkening the colours used in the sky and the ground as necessary. Continue tightening the clouds and sky with the sky mix, and add more titanium white to lighten the sky.

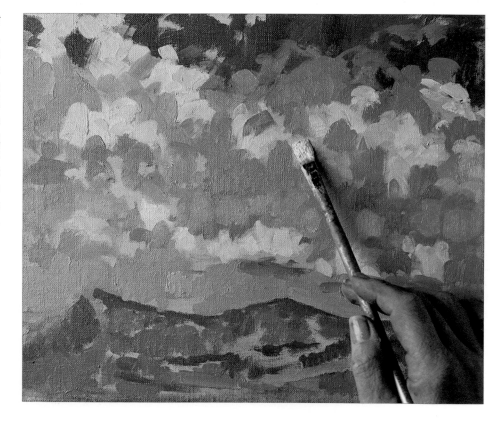

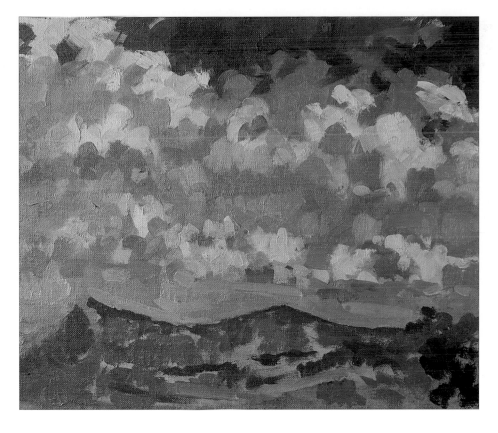

7. Still using a size 4 flat brush, strengthen the relationship between the ground and sky by adding yellow ochre to warm the cloud mixes. While painting, try to build the relationships between the initial blocks of colour. Touch and re-touch each part to incorporate it into the whole, and vary the size and direction of the brushstrokes you use. This will help keep the painting fresh and vital.

8. Using a size 2 round brush, begin softening the hard edges of the clouds with more subtle mixes of the sky colour. Tighten the painting with progressively smaller brush strokes and still more subtle mixes of the sky colour.

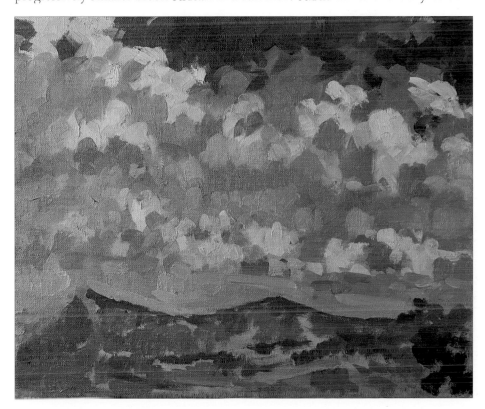

Tip

Notice how the toned ground of the primed canvas prevents bare white canvas from influencing your colour choices. Do not feel that you have to cover the whole canvas with paint: feel free to let some of the primer show through.

55

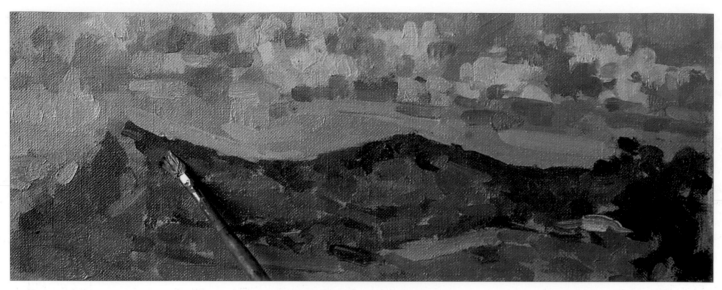

9. Using a size 4 flat brush, add highlights to the quarry in the bottom left of the painting with a strong mix of cadmium yellow, cadmium red and titanium white. Tighten the ground, reaffirming the relationships between the colours, but making sure the different areas of colour are kept distinct.

Tip

In these final stages, you can simply move and blend the paint already on the canvas rather than adding more.

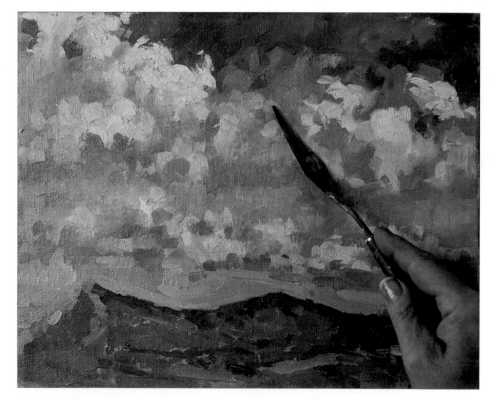

10. Use the painting knife to gently scrape excess paint between areas, helping to blend the paint together. Paint the hedgerows with a size 2 round brush and a dark blue-green mix of French ultramarine, yellow ochre and cadmium yellow. Strengthen the warm fields with a mix of cadmium yellow, cadmium red and yellow ochre.

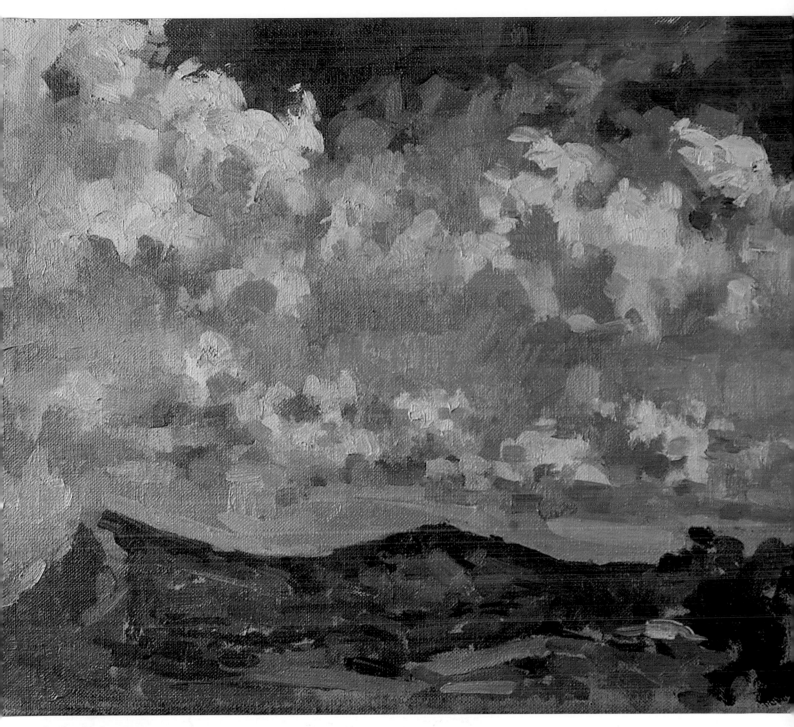

The finished painting
30.5 x 25.5cm (12 x 10in)

This is a study in fleeting cloud structures. Notice how the intensity of the blue in the sky increases the higher it goes.

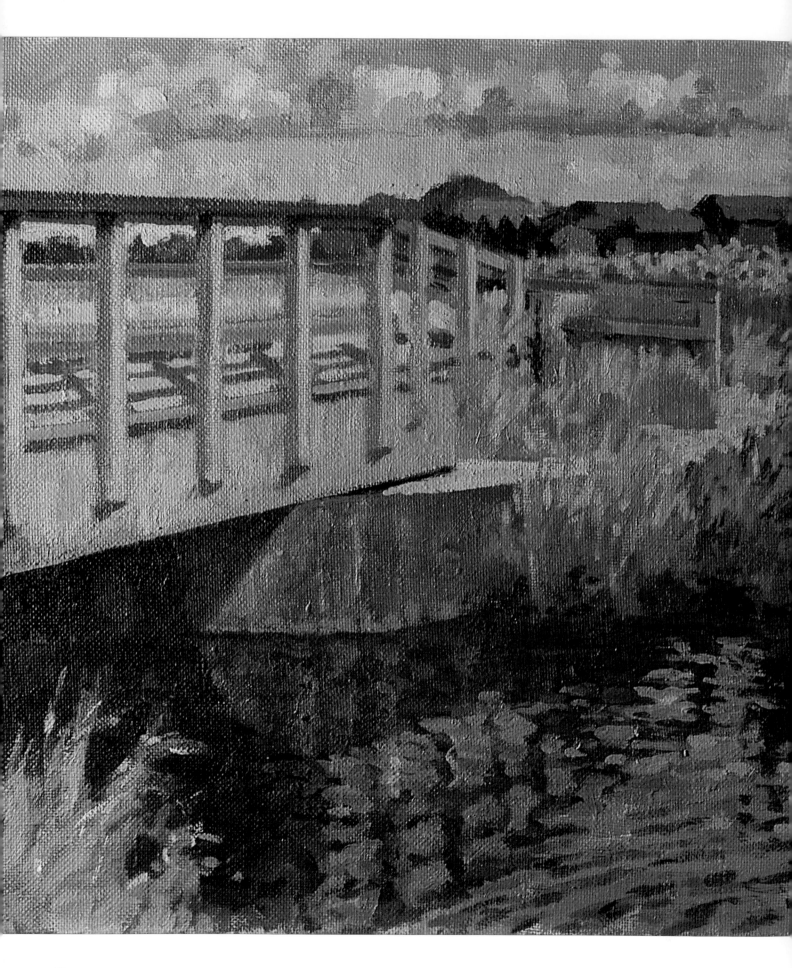

Water

Water is of perennial interest to painters. Whether sea, river or lake, the challenge of painting water convincingly is one of the most difficult aspects of landscape painting. Perhaps what attracts us to water is the business of reflections. Like moving clouds, rippling reflections need a technique of 'freeze frame' within your mind's eye. This is so often a case of more looking, less painting. The more you understand the structure of the thing you are going to paint, the more likely you are to paint it successfully.

Most water is clear – it is what is around it that affects its apparent colour. For example, puddles are conditioned by the pavement, road or soil that they lie on, and a mill pond will appear dark because of the muddy bank. Light from above also affects the appearance and colour of water. The examples on these pages demonstrate this well.

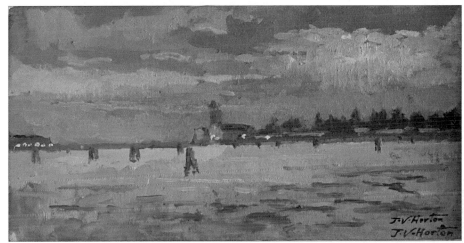

Sunrise over San Michele, Venice
28 x 15.2cm (11 x 6in)

Although sunrise in Venice is somewhat of a cliché, the huge expanse of sky and water creates the most wonderful layering of colour. Notice how at the horizon the sky is darker than the sea; very unusual, and also attractive.

Bridge and Beach Huts, Walberswick
61 x 45.7cm (24 x 18in)

This picture shows a river reflection neither still nor particularly churned up. Although the reflections show the objects reflected very clearly, care has to be taken to keep the structure of ripples within the water.

59

Cliffs and Sea

This is a painting about reflections in a sea with gently undulating waves. The aim in this project is to understand how reflections work in strong sunlight on a typical blue, Mediterranean coastal bay.

You will need

Canvas board, 40.5 x 30.5cm
 (16 x 12in)
Medium mix (see page 7) or ready-
 made medium
Brushes: size 2 round, size 2 flat,
 size 4 flat
Colours: French ultramarine,
 titanium white, permanent rose,
 lemon yellow, Venetian red,
 yellow ochre, ivory black, phthalo
 blue, cobalt violet, cadmium red,
 cadmium yellow
Clean rag

Tip

Reflections in still water are always in a proportion of one to one. However, as ripples occur, the refraction of light causes the reflections to get longer.

Useful mixes on the palette

Earthy green mix

Cliff and beach mix

Sea shading mix

Cliff shading mix

Shadow mix

Sky mix

Wet rock mix

Sea mix

Tip

Reflections in water will always absorb light, especially murky water, so the object reflected will generally be a little darker than its real counterpart.

1. Using a size 2 round brush and French ultramarine, sketch in the main shapes of the cliffs, the beach and the foliage in the top left.

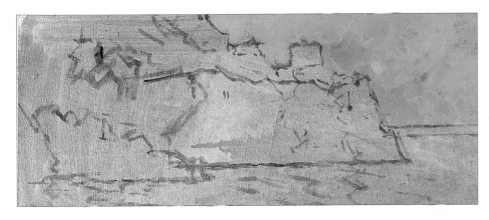

2. Change to a size 4 flat brush, and mix titanium white with French ultramarine. Use this to paint in the sky at the top right. Add a spot of permanent rose to the mix to vary the colour and add interest.

3. Add phthalo blue to the sky mix and begin blocking in the sea, starting from the horizon. As well as varying the tones on the sea by adding touches of lemon yellow and permanent rose, vary the length and speed of your brushstrokes. Both of these techniques will help to avoid a flat finish to the sea.

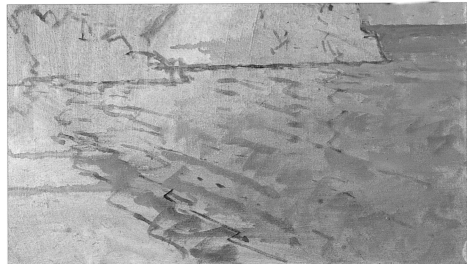

Tip

Scumbling is the use of paint thinned only slightly, and then dragged across a surface such as canvas to give a broken texture.

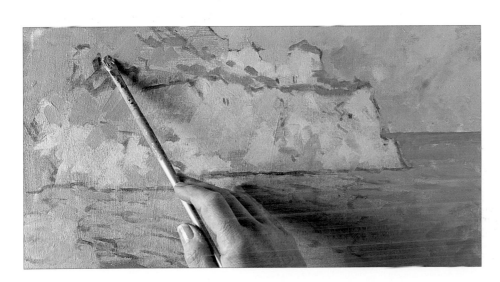

4. Block in the cliffs with a size 4 flat brush, using an earth tone mix of titanium white, Venetian red and yellow ochre. Add touches of lemon yellow and cadmium red for variety, and add more Venetian red and yellow ochre for shading. Use these same colours to block in the beach and for the reflections beneath the cliff. Add more yellow ochre and lemon yellow to the mix to provide a base for the foliage.

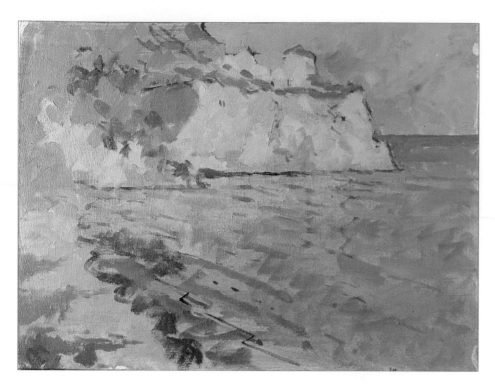

5. Build up the foliage by mixing the sky mix (titanium white and French ultramarine) with the foliage mix for earthy greens, then add a touch of ivory black to darken the colour for the wet sand of the beach. The purpose of these early stages is to approximate the colours that will then be tightened and further refined as the painting progresses. Add French ultramarine and permanent rose to the sky mix for the major areas of shadow on the left of the painting.

6. Mix lemon yellow and French ultramarine with titanium white, phthalo blue and cobalt violet to get a grey-purple colour to define the wet and exposed rock at the base of the cliffs. Switch to a size 2 round brush and use a very light tint of this grey mix to suggest the breakers and crests of the waves. Cobalt violet added sparingly reduces the otherwise stark quality of the titanium white.

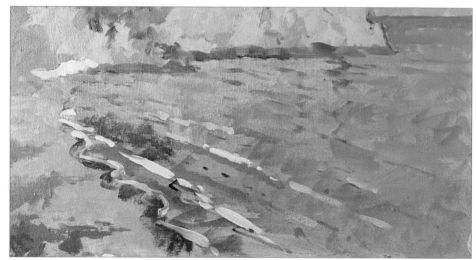

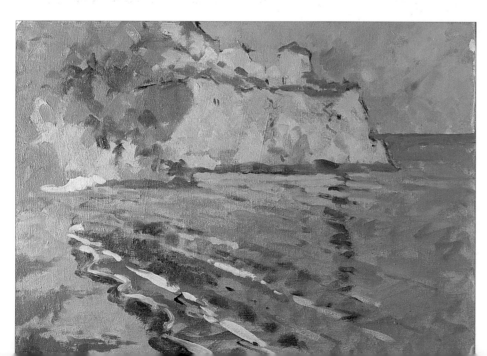

7. Add lemon yellow and titanium white to the earthy green mix used to paint the cliffs. This produces a lighter tint to highlight and refine the cliff shapes. Paint the reflections in the sea using this, adding cadmium red for a rosier hue on the reflections in the foreground. Use the wet sand mix from step 5 for darker reflections to strengthen the impact of the sea.

8. Add French ultramarine and lemon yellow to the foliage mixes to tighten the foliage using a size 2 round brush. Adding cadmium yellow to the mix makes a warm brown hue for shading and suggesting texture on the cliff. Continue refining these areas and the beach.

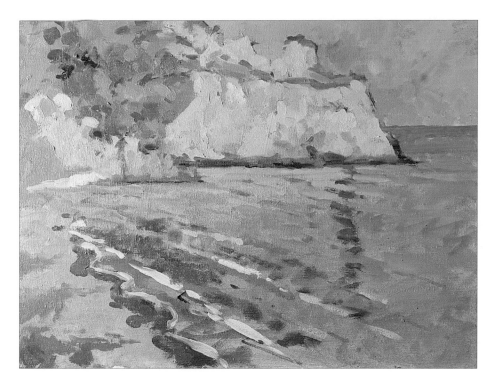

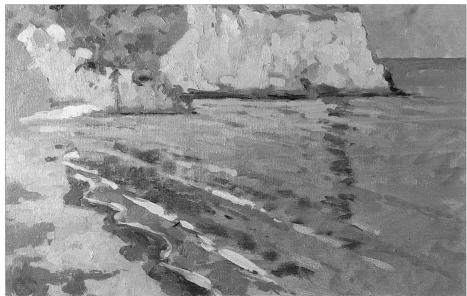

9. Continue blending and teasing the colours of the beach into each other to soften the sharp transitions between areas of paint. Use a size 2 flat brush in the foliage to introduce smaller, sharper transitions and suggest the density of the vegetation. Texture the cliffs in the background with the titanium white, Venetian red and yellow ochre mix. Make a grey-green mix by adding French ultramarine and lemon yellow to the sky mix, and use long brushstrokes with a size 2 round brush to paint in the shadows of the waves on the water.

10. Continue detailing the foliage, cliffs and ground with mid-tones of all of the mixes on your palette, varying both the brushes you use and your brushstrokes. Ensure you are happy with the cliffs before you start detailing the sea, as everything that you change later will have to be duplicated in the reflection.

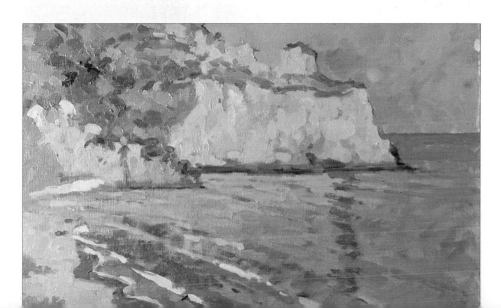

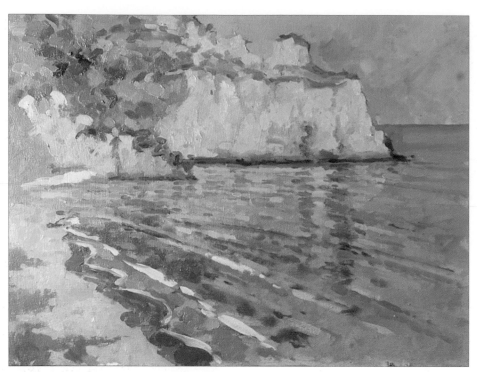

11. Switch between size 2 round and size 2 flat brushes while tightening the overall picture. Use the original mixes for the sky, sea and beach, varying each mix with touches of French ultramarine, cadmium yellow, yellow ochre and permanent rose to add interest.

12. Make lighter tints of the new mixes on your palette by adding titanium white, and use them to add smaller details on the sea with the corner of a size 2 flat brush. Short, tight brushstrokes suggest the movement in the sea swell.

13. Use a size 2 round brush to add light tints to the sky to suggest faint cloud cover and break up the flat expanse. Small crests on the waves made with French ultramarine, phthalo blue and titanium white enliven the foreground. Finally, take the flatness out of the shadows on the beach with a lighter tint of French ultramarine, Venetian red and titanium white.

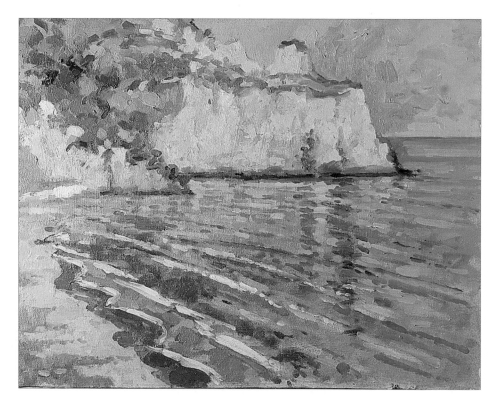

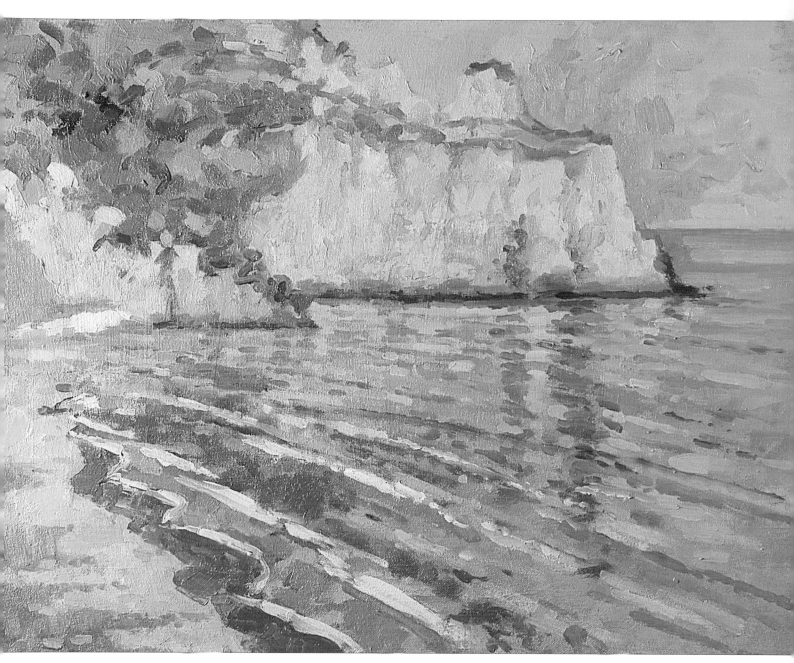

The finished painting
40.5 x 30.5cm (16 x 12in)

The finished painting shows how the reflections in the sea must relate to the object they are reflecting across a broken water surface. Because the water has ripples and waves, the reflection is broken and hence becomes longer than the actual height of the cliff.

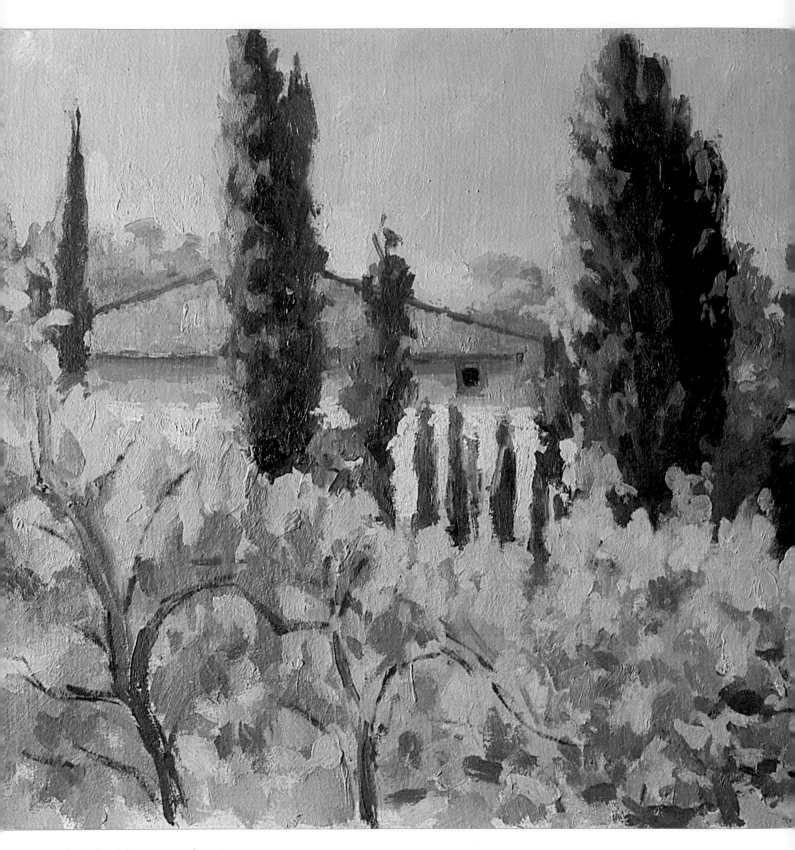

The Villa del Monte, Rufina, Tuscany
40.5 x 30.5cm (16 x 12in)

In this typical Tuscan scene the warm greens of the pencil-like Cypress trees contrast well with the cool blue-grey greens of the olive grove in the foreground. To show the difference in these colours it is essential to identify the individual trees correctly and to create artistic diversity.

Trees & foliage

In classical landscape painting, trees were portrayed as fluffy-edged and nondescript until John Constable showed the difference in species. He also showed how foliage comprised many different types of green and not just a uniform brown as was previously the case.

The subsequent rise in the status of landscape painting has made painters much more aware of these aspects of trees and foliage today. Just as the specific shape of a tree is important, so is its colour. Foliage also comes in all shades of green and the nuances need to be carefully observed if a convincing result is to be achieved.

Spring from Can-Xenet, Majorca
68.5 x 56cm (27 x 22in)

Despite the autumnal colouring in the tree it is in fact spring growth. This is a good example of how one should never take anything for granted and observe freshly and honestly each time.

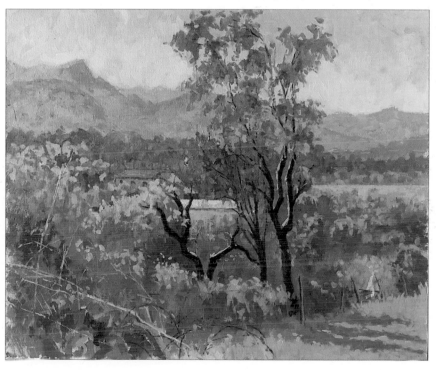

Trees on the Fen

The predominant feature here is the difference between the various types of tree. Being able to portray the shape and colour of the individual tree types is essential to give this very English scene its character. In particular, the rendering of greens, both in the foliage and grass, is a great exercise in colour mixing.

You will need

Canvas 45.7 x 35.5cm (18 x 14in)
Medium mix (see page 7) or ready-made medium
Brushes: size 2 round, size 4 flat, size 4 filbert
Colours: French ultramarine, ivory black, phthalo blue, cobalt violet, permanent rose, cadmium red, yellow ochre, Venetian red, cadmium yellow, lemon yellow, titanium white
Medium painting knife
Clean rag

Useful mixes on the palette

Basic sky mix
Cloud mix
Tree trunk mix
Warm conifer mix

Cool conifer mix

Foliage mix

Sky mix

Grass mix

Willow mix

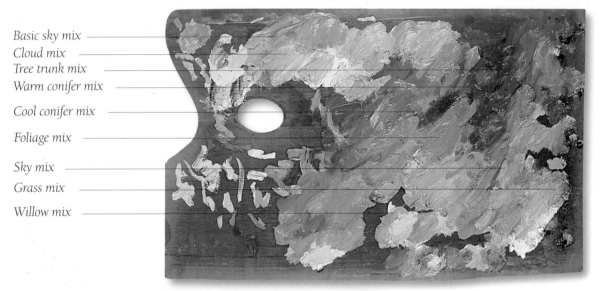

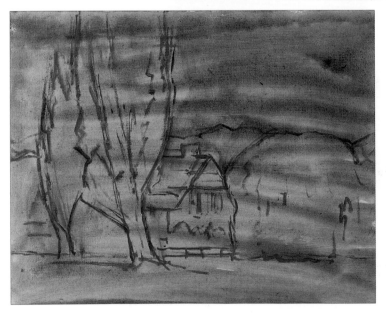

1. Sketch out the initial outline using French ultramarine and a size 2 round brush.

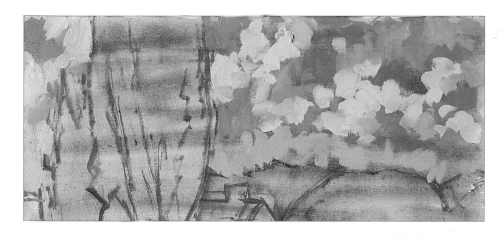

2. Use a size 4 flat brush to paint the sky with a mix of permanent rose, French ultramarine and titanium white. The lightest tints should be at the bottom of the sky, while a darker shade with less titanium white should be at the top. Paint in the clouds with a mix of titanium white and lemon yellow. Vary the colour by combining it with the sky mix. Try to build the relationship between the dark and light blues of the sky and the more yellow colour of the clouds

3. Make a mix of lemon yellow and French ultramarine, then knock it back with yellow ochre to create the basis for the weeping willow on the right. Add more yellow ochre to break up the shape, then add French ultramarine and a touch of ivory black to create a basis for the distant conifers. Warm this conifer mix with yellow ochre and paint the conifer in the foreground. Paint the trunk in with a mix of ivory black, cadmium red and titanium white.

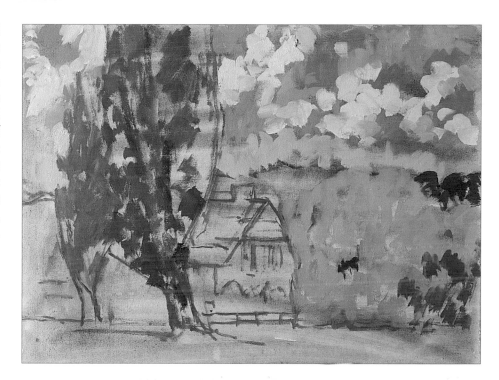

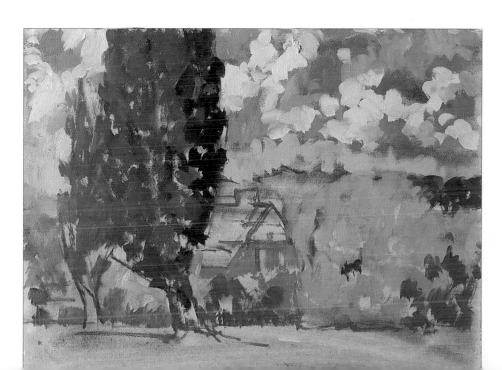

4. Still using a size 4 flat brush, combine the trunk mix with the sky mix and paint the front of the house. Add French ultramarine with the mixes you have made for the foliage to get muted greens that are perfect for shading the trees and bringing the brighter shades forward.

69

5. Paint in the foreground grasses, using earthy tones made from combinations of the foliage mixes used in steps 3 and 4, varied with the addition of lemon yellow, yellow ochre and French ultramarine. Paint in the roof of the building using a mix of cadmium red, yellow ochre and titanium white.

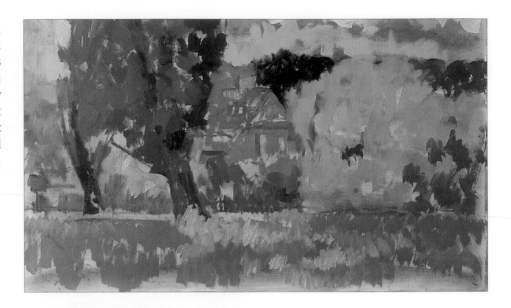

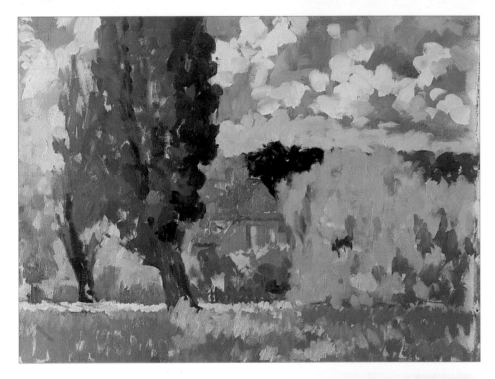

6. Begin tightening the greens and browns in the foliage and foreground with a size 4 filbert brush. Fill in the spaces in the sky where the primed canvas shows through using the cloud and sky mixes, varying and blending the colours.

7. Using a size 2 round brush, add browns into the foreground and foliage by combining the sky mix and the foliage mixes on your palette with Venetian red for a rich dark brown; perfect for shading the tree trunks.

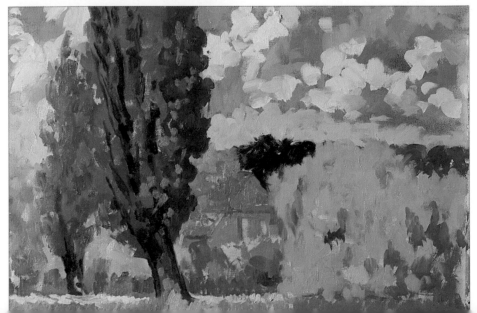

8. Touch in the details on the front of the building with a very light tint of the sky mix. This will ensure that the building does not fade completely into the background, but has a more important role in the final composition.

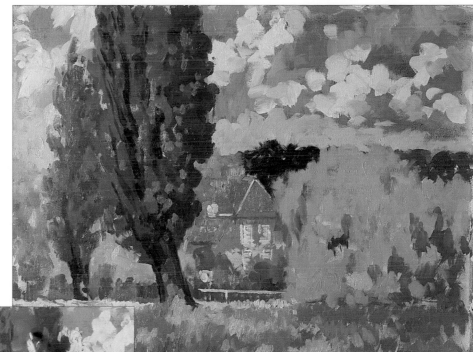

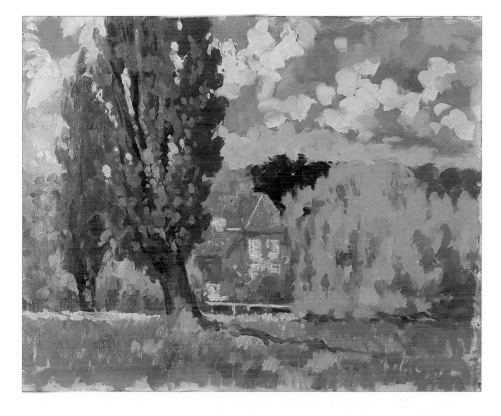

9. Use the cloud mix and a size 2 round brush to paint flecks of sky showing through the central conifer. Use the sky mix to vary the effect.

10. Paint the central poplar's shadow with a dark shade of your foliage colours. Begin tightening up each of the major sections by blending and working the paints on the canvas. Make sure you keep each section distinct from the others: blend only within each separate part, not between them.

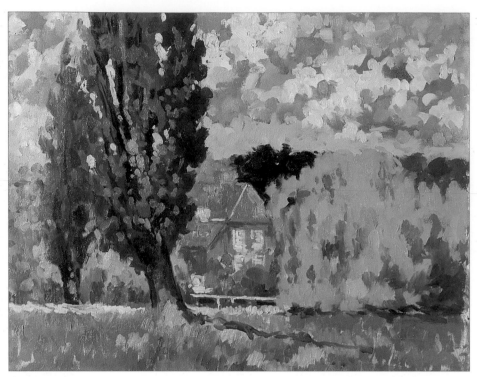

11. Work on the cloud and sky sections using a size 4 filbert brush, paying particular attention to the mid-tones. Switch to a size 2 round brush and tighten the sky areas still further. Go back and tighten up the tree on the left-hand side of the painting.

12. Use the painting knife to smooth the sky, then vary the tones on the painting with a size 2 round brush and very small, tight brushstrokes. Use short, vertical strokes to paint longer grasses in the meadow.

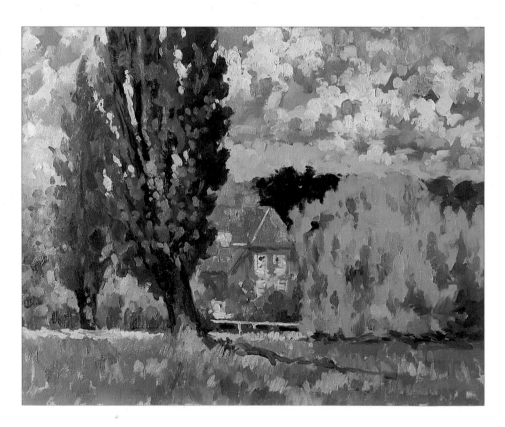

The finished painting
45.7 x 35.5cm (18 x 14in)

This is a typical East Anglian location with a variety of trees. Note how important it is to show the difference in colour between each type of tree.

Hills & mountains

Anywhere there are hills and mountains you can be sure of a great variation in light and atmosphere. Cloudy skies are often found around hills and create interesting scenes. As with any other aspect of objective painting, there is no real formula for painting hills and mountains, but one thing to watch out for is how mountains can change their apparent position in space according to the light. In sharp sunlight they are well-defined, with plenty of colour; but in bad light or in the evening, they can be blue or grey and difficult to place. This can then result in a wide range of potential colour.

Perhaps no other subject contains such a wide variety of the effects of aerial perspective as mountains. Mountains constantly change their appearance throughout the day, providing a permanent challenge for the painter to register their pitch accurately.

Cloud Over the Mountains from Can-Xenet
35.5 x 30cm (14 x 12in)

Like Cézanne I have enjoyed painting the same range of mountains in all their variations and many of the pictures appear in this section. In this instance the cloud was heavy and sitting along the top of the whole range. This has the effect of lowering the tonality of the whole picture. Notice how light the house and outbuildings are against the dark surroundings.

Mountain Bay

This picture is primarily about the relationship of the sky, mountains and the water in the bay. However, the inclusion of the sunbathers and their brightly coloured swimming costumes is a wonderful chance to create complementaries against the blue of the water.

You will need

Canvas 45.7 x 35.5cm (18 x 14in)
Medium mix (see page 7) or ready-made medium
Brushes: size 2 flat, size 4 flat,
Colours: French ultramarine, ivory black, titanium white, phthalo blue, Indian red, cadmium yellow, cadmium red, raw sienna, cobalt violet, lemon yellow and permanent rose
Clean rag

Useful mixes on the palette

Hill mix

Water mix

Dark cloud mix

Sky mix

Pink mix

Cloud mix

Hair mix

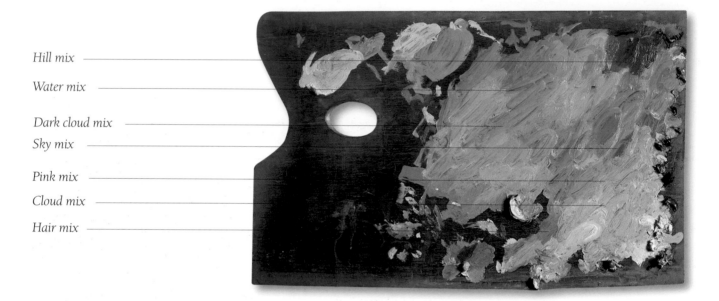

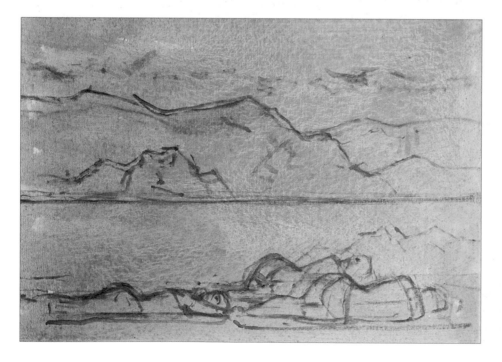

1. Use thinned French ultramarine and a size 2 flat brush to sketch in the main areas of the picture.

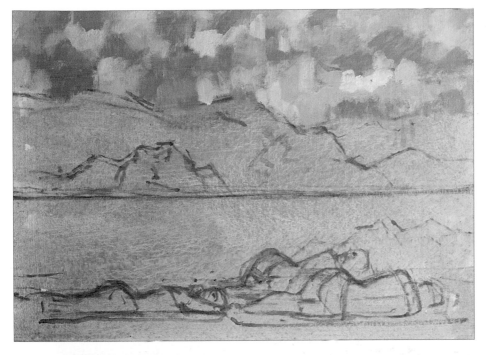

2. With a size 4 flat brush, mix French ultramarine, ivory black and titanium white with a touch of phthalo blue for a sky mix, and apply to the top of the painting. Vary the tones by adding Indian red and palette grey to the basic mix. I make palette grey by scraping any remaining paint from the palette when I have finished a painting and storing it in a jar. This means I always have a ready supply of a neutral grey to use.

3. Add spots of this mix to the hills. Vary this with touches of French ultramarine, phthalo blue and cadmium yellow.

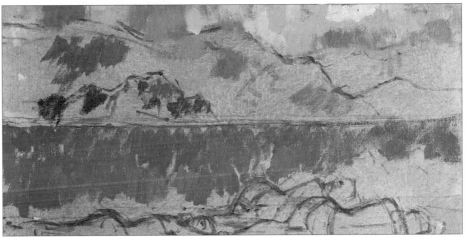

4. Darken the sky mix with French ultramarine, phthalo blue and cadmium yellow, and use this mix to block in the water in the bay. Add cadmium red as the water nears the hills.

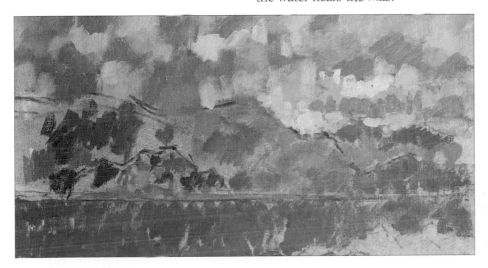

5. Begin to add to the hills with variations and combinations of the sea and sky mixes. Create a pink from titanium white with cadmium red and cadmium yellow and add this to the hills. Add progressively more pink to the hills as they advance, saving the thickest mix for the closest hill.

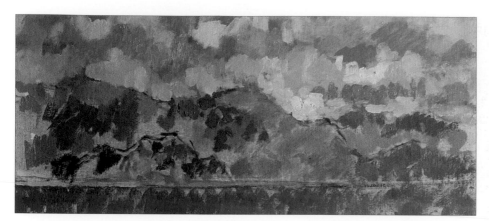
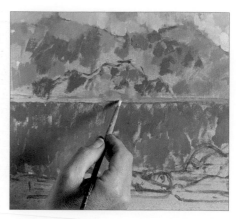

6. Add palette grey to the pink mix and begin to tint the hills with lighter combinations of the mixes. Add titanium white to the mix and begin to paint some loose clouds. Highlight these with the sky mix with added titanium white and cadmium yellow.

7. Use the pink mix with a size 2 flat brush to paint a neat line of sand across the base of the hills to help differentiate the hills from the water.

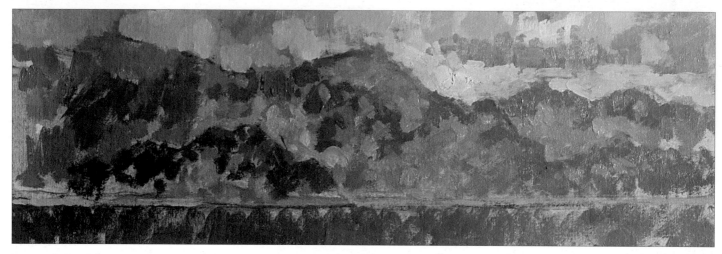

8. Look for the interesting colour combinations in the hills and arrange the mixes on the palette to complement each other, following the cues from your source material.

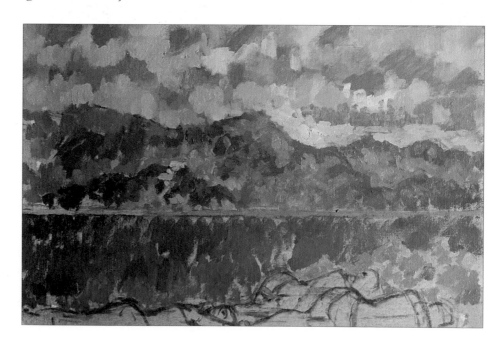

9. Begin tightening and refining the sky and hills. Use a size 2 flat brush and the pink mix (titanium white, cadmium red and cadmium yellow) with palette grey and titanium white to begin the rocks in the foreground.

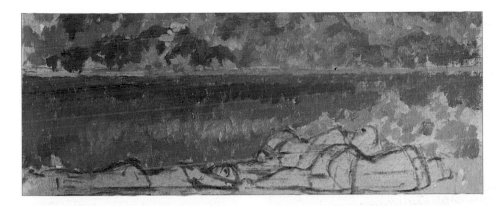

10. Adjust and tighten the water, covering any areas of bare canvas with the water mix (French ultramarine, phthalo blue and cadmium yellow) varied with the addition of more French ultramarine and phthalo blue.

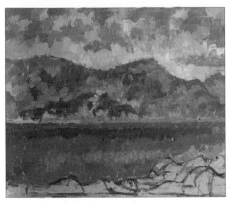

11. Use palette grey to vary the grey sky, and introduce cadmium yellow to the cloud mix to vary the tones. Add this colour to the water mix and touch in areas of the hills on the left.

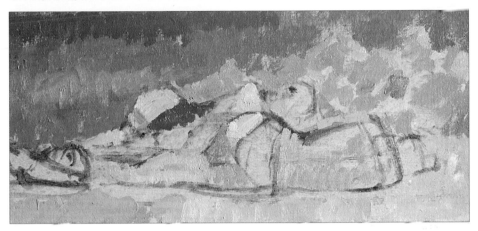

12. Make a skin mix of titanium white, raw sienna and cadmium red and begin to paint the sunbathers at the bottom right. Add touches of cobalt violet, palette grey and French ultramarine for shading. Begin to paint the red swimming costume with a mix of cadmium red, titanium white and palette grey.

13. Continue painting the red swimming costume, and refining the skin areas. Use an ivory black, lemon yellow and cadmium red mix for hair.

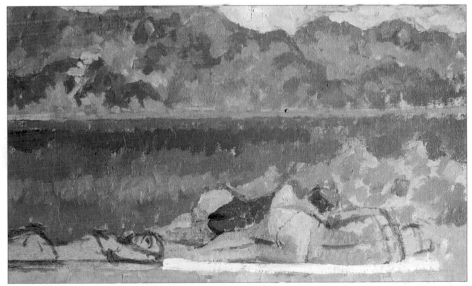

14. Use a combination of the water and pink mixes to cut in the rocks around the sunbathers. Shade the red swimming costume with the addition of Indian red and permanent rose. Block in the yellow bikini with cadmium yellow, and add raw sienna and cadmium red to shade. Block in the beach towel with titanium white.

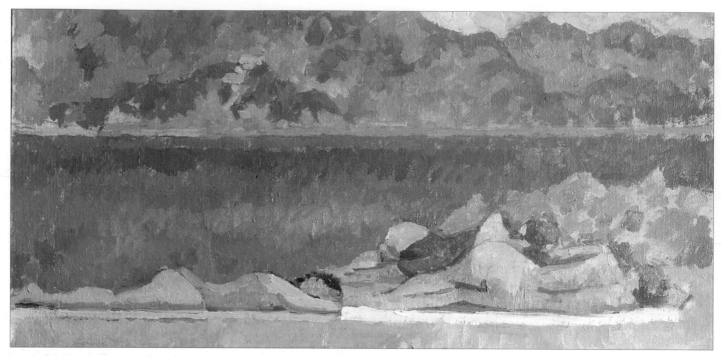

15. Add cobalt violet to the water mix and paint in the cast shadows beneath the figures. Add highlights to the closest sunbather with the skin mixes from steps 12–14. Paint the final sunbather using the same techniques as the other two. Add phthalo blue to the water mixes for her swimming costume.

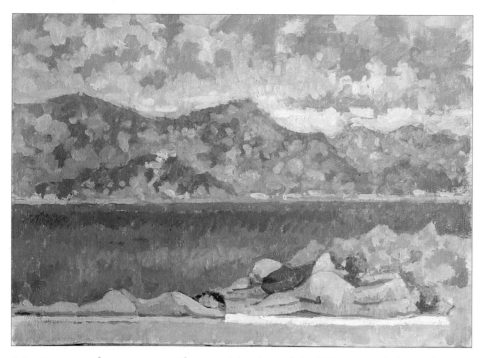

16. Cover any bare canvas with a combination of the hill mix and the pink mix, and tighten the picture now all the tonal values are roughed in.

The finished painting
45.7 x 35.5cm (18 x 14in)

Although this painting is primarily about the mountains and the water, the arrival of the sunbathers while I was painting the scene was a great stroke of luck. The red, yellow and blue of their swimming costumes gives an instant complementary colour effect.

SEA & SKY IN OILS

by Roy Lang

I do not consider myself to be an artist; rather someone who has a passion for the sea and has learnt to portray its moods, colours and movements with paint on canvas.

I opted out of art when I was thirteen (the earliest year I could do so). I started again in my late thirties while out of work, and it was my understanding of the sea which I had observed when angling in my youth that made up for my lack of any formal training in art.

Putting together the many aspects of the sea – light, reflections, shadows, movement of the sky and water, foam bursts, spill-offs – became both a fascination and a challenge to produce a painting that captured all the interactions of waves, wind and rocks.

I now travel, giving demonstrations and workshops, during which I endeavour to pass on my techniques and tips to fellow artists.

Atlantic Fury
56 x 40.6cm (22 x 16in)

I wanted to portray the effect that occurs in stormy conditions, where the undertow of previous waves holds the sea back in an unstable wall of water. This was achieved by omitting the background sea and horizon.

The clouds give both direction to the wind and a dark backdrop for the main wave. They also add to the imposing feeling, giving an air of tension.

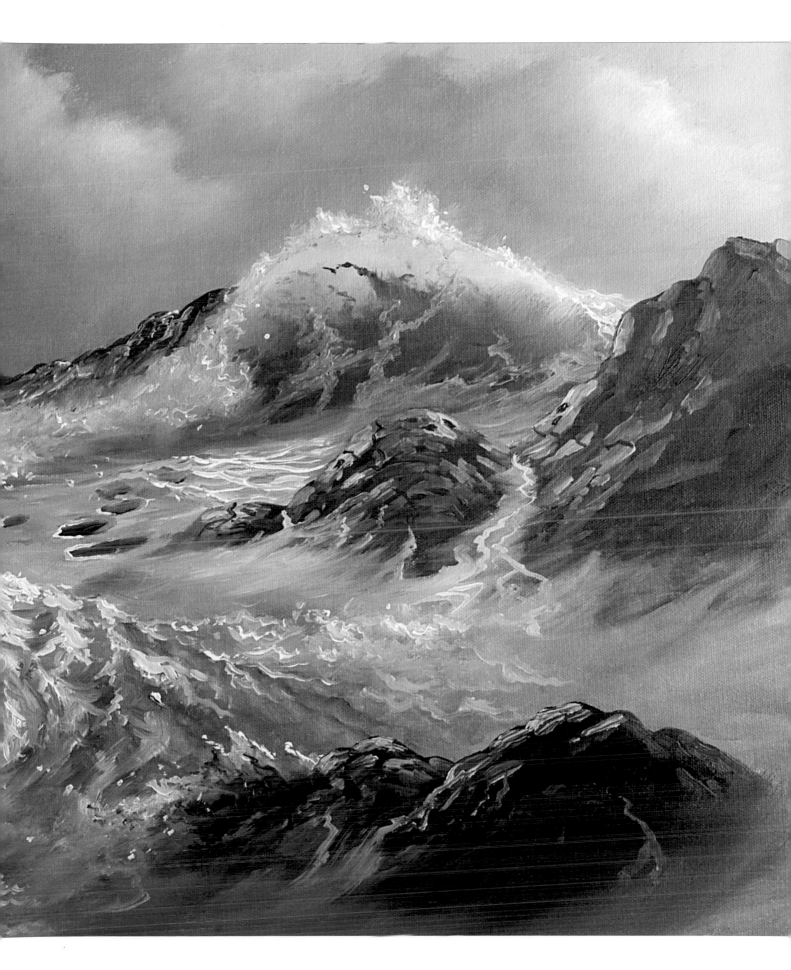

My palette for sea and sky

The nine colours listed below make for a good starter palette.

- **Titanium white** is useful for its creamy texture and workability.

- **French ultramarine** is a very dark translucent blue, suitable for overhead daytime skies and very prominent in night skies and the sea in general.

- **Burnt sienna** used in conjunction with French ultramarine is good for painting night skies, and is also a useful base colour for rocks. See the tip box at the bottom of the page for approximate proportions.

- **Cadmium yellow pale** can be mixed in minute amounts into titanium white, which will give warmth to foam spatters and bursts. It is also useful in skies, particularly in sunsets.

- **Yellow ochre** can be mixed with other colours to produce a good basis for beaches. I use it to depict sun and moonlight on rocks, and to warm up clouds.

- **Alizarin crimson** can be added to most of the blues for sky and foam areas, especially in the foreground. It is also handy to use when painting distant headlands and to vary the colours of sand. Be careful: it should only be used in small amounts in mixes.

- **Cobalt blue** gives a realistic lowering of elevation towards the horizon, and also helps to create interest and a sense of form to foam bursts and patterns.

- **Sap green** gives the top of the wave a translucent look (at the very top edge blend in titanium white with a touch of cadmium yellow pale to heighten the effect). You can also use sap green to paint weeds on rocks.

- **Cerulean blue** gives a good aerated water colour for water spill-offs below rocks. It is also used in the sky at its lowest elevation.

Other colours that you might like to add to your palette are:

- **Prussian blue** and **phthalo turquoise**. Both are useful in foam areas, lightning strikes and for reflective light on rocks, caves and so forth.

Tip

Mix French ultramarine and burnt sienna in approximately the following proportions for rocks: 25–30% French ultramarine to the remainder burnt sienna.

The same colours can be used for night skies, in which case you should use 70–75% French ultramarine to the remainder burnt sienna.

Tip

As a word of warning, I have tried viridian hue, but when put on canvas the feeling in my gut reminded me of the time I spilt a gallon of engine oil on the hall carpet. When painting seas and skies in oils, I would avoid this colour.

Using colour

Colours, in conjunction with their tones, help to create mood and form, and also suggest the time of day and atmospheric conditions. They can also create a sense of distance.

The tones and colours used in the sky will have a great influence on the rest of the painting. It will certainly change the general colour of the sea and light reflected off the waves. It would be as well to remember that the sea does not have to be calm with a gentle sunny sky. A storm hundreds of miles out in the ocean can send in massive swells. Likewise, you can have a dark foreboding sky with a gentle sea.

A good rule when choosing colours is to identify the main colour in the scene, and use a small amount of its opposite on the colour wheel to provide contrast. Pick any of the four colours that are adjacent to these main colours as your third colour.

For example, in the painting below, the main colour is the blue used in the sky and sea. Opposite blue on the colour wheel is orange, so this is included as the second colour. For the third colour I had the choice of yellow or red (either side of orange on the colour wheel) or green and purple (either side of the blue). I chose green to highlight the shallows and the tips of the waves, but hints of other colours are used to liven up the wood of the groyne.

Colours can also give a sense of distance in a painting. Cool colours appear to recede into the distance, whereas warm colours appear nearer. Generally speaking, reds and yellows are warm colours, and blues are cool. Having said that, any particular colour can have warm and cool variants. For example, sap green is a warm green, while viridian hue is a cool green.

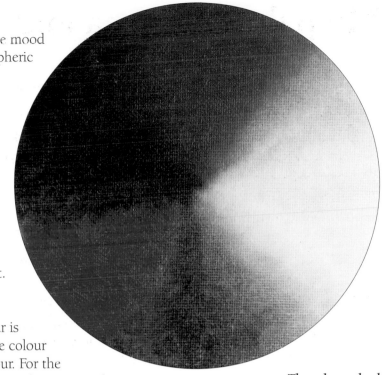

The colour wheel
Complementary colours are found directly opposite one another.

The Groynes
40.6 x 30.5cm (16 x 12in)

The same colour used in the sky is incorporated into the sea. Note that the sky is simply a lighter tint of the darker sea.

A touch of red added to the sea warms the overall composition.

Orange (opposite blue on the colour wheel) is used to contrast with the blue and draw attention to the top edge of the groyne.

The darkest tones in the sea are contrasted with and emphasise the light tones of the spray.

The yellow of the sand combines with the blue of the sea to give a green colour to the shallows.

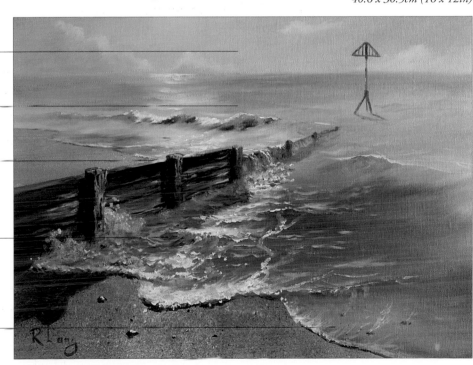

Tonal underpainting

Having chosen and sketched my subject, I often use watered-down French ultramarine and burnt sienna acrylic paints to make a tonal underpainting. Squint your eyes when looking at the view, this cuts down on the complication of colour and allows you to concentrate on the tones. Because acrylics dry quickly, I build up tones gradually with several coats. I like to save the lightest and darkest areas for the centre of interest for maximum contrast. Putting dark tones nearest the light makes the light areas appear much lighter than the paint normally looks. To achieve this I find an excuse to put a dark rock or shadow against an area of glare. Moonlit seascapes heighten this effect.

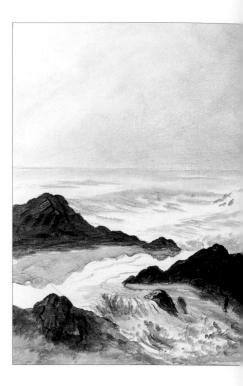

Once the acrylic has dried I can start to lay on colour in oils. I apply paint using one of two methods. The first involves working methodically from the top of a painting, beginning with the sky, moving on to the background sea, then the waves in the foreground, water and finally the rocks; finishing each section in detail before moving on to another. The advantage this method has is that you can steady the heel of your hand on dry canvas. This makes it easier to be more precise and helps to ensure that you can keep your colours separate, so that the different areas do not mix and get 'muddy'.

The second method involves putting a particular colour on to my brush and scrubbing it on all the areas that require it; then building on the scene when the canvas is covered, working from the basic shapes to fine details and textures.

Brush-rolling

When painting wet into wet without thinning the paints, I use a brush-rolling technique that helps the paint to adhere to previous layers. It also gives one defined edge while the other is faded away.

You may find that the technique is awkward at first, but it is well worth mastering and comes naturally after a while.

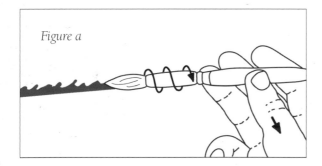

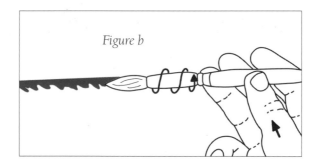

Figure *a* shows the brush being rolled downwards. This is very useful for highlighting background waves because it leaves a sharp light-toned edge above the wave and gradates the tone up into the wave beyond, giving the sense of curvature to the water's surface in the troughs.

Figure *b* shows the brush being rolled upwards, leaving a flat bottom to the brushstroke. This is ideal for adding highlights to the horizon, and it is also useful when painting the base colour of a rock or wave to obtain a distinct upper edge.

The tonal underpainting for
Passing Squall, *shown below.*

Passing Squall
50.8 x 40.6cm (20 x 16in)

I relish painting this type of seascape with all its action. It gives me the opportunity to include the many details and tricks of the trade that can be termed 'stirring'.

Once you have finished, do not clean the palette for a while, because I can guarantee you that in a short time – perhaps an hour, perhaps a day – you will want to make a minor adjustment. I do every time!

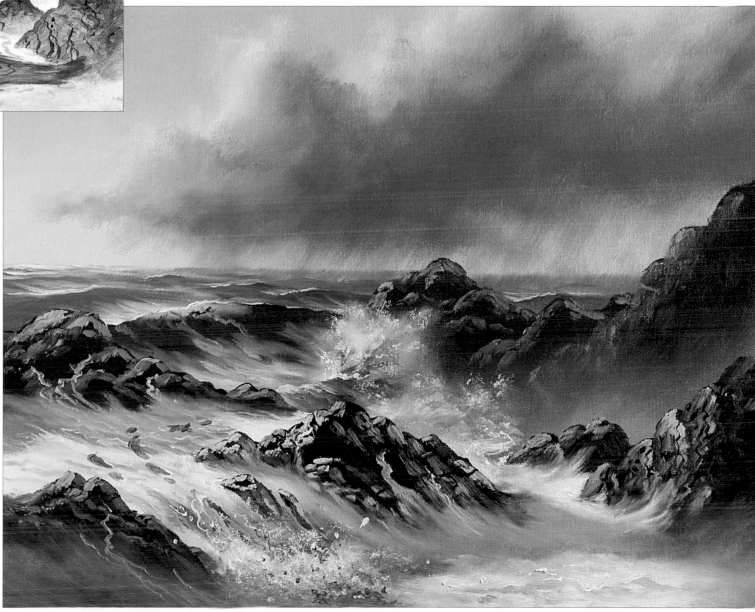

Composition for sea and sky

When I first started painting the sea I ran around the Cornish coast like a headless chicken, taking photographs that I felt sure would give me endless views from which to paint. I soon found out that while it gave me handy reference material for different aspects of the sea, the photographs were of little use for composition for several reasons.

First and foremost I found that it was dangerous to get a shot from the elevation from which I like to paint, and I certainly could not paint *in situ*. In addition, photographs tend to foreshorten the scene and fail to capture the movement and story of the moment.

It is much better to sketch a scene from a safe distance and make notes of the colours to be used. Most of my compositions are based on these sketches, or on a combination of imagination and experience. This gives the artist freedom to strategically place rocks, waves, clouds, foam patterns, light and so forth to lead the eye around the painting.

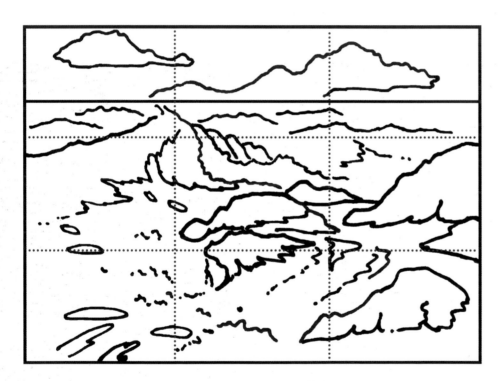

This sketch shows how a grid and the 'S' can help you to plan your painting and guide your composition.

Focal points

Focal points, also called 'points of interest', are parts of the painting that attract the eye. Divide the canvas in three, both horizontally and vertically, with faint pencil marks to make a grid. This is shown on the diagram on the left in dotted lines. It is at any one of the four intersections that the main point of interest should be placed for optimum effect. A secondary point of interest looks good at the intersection diagonally opposite.

The 'S'

Very often I try to get a subtle 'S' or 'Z' shape into the composition. This leads the eye around the painting. In the sketch above, the 'S' is marked in red. Starting on the top edge of the cloud in the right-hand corner, it moves down over the main focus of the painting: the breaking wave. From here, it travels down the foam line to the rocks and into the pool of water: the secondary focal point. After continuing down the cascade of water the 'S' starts to peter out into the boiling area of foam, but it very gently leads the eye back up towards the face of the wave again. This is helped by the elliptical holes in the foam pattern.

The horizon

An important consideration is where to position the horizon line. If you want to concentrate on details of the sea, keep it nearer the top of the painting (as in *Ocean Spray* below).

If you want to feature the sky or give an airy effect, keep the horizon line low. Try to avoid having the horizon on the midline of the painting because this tends to cut the view in half and make for a flat, dull painting.

To achieve the feeling that the viewer is about to be swept into the sea, only show a little or none of the background sea. Obscuring the horizon with waves is another way of achieving this effect. A good example of this technique is shown in *Aftermath* (right).

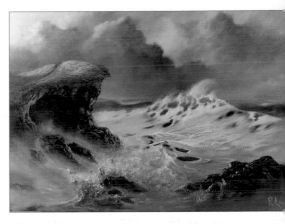

Aftermath
91.4 x 61cm (36 x 24in)

Ocean Spray
55.9 x 40.6cm (22 x 16in)

Strong shadows on the face of the main wave give a good contrast to the light coming through the water. The shadows cast by the rocks also heighten the lightness of the foam on the water and give direction to the spill-offs. By keeping the atmospheric conditions clear, I could maintain dark tones on the sea. This contrasts well with the mid-tone of the sky, leaving the foreground with its variations of blues and the orange highlights on the rocks to give a strong three-dimensional feel.

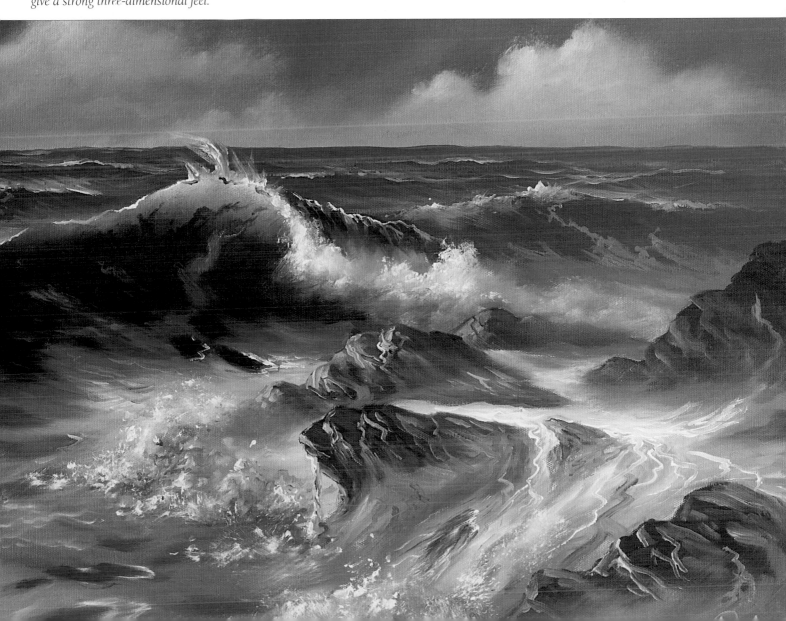

Understanding the sea

To me, the more action, the more interest. Without it, the scene is flat. Calm seas have little wave action so therefore lack spray and spill-offs, resulting in few, if any, foam patterns, wet rocks or beach reflections. A few pointers for common elements in painting seas are covered in this chapter.

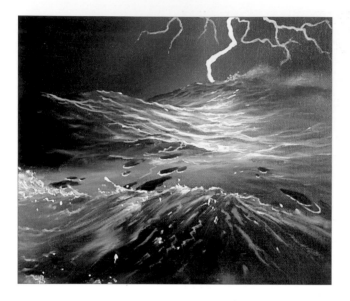

Swells

These are deep ocean waves caused by far-off storms. They do not have a sharp form, and are good to use to break up a flat horizon, giving a useful dark backdrop for a wave painted with light showing through it. In the example shown on the left, I have used swells to reflect the lightning strike.

Swell detail from Electric Blue *(page 95).*

Foam burst detail from Electric Blue, *page 95.*

Foam bursts

One of the major mistakes that can occur in a painting of a seascape is in the relationship between waves and rocks and the resulting foam bursts. For example, a knee-high wave is highly unlikely to produce a foam burst the size of a house and vice versa. The size of the foam burst may also vary depending on the shape, angle and size of rock a given wave hits: the burst is greatest against a large, upright rock that is square on to the wave.

You can paint foam bursts with hard or soft edges, but in general, try to keep them softer than the foam at the base of a collapsing wave. You can soften the burst with a goat hair wash brush. Not only does this increase the misting effect, it also gives a sense of movement. Before painting in too much detail, paint in the rock with your chosen base colour, letting the paint run out on the brush near the water's impact point. This gives the appearance of the rock misting into the foam burst.

Detailing of the burst can now be added. Show a little light coming through its base using the same colours as those in the lighter water area in the wave. Water splashes can be added in front of the rock.

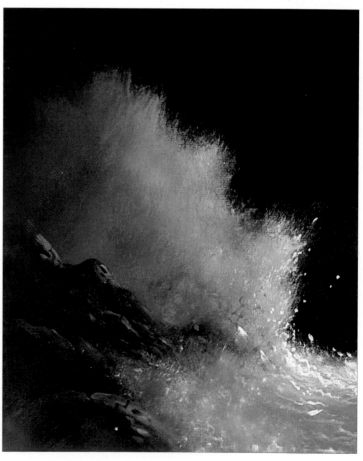

Waves and spray

As a swell reaches shallower water, it will start to build in height and change its profile until it is recognisable as a classic wave shape. Waves can also form in deeper waters if the weather is severe. They break and collapse near the shore due to the shallows and the undertow water from previous waves.

Wave detail from my painting Atlantic Fury *(pages 82–83).*

Tip

Look upon the waves as the cast in a play and the shoreline as the stage. The story is told by the interaction between them.

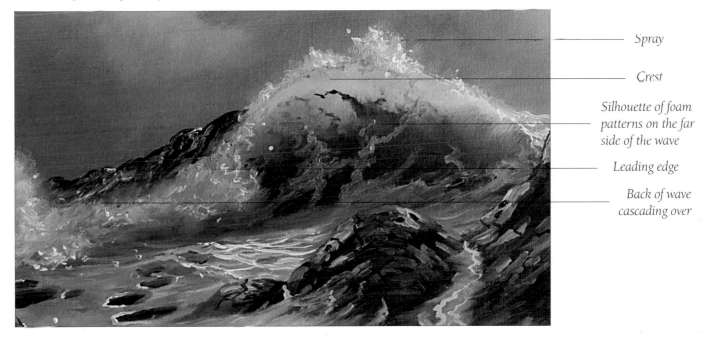

Spray

Crest

Silhouette of foam patterns on the far side of the wave

Leading edge

Back of wave cascading over

A wave appears very dark at its base, and becomes progressively thinner towards the crest. This means that it gets lighter in tone and changes colour towards the crest. In the example shown, I first painted the base of the wave with a dark mixture of French ultramarine, burnt sienna and a little sap green. Above that I painted a strip of cobalt blue into titanium white, and at the top of the wave I painted cerulean blue into titanium white.

I then blended these together for a smooth gradient from dark to light using the goat hair wash brush. Holding it square on to the surface of the canvas, and with a very light touch, I worked small circles from side to side, gradually working up to the top of the wave. To add to the effect I then used a sable 00 watercolour brush to paint in the suggestion of foam patterns on the other side of the wave, with the dark colour used at the base of the wave. I also used the goat hair wash brush to paint in the area where the back of the wave is cascading forward in the direction of the shore.

Where the wave is at a crest, the water tends to fragment into water droplets and spray. This process continues along the leading edge of the wave as it collapses, picking up air until its cascade collides with the water surface or beach, at which point it turns into a maelstrom. When painting this, avoid the temptation of painting it all white. Think of it as having shadows, much like a cloud. Unlike clouds, however, waves have large water globules, spray and confusion of direction: this means that the profile of spray needs more hard and soft edges. Use the surrounding local colour, and those of the sky and light source, to give the spray form.

Mass foam

Mass foam (also called surface foam) is caused by wave action forcing air into the water, which then rises to the surface as bubbles. Areas of mass foam gradually disperse, leaving holes through which the underlying water shows. These can make a good lead-in for the eye towards the point of interest. Highlighting these holes in places that would naturally pick up the sun or moonlight, and shading the opposite side gives the foam an impression of depth and thickness.

Varying the shape and size of patches of foam in a random and natural way will help to give them realistic form and direction.

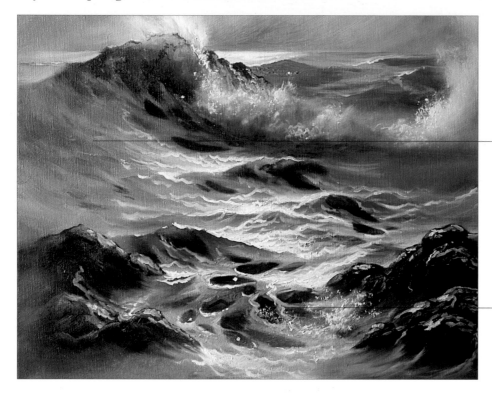

Foam detail from my painting Cornish Moonshine on the Rocks *(page 97).*

Mass foam

Linear foam

Linear foam patterns

Further away from the shore or rocks there will be less foam: only lines or isolated patches remain. These are known as linear patterns and can often be observed where a wave is building up (as it rises, it stretches the foam apart). This is therefore an ideal place to use them to add interest and lead the eye to the wave. They also occur where water is running back off a rock or beach.

Paint linear patterns in various shapes, widths and lengths. Connect some together, divide others and leave spots of foams isolated in clear areas. Do not paint them parallel to each other. In the example shown above, the wave is backlit, so the wave casts a shadow on the foam on its face and near it. The tone of the foam lightens as it comes away from the wave. To add texture and give form to the surface, cut in with the darker tones to create ripples and wavelets. The colours used were the same as those used in the sky (French ultramarine and burnt sienna into titanium white), with the addition of cobalt blue and cerulean blue in places. A minute amount of cadmium yellow pale was mixed into titanium white to highlight the foam.

Tip

Bring attention to the point of interest in your painting by giving it strong tones – dark, light or even a combination of both.

Submerged details

Submerged details add another dimension to water depth. In this detail of *Undertow*, the shallow water has been emphasised by painting ripples in the sand. Having painted in the wave with dark blue and green, I started to introduce yellow ochre to show the submerged sand – near the water's edge it is pure yellow ochre. Then, using the soft goat hair wash brush, I blended these areas in order to get a smooth gradient.

Using the darker tones, I painted in the dark shadows of the sand ripples, and in between these I lifted off some of the green/ochre. This created light on each of the ridges. The rocks were then blocked in using French ultramarine and burnt sienna, and their bottom edges hazed out.

Yellow ochre and alizarin crimson into titanium white was used to show the sunlight on the top of the rocks, while to highlight the rock underwater I used phthalo turquoise and sap green into titanium white. Finally, using the darker blue-green mix of the sea, shadows of the foam were painted on to the submerged beach. As the water becomes more shallow, the shadows appear closer to each respective patch of foam.

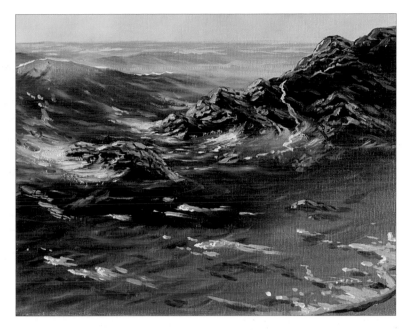

Submerged detail from my painting Undertow.

Shorelines

Shorelines are nigh-on essential to me because they help in composition and are useful in leading the eye around a painting. A distant headland can break up the flat line of a horizon. Rocks give structure, tone and colour to a painting. They also offer the opportunity to create foam bursts and patterns; rock spills and trickles; pools and reflections, and of course create shadows. Distant rocks, in general, should be lighter in tone and cooler in colour than those in the foreground.

Beaches can add colour and allow the use of reflections in wet sand. Most of the time beaches come secondary to the sea in my paintings, but if I want to make more of a feature of them, I give texture to the sand by spattering various thinned-down tones of paint over a general base colour using an old toothbrush and palette knife. Where a wave has expelled its energy on a beach and run back, it leaves a foam scud line. Painted into a beach scene, this adds interest and helps define the dry from the wet sand. Remember to give these foam areas light and shade and do not forget that they will cast shadows on to the sand.

Perranuthnoe Sands
56 x 40.6cm (22 x 16in)

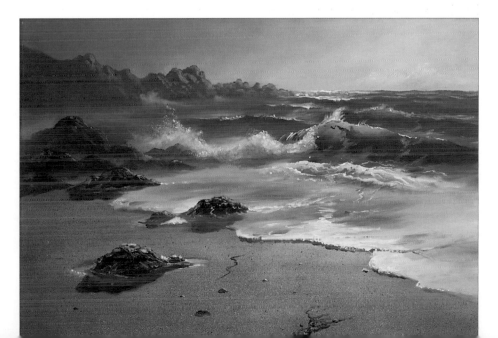

Understanding the sky

The sky not only helps to create the mood of a painting, but also sets the time of day, changes contrasts, alters colours and determines the strength of the light and length of the shadows.

Because water reflects the colours of the sky, skies have a greater influence on colour and tone in a seascape than in a landscape. It is also worth mentioning that there is a constant interaction between sea, land and atmosphere that generates our weather systems (with a little help from other celestial bodies), and that this has a great effect on sea conditions.

Tip

In appearance the sky is generally softer than the sea. Other than in cumulus and thunderhead clouds, you will rarely find hard edges in the sky.

Summer sky

When thinking of a summer sky, most people will instantly think of a clear blue sky with intense French ultramarine overhead, changing to cobalt blue and then the ethereal quality of cerulean blue drawing the eye to the horizon. However, there are many other colours and effects that are just as suitable for summer skies.

In the example below, I have created an atmosphere commonly found on the Cornish coast in the summer, starting with a thick early morning mist which is then burnt off by the heat of the sun. This mist is a sign of the day to come and the promise of a good catch of pilchards for the fishermen, hence the local term that gives the painting its title.

All for Heat and Pilchards
40.6 x 30.5cm (16 x 12in)

The colours used in the sky run from cadmium yellow into titanium white on the right-hand side; through cerulean blue into cobalt blue on the left. These colours were blended to give the soft, misty effect and painted down to the main wave in the foreground.

With the sky in place, St Michael's Mount and the background waves were overpainted faintly then blended into the mist with the soft goat hair wash brush.

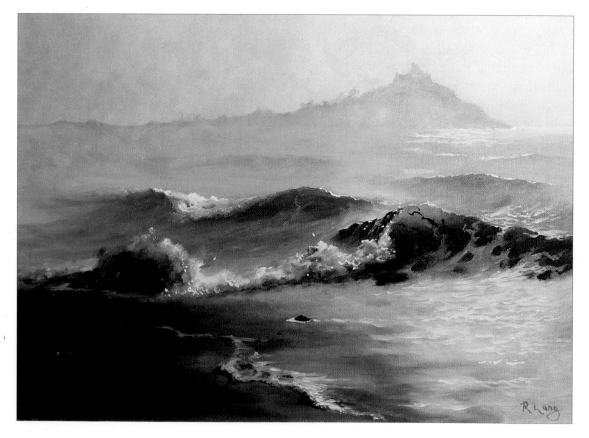

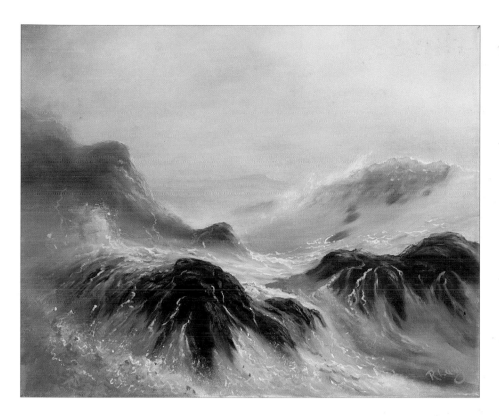

Cloudy sky

In *Storm Surge* (left), a stormy sky was used to set off the turbulent sea, but soft edges and tones ensure that it does not compete with the foreground. Too dark a sky in this painting would have combined with the downward curve between the wave and rocks, and this would have resulted in a generally oppressive scene.

Storm Surge
50 x 40cm (19¾ x 15¾in)

Stormy sky

A dark-toned stormy sky makes a good backdrop to a sea with strong highlighting, as in *Aftermath* on page 89. Placing the cliff and dark cloud next to the sunlit wave makes the paint appear brighter than it is in reality.

In the night scene *Electric Blue* (right), the lightning strike not only sets the storm off, but also gives a source of light in an otherwise dark painting.

Lightning strikes last only a quarter of a second, so I made the highlights appear jagged. I used Prussian blue into titanium white for the strike, the brightest part being the main bolt that has touched down somewhere behind the background swell. 'Spurs' were added in fainter tones coming off the main bolt. Reference material for lightning can be found in libraries or on the internet.

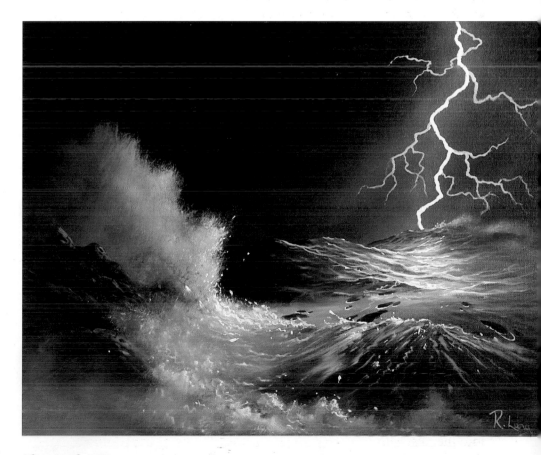

Electric Blue
51 x 40.6cm (20 x 16in)

Evening sky

Sunsets are both the most colourful and the most challenging skies to paint. The colours and tones have to be well-balanced for an attractive finished painting. For instance, the blues in the upper corners of *Time to Reflect* (below) had to be toned down a little with complementary orange to give contrast against the reds and yellows that gradually blend towards the sun.

I really wanted the brilliance of the sun and its reflection to shine in the sea, so I darkened the sky further by overlaying clouds. You will notice that the clouds are generally much the same tone, but red is added to the areas nearer the sun to emphasise the feeling of warmth in them.

Highlighting adds a three-dimensional look and softness to the clouds, except those adjacent to the sun. Highlights here would be lost and would detract from the strong light behind them. The sky colours were reflected in the wet sands and also at the base of the headland to great effect.

As a word of warning, unless you wish the sky to be the main feature of the picture, avoid intense colours and tones in the sky as these will jump forward in the scene and draw the eye from the sea.

Time to Reflect
56 x 40.6cm (22 x 16in)

The colours, tones and softened edges convey a feeling of relaxation and contemplation at the end of the day.

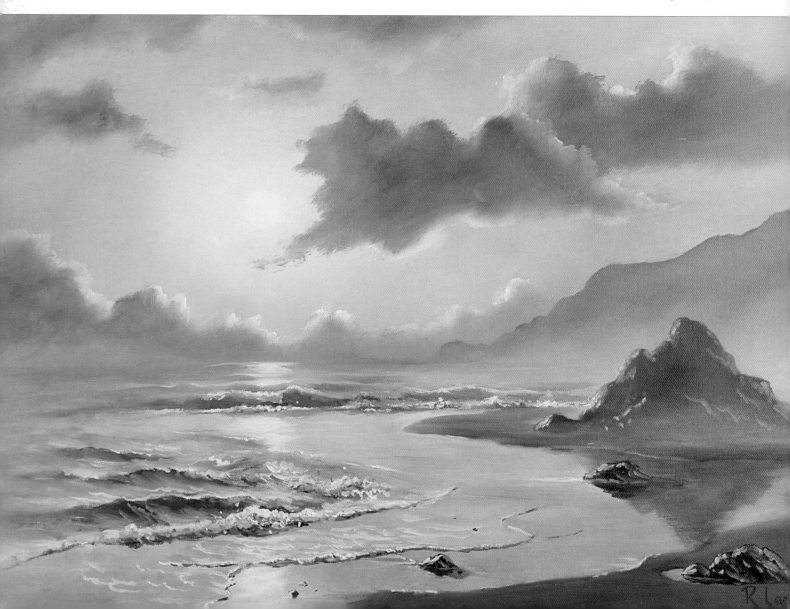

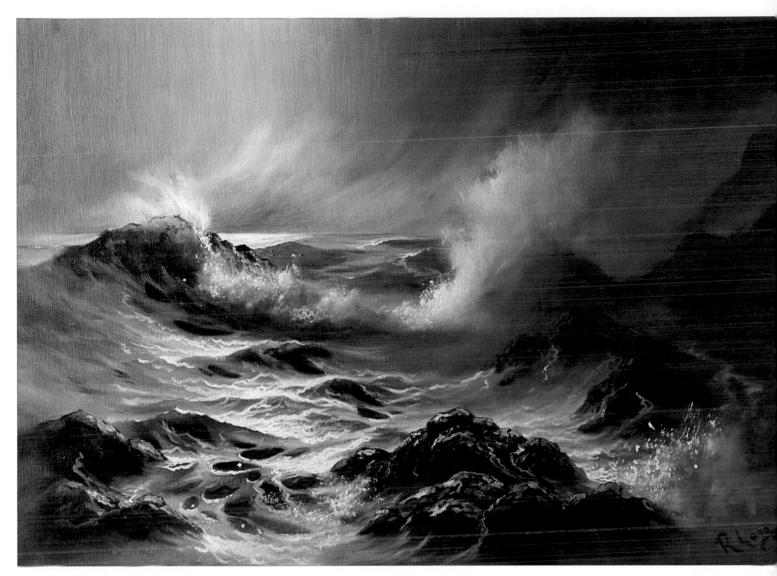

Cornish Moonshine on the Rocks
70 x 50cm (27½ x 19¾in)

Night sky

Now the sun is out of the sky and equation, the number of colours used while painting is drastically reduced, and therefore easier to control. Since the scene will generally be dark (even allowing for moonlight), clouds are not necessary to create contrast. In *Cornish Moonshine on the Rocks* (above), I used a soft fog to add to the composition. This calm sky set off the busy foreground.

The holes in the foreground foam not only give direction to the eye and water movement, but they also contrast well with the moonlight.

Understanding light

Light source

When planning your composition, you should always bear in mind the direction of the light source to maximise the use of shadows. This is particularly important in bright sunlight. Strong light creates well-defined shadows, whereas cloud or mist leads to diffuse or subtle shadows.

Tip

If the sun or moon is to be in view, mask off that part of the canvas with a disc of masking tape prior to painting the sky. When this is removed, the moon can be applied to the clean area of canvas without picking up the sky colour.

Direction of light

Lighting a scene from directly overhead tends to deaden a scene and tones, so avoid this if possible. Back lighting allows the use of light coming through a wave, as shown in this detail from *Spring Tide* (right). Front lighting can be useful if a cliff is behind the view, casting a shadow on the foreground. It can give a spotlight effect on an incoming wave and its foam patterns. Side lighting gives the opportunity to use shadows to their maximum effect.

Detail from Spring Tide *(opposite).*

Light source

Direct highlights always face the light source

Moonlight reflected on the sea

Wave is lit from the back

Sunlight

The lightest paint is white, and so to create the brilliance of sunlight on a white surface such as foam, all other areas in a painting should be toned down in relation to it. For instance, in *St Ives Bay* (right), the foam running up the beach was in full sunlight. To darken the blue sea around it I added blue's complementary colour – orange – to tone it down. As an aside, I could also have replaced the complementary colour with Payne's gray to mute the colour and achieve a very similar effect.

St Ives Bay
40.6 x 30.5cm (16 x 12in)

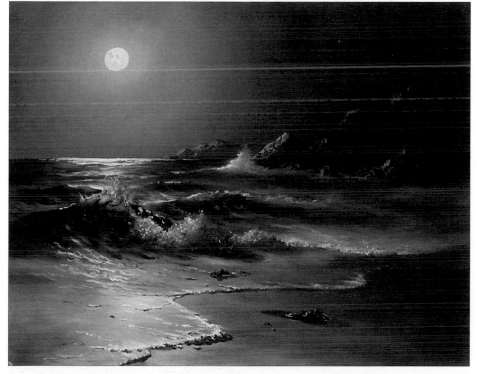

Moonlight

Night scenes are the best for the newcomer to seascapes because they are far easier to control than day or sunset seascapes, as the reflected colours are easier to portray.
When painting moonlit scenes, I use the same palette of colours as usual, but I tend to use more French ultramarine and burnt sienna. Moonlight can heighten the sense of romance and mystery in a view.

Spring Tide
55.8 x 40.6cm (22 x 16in)

Reflected light

Remember that reflected light illuminates shadow areas and brings them alive, but keep the shadow edge dark. For maximum impact, the darkest shade should be next to the lightest tint.

Reflections

Reflections are another important part of painting seas and skies in oils, appearing not only in the sea but in wet sand, pools of water and so forth.

In calm water, reflections occur directly below their objects, and in mirror image. It is a good point to remember that in calm water reflections are well-defined, but they become increasingly diffused as the water surface gets rougher. Reflections on calm water also appear stronger as the angle becomes greater between an object and the viewer's eye, but less intense as the angle decreases. The reason for this is that more of the light from the image is lost into the water, reducing the amount of light being reflected back up into the eye. In addition, the visual information from below the water's surface increases and therefore competes for attention.

Shadows and reflections

Be careful not to confuse shadows with reflections, particularly in the case of side lighting where the shadow will occur on the opposite side of the object, but the reflection will still appear below it.

Reflected colours and tones

Both colours and tones will appear different in an object and its reflection. Colours are more muted in reflections than in objects, while the tones in reflections tend towards mid-tones, with dark-toned objects appearing slightly lighter and light-toned objects becoming darker.

Tip

Avoid scenes where reflections will over-complicate your painting.

Detail from Time to Reflect *(page 96)*

The colours of the sky are muted in the reflection

Reflection in wet sand

This shadow is behind the rock, but the reflection of the rock remains below it

The tones of the dark rocks appear lighter in their reflection

Turbulent water disrupts the reflections

Opposite:
First Light at Gillian Creek
55.9 x 40.6cm (22 x 16in)

In this painting the reflections of the trees are softer in tone than the trees themselves. Note also that the more distant the object from the viewer, the softer the reflection. Compare the foreground firs' reflections to the reflections of the trees in the middle distance. The reflections (particularly those of tree branches) may alter slightly due to their angles, and to inaccuracies in portraying them. They are therefore best painted from life (or reference material close at hand). Try to sketch the reflections first, as you may soon miss them if the tide goes out while painting.

Ebb Tide

With this painting I wanted to capture the exhilarating freshness of a beach newly uncovered by the receding tide, and evoke the salty smell of a beach after rainfall; perfect for clearing the mind – and your nostrils!

The composition of the painting leads the eye to the main wave and entices the viewer to wander down the beach to the sea.

You will need

Sketch pad
HB pencil
Canvas board, 50.8 x 40.6cm
 (20 x 16in)
Masking tape
Palette
White spirit and cleaning rag
Kitchen paper
Palette knife
Brushes:
 Size 00 sable, size 2 round,
 size 6 round, size 2 flat, size 4
 filbert, size 6 filbert, 22mm
 (⅞ in) goat hair wash brush,
 cheap bristle brush
Paints:
 French ultramarine, cadmium
 yellow pale, alizarin crimson,
 titanium white, cobalt blue,
 cerulean blue, burnt sienna,
 yellow ochre, sap green

1. Sketch out the composition in your pad, and draw a grid of sixteen equal squares across it.

2. Divide your board into sixteen squares, and then work square by square to transfer your sketch to the board, using the HB pencil.

3. Use masking tape on the sea, so that the top edge is on the horizon line. This will keep the horizon clean and level, and make it easier to block in the sea later.

4. Mix a neutral grey from French ultramarine, cadmium yellow pale and alizarin crimson. Add titanium white, French ultramarine and cobalt blue to this for the sky mix. Scrub this mix into the sky area with the size 6 round brush, working from the top downwards with a scrubbing motion to work it into the weave.

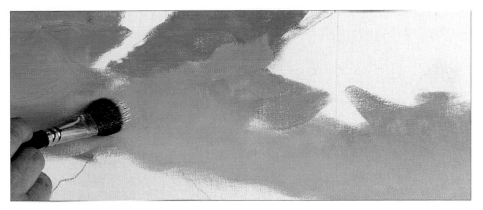

5. Add cerulean blue to titanium white, then paint in the lower area of the sky. Lighten the sky towards the right-hand side of the painting by mixing more titanium white directly on to the board.

Tip

Mix a fairly large amount of each of the main colours and save part of each one. Using the same colours throughout the work helps to tie the finished painting together.

6. Add cobalt blue to this mix and add a mid-tone to the sky between the two colours already on the board. Again, add a little more titanium white to the mix on the right-hand side. Use the goat hair wash brush to blend the colours in the sky into one another.

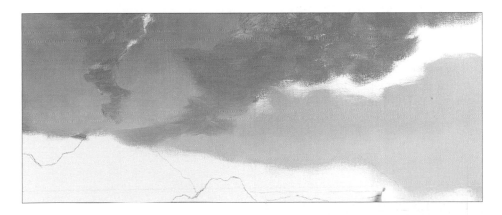

7. Start adding clouds with a mix of titanium white, French ultramarine, alizarin crimson and yellow ochre. Block them in with the size 6 filbert, scrubbing the colour into the canvas, leaving bare canvas showing on the right of the clouds.

8. Switch to the size 4 filbert, and highlight the clouds using titanium white with a drop of cadmium yellow pale added.

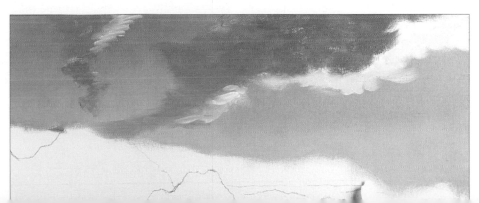

9. Add alizarin crimson to this cloud highlight mix and scrub this pink mix on to the clouds between the highlights and main colour.

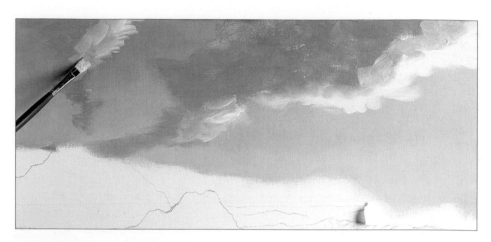

10. Blend the cloud colours into one another using the goat hair wash brush.

Tip

It is very important that you use the very lightest touch when blending oils. The tip of the brush should barely tickle the canvas, and the brush must be absolutely bone dry.

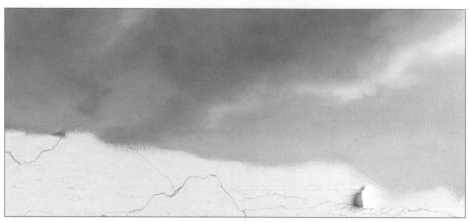

11. Use the size 6 filbert to block in the headland using a mix of titanium white, French ultramarine, cobalt blue, alizarin crimson and a touch of burnt sienna. Keep the edge sharp at the top by turning the brush as you pull it across the board, as shown in the inset. Tidy up the paint with the size 2 flat brush and remove the masking tape.

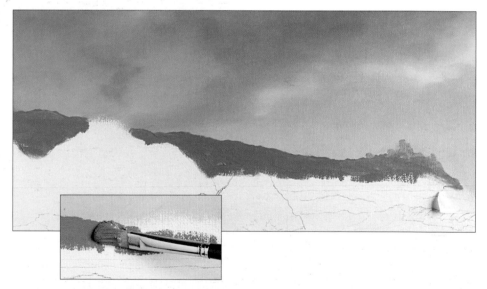

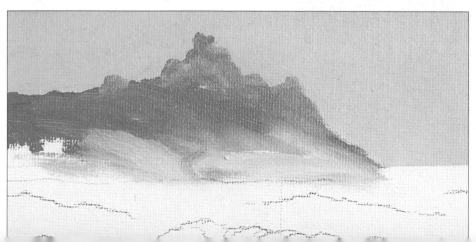

12. Use the cloud highlight mix to paint in the misting below the outcrop on the far right of the headland.

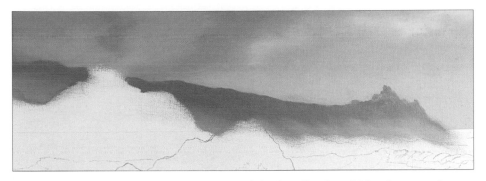

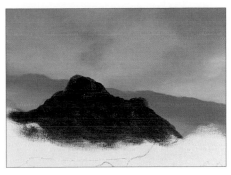

13. Block in the sky mix at the bottom of the headland and blend it in with a very light touch to ensure the headland colour does not muddy the misty effect. Notice how this makes the colours recede. Blend with brushstrokes going up the hill to suggest the spray wafting up the cliff.

14. Make a strong mix of titanium white, French ultramarine, cobalt blue, alizarin crimson and a drop of burnt sienna. Use this to block in the rocky outcrop in the middle distance, rolling the brush to get a sharp edge.

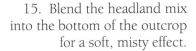

15. Blend the headland mix into the bottom of the outcrop for a soft, misty effect.

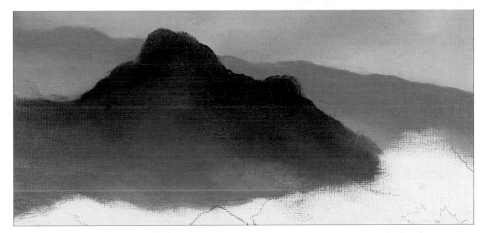

16. As we advance into the picture, we need to start adding reflected highlights from the sky. Add yellow ochre to the headland mix, and add this to the edge of the outcrop where the sunlight catches it, using the size 6 round brush.

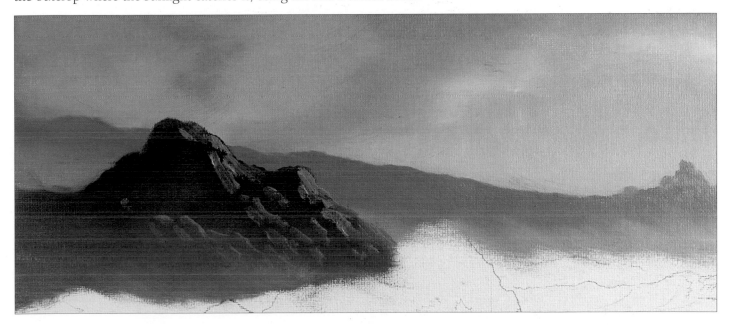

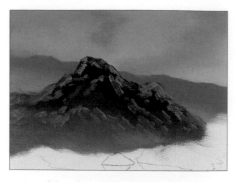 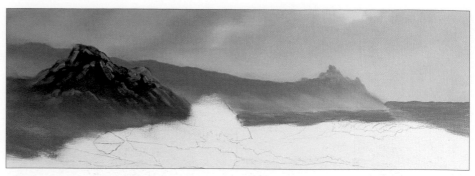

17. Add reflected light on the left-hand side of the outcrop using the original sky mix, and blend these highlights into the main colour, particularly at the bottom of the outcrop, to represent misting.

18. Use the size 4 filbert to draw the misting effect on the outcrop further down the board, then make a sea colour by mixing titanium white, French ultramarine, cobalt blue, a drop of burnt sienna and a spot of sap green. Paint in the sea on the horizon line using the size 6 filbert, and draw it down to the top of the main wave and along the bottom of the headland.

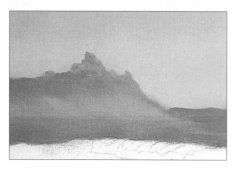 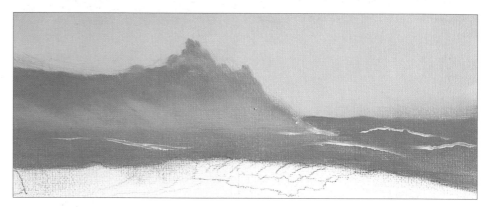

19. Tidy the edges with the size 4 filbert, and then blend and soften until any hard lines are lost.

20. Add titanium white, a drop of cadmium yellow pale and a touch of alizarin crimson to the sky mix, and use this to highlight the edges of some of the background waves.

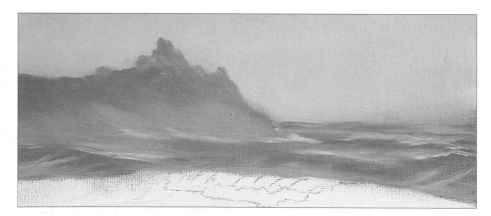 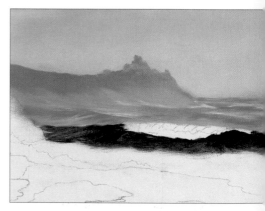

21. The troughs of the waves catch the light and reflect the sky, so use the sky colour to paint reflections on the sea. Start above each of the waves, blending them slightly. Use long, curving strokes of the size 00 sable to suggest the shapes of the waves. Use the pale blue-grey to suggest more disturbances at the bottom of the cliff, then blend these stages slightly.

22. Add more French ultramarine, burnt sienna and sap green to part of the sea mix for the foreground wave. Paint around the foam pattern and up either side using the size 4 filbert.

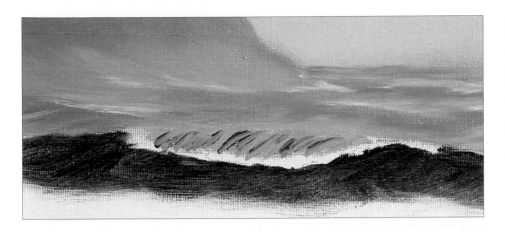

23. Add cerulean blue and titanium white to the original sea mix and use this to paint the fold where the wave is coming over, using a size 2 round brush. Blend some of the foreground wave mix into this area.

24. Mix titanium white, cadmium yellow pale and sap green and use this mix to paint the sides of the wave to represent the sun shining through the water.

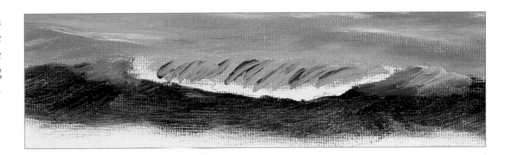

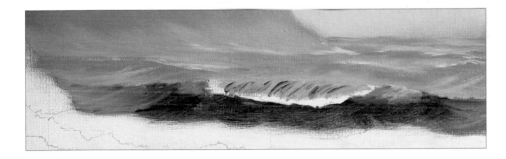

25. Add a touch of the sky mix to either end of the wave, keeping the brushstrokes following the water from the surface to the crest of the wave.

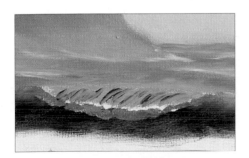

26. Blend the front of the wave using the small cheap bristle brush, and use the sky mix to paint underneath the foam burst with the size 2 round brush

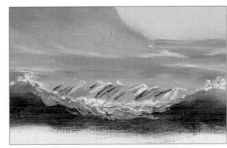

27. Use the cloud highlight yellow mix to highlight the wave along the crest and along the top edge of the foam burst. Pick out extreme highlights on the top of the wave, and use the same mix for some spray.

28. Suggest foam patterns with the darker sky colour on the front of the wave to help give it shape and form. Soften this a little and dot in loose spray with the cloud highlight yellow mix.

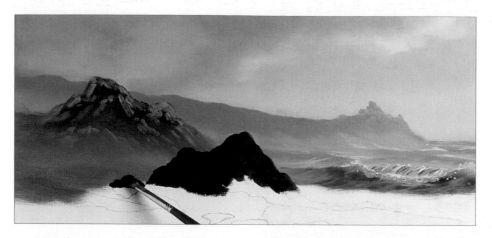

29. Use the main wave mix to block in the beach on the left, then paint in the central rock using a mix of French ultramarine and burnt sienna with the size 4 filbert. Use the brush-rolling technique (see page 86) for sharp edges on the rock.

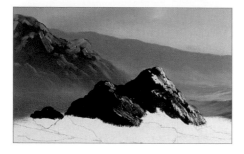

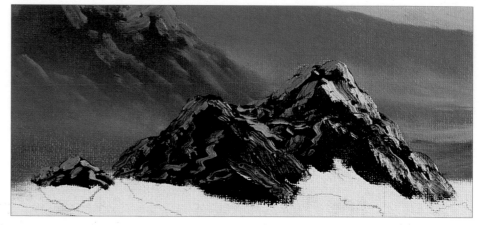

30. Add highlights to the right-hand sides of the rock with the size 2 flat brush and a mix of titanium white, yellow ochre and a touch of alizarin crimson.

31. Use the darker sky colour for reflected light on the left-hand sides of the rocks, then add zigzag lines with the size 00 sable brush to add interest.

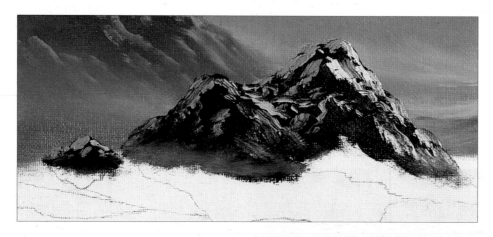

32. Use the rocky outcrop colour for a little misting around the base of the rocks to soften the hard lines at the base.

33. Use the rock colour to add in some more cracks and crevices in the rocks. Paint in the shallow waters and the slick areas around the wet beach with the size 6 filbert brush. As the water advances, darken the mix, mirroring the gradient of colour in the sky. Use the cloud highlight on the far right, again mirroring the sky.

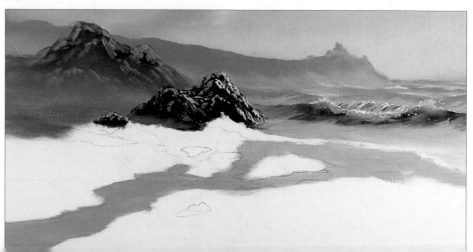

34. Mix the rocky outcrop colour with the sky mix and foreground rock mix and lay in the reflection of the outcrop and foreground rock with the size 2 flat brush. Follow the contours of the drier sand, and be careful not to overlap the wave breaking on the rock. Add some of the cloud highlight mix to bring the reflection out a little.

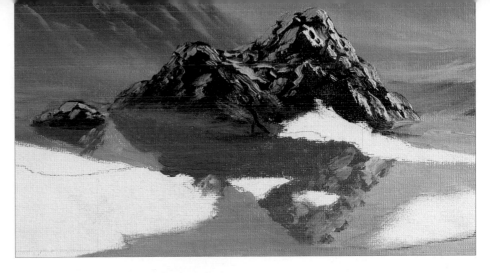

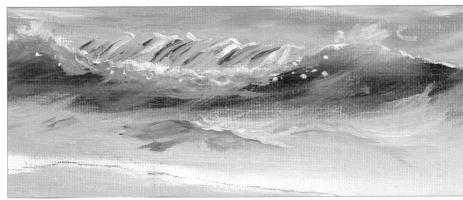

35. Mix the darker sky colour with the green wave mix and paint some ripples in front of the completed wave. Emphasise these with the cloud highlight mix.

36. Add cobalt blue and alizarin crimson to the dark sky mix and paint this mix along the shallow edge of the water lapping up the wet beach. Use the same mix for the expiring wave on the right and the foam burst on the foreground rock.

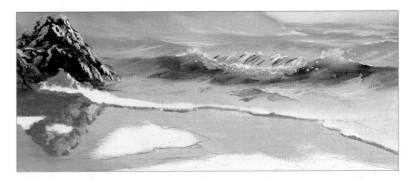

37. Highlight the scud line with the lighter sky mix, paying particular attention to the foam burst around the rock. Blend the cloud highlight in with the goat hair brush, and drag it down with a size 2 round brush to texture the leading edge of the scud line. Use titanium white on its own to add bright highlights to the area, dotting it on with the size 2 round.

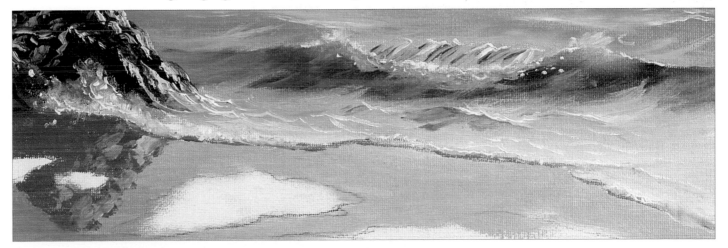

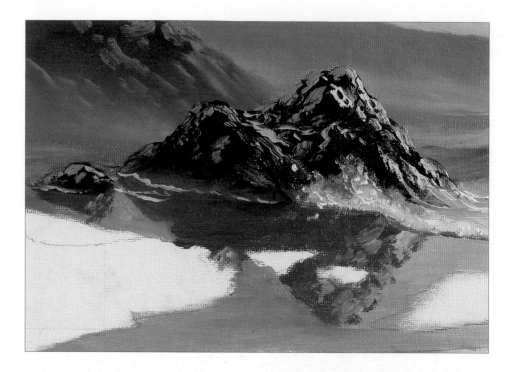

38. Use the sky mix to define a line between the rock and its reflection, and add foam running back to the right of the rocks, following the retreating water.

39. Mix titanium white, French ultramarine, cobalt blue, sap green, yellow ochre and the rock mix for a grey-green beach mix, and paint in the sandy areas with horizontal strokes of the size 6 filbert. Fade the sand towards the edges of the painting.

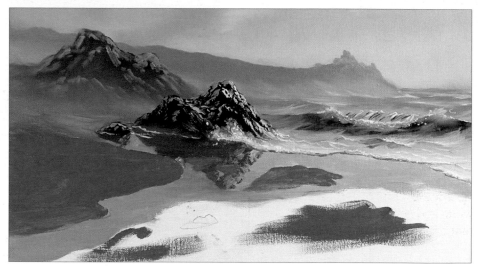

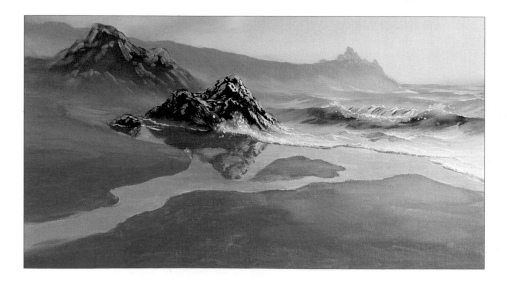

40. Add yellow ochre and titanium white to the mix to vary the tone as you work towards the bottom of the painting. Suggest reflections of the cloud in the wetter areas of the beach, and blend the reflected sky colours into the wet sand.

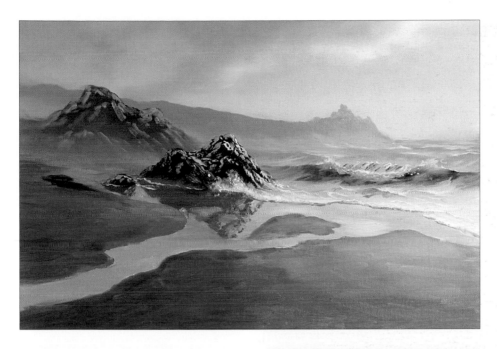

41. Use the goat hair wash brush to blend and soften the beach, to ensure the sand and water are not starkly separated.

42. Highlight the beach on the right using a mix of titanium white and yellow ochre with a hint of alizarin crimson.

43. Paint the areas where the sand is eroded and catches the light with a stronger mix of the same colours. Use the rock mix to pick out the shade on the opposite shore.

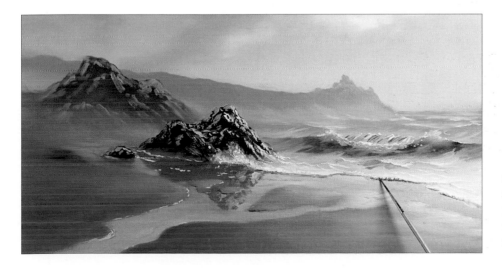

44. Switch to the size 2 round brush and use the paler sky mix to paint some areas of foam trailing across the reflections of the rocks. Use the same mix for some subtle lines on the water for added texture and interest.

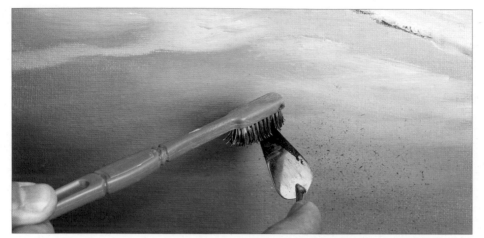

Tip

Spattering can be very messy, so be gentle and keep the toothbrush a good distance away from any areas you do not want spattered.

45. Combine the rocky outcrop and foreground rock mixes, and thin the mix down with white spirit to the consistency of single cream. Use an old toothbrush to spatter this mix over the foreground beach, drawing a palette knife across the bristles to flick the paint on to the painting.

46. Thin the rocky outcrop colour and spatter it on to the closest area of beach, as before. Make sure that you clean and dry the brushes you use thoroughly to make sure that no white spirit pollutes the painting.

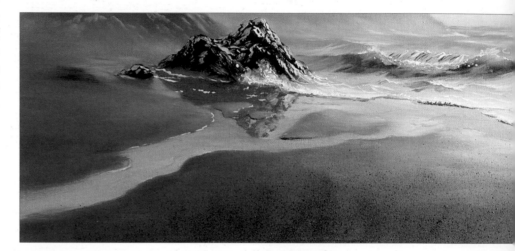

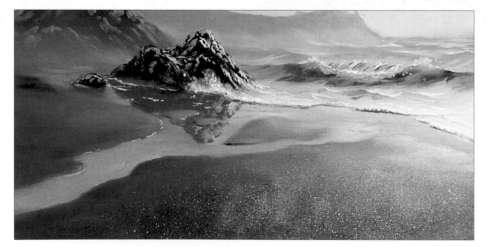

47. Repeat the spattering technique with the sky highlight mix, and then repeat once more with thinned titanium white for the final highlight.

48. To complete the picture, add a few pebbles using the same colours and techniques as for the foreground rocks; and some pure titanium white ripples in the foreground water.

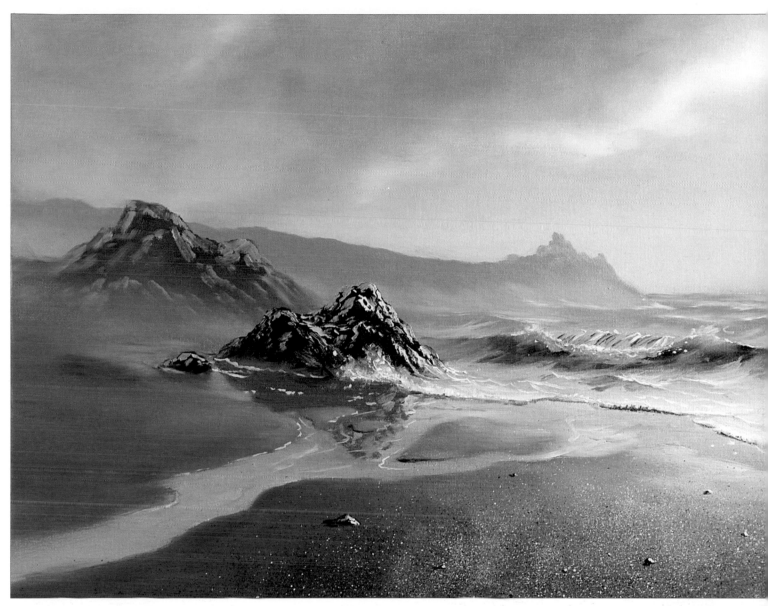

The finished painting
50.8 x 40.6cm (20 x 16in)

The plain beach gives this scene a calming effect. It makes it uncomplicated to paint and relaxing to look at.

FLOWERS IN OILS

by Noel Gregory

I often hear the words 'If only I could do that', 'I wish I had the talent for painting' or, more often, 'I can't even draw a straight line'. Let me tell you something – I cannot draw a straight line nor, I might add, would I want to. Painting pictures is not about talent or an extra gift given at birth; it is about work and tenacity, making mistakes, being able to recognise them and trying to correct them. Painting, I have found, is often about sudden advancement. Just as you think of never being able to improve, you produce a work that far outshines anything you have done before, and off you go again. While teaching adults earlier in my career, I was responsible for many hundreds of beginners, and I never found any who did not improve with persistence. You only have to want to do something, then, with the proper tools and encouragement, you can begin the greatest adventure of your life.

Garden Foxgloves
Size 40.5 x 29cm (16 x 11½in)

This painting shows how a picture can be formed by setting up your easel next to almost any spot in the garden. Here, the sunlight creates good tonal contrasts in the composition. Without this strong light source, the subjects would have been flat and uninteresting. Remember that mastering tone is paramount for a good painting – light against dark, and dark against light – and that your skills of drawing and the use of colour are of secondary importance.

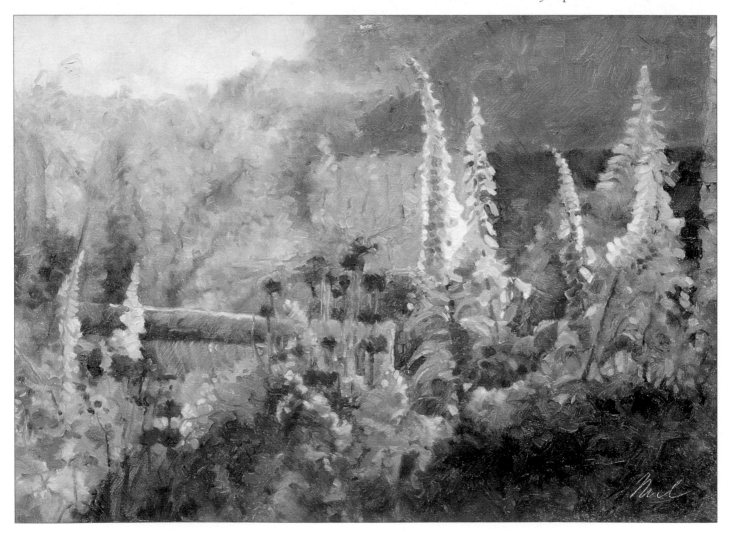

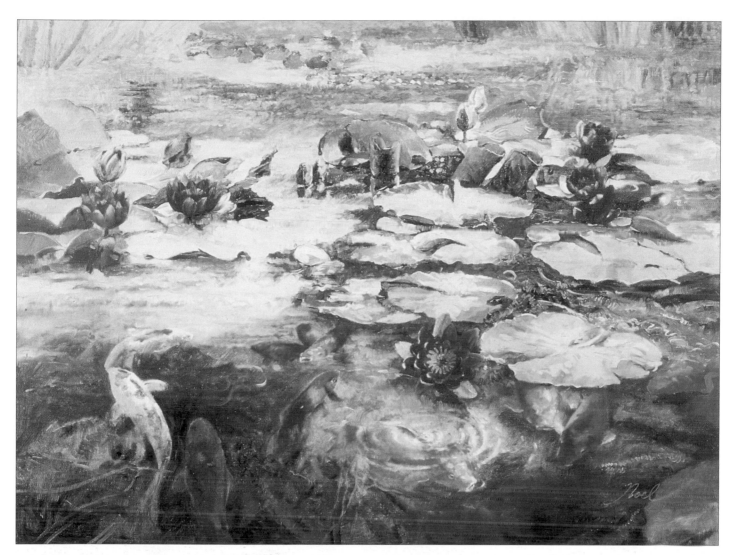

Goldfish and Water Lilies
Size 101.5 x 76cm (40 x 30in)

This type of subject is a particular favourite of mine It is not strictly a painting of flowers, but the addition of water lilies is of significant importance to this composition. They add colour and strength to the design, as well as interest, and the whole picture has benefited by their inclusion.

So let me introduce you to what is one of my favourite subjects – painting flowers in oils. Flowers have excited artists for centuries: Dutch Great Masters painted them in extraordinary detail; early explorers took artists with them to reproduce, usually in watercolour I might add, the flora they discovered on their travels; and impressionists used flowers as an influence in their subject matter. Claude Monet's water lilies and Vincent Van Gogh's sunflowers have been reproduced so many times that few would not be able to describe them.

Flowers are the ideal subject for both the beginner and the advanced student. They can be painted without worrying about perspective and almost without regard to colour. They can be painted in the crudest manner or with great sensitivity. No matter how you deal with them, flowers always seem to end up looking like flowers.

Choosing a subject

When painting landscapes, composition is of paramount importance, and you often have to add objects to a scene to make it more interesting. On the other hand, if you choose to paint flowers, the subject really dictates how you paint it. Most of my flower studies are painted *in situ* or as still-life arrangements in my studio. However, I am not averse to using photographs as a reference source or as the basis of a collaged scene.

Painting from life

Flowers give you considerable scope, and the projects in this section show you several different types of composition.

Still-life arrangements of flowers in a vase are very popular. However, some flowers with large single blooms lend themselves to being painted life-size or even bigger. Others, especially those with smaller individual flower heads, appear best when painted as a group. Finally, you can use flowers as the major part of a landscape.

A single flower study

This water lily is an excellent subject for a single flower study. The simple shape of the petals makes it ideal for painting larger than life and I purposely enlarged it to cover the entire canvas area for the project on page 120.

A group of flower heads

Cyclamen, with their small but highly sculptured petals, need to be seen as a group. At first, they appear to be quite complex but, as you will see in the project on page 122, they can be treated as lots of simple shapes.

A still-life arrangement

Why do so many still-life flower studies in pots look like 'Van Goghs'? This was not my intention when I painted this project, but it seems to have worked out this way. The secret for this type of composition is to keep things simple. There are two basic rules: do not put too many different types of flower in the group; and do not include too many colours.

Flowers in a garden

Flowers in the garden provide an endless source of subjects. Treat this type of painting as you would a landscape, removing any unsightly objects and adding points of interest. For this particular scene, I 'imported' the flower pot at bottom left to balance the composition. Alternatively, I could have added some flowers, painted from cut stems, to this part of the foreground.

Monet's Garden with Irises
Size 91.5 x 66cm (36 x 26in)

Monet's garden is a great source of images for any painter. He managed to put any old flower colours, shapes and species together without losing the sense of composition. You can also add extra flowers, as I have done here, if you need more colour in the foreground.

Cornish Village
Size 91.5 x 68.5cm (36 x 27in)

This is my favourite place, Portloe, in Cornwall. I added more hydrangeas in the foreground to make a frame for this composition. The scene is attractive enough without these flowers, but the colour perspective of the warm pinks against the blues of the background adds depth to the scene.

117

Composing with photographs

I often use photographs when painting flowers. Sometimes, I use a single photograph as a straightforward reference source, other times, I cut up several photographs to create a pleasing composition. Photographs provide an easy way of tackling perspective, especially if you add a grid to help you transpose the composition on to the canvas. When making a collage from photographs, remember that everything must be scaled correctly.

Taking your own photographs would be the most personal way to work, but there is nothing to stop you from using illustrations from books or magazines. I keep a scrapbook containing photographs, sketches, cuttings from gardening books and magazines and reproductions of painted flower studies. In fact, I save anything that might prove interesting in the future.

There do not have to be flowers in the original scene, just places for them to look natural. If your picture would benefit from, say, delphiniums, you can add them to the scene, either painting them from life or from references in the scrapbook.

Here I show you how to create a simple composition from three separate photographs taken at the same location. The photograph of the country lane lacked detail at the left-hand side, so I cut out two close-up photographs of rhododendron heads and placed these in the foreground to produce a strong sense of perspective.

1. Cut round the outline of the parts of the photographs you want to include in your composition.

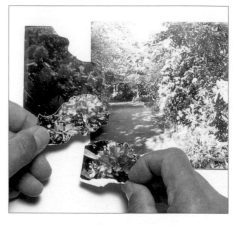

2. Move the component parts of the scene around until you are happy with the composition.

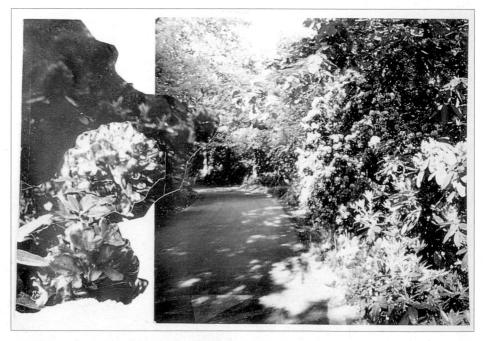

3. Stick the pieces of photographs on to a sheet of card or paper.

4. Draw a grid of equi-spaced horizontal and vertical lines on the collage. Transpose this grid, to either a larger or smaller scale, on to the canvas, then use the grid to sketch in the main outlines of the composition.

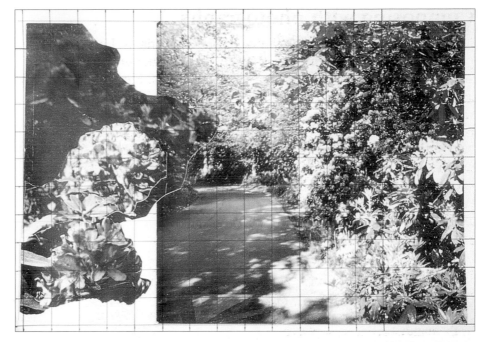

Rhododendron Lane
Size 76 x 61cm (30 x 24in)
The finished painting. When I came to paint this scene, I felt that it was not well balanced, so I made the painting squarer by cropping out some of the foliage at the right-hand side.

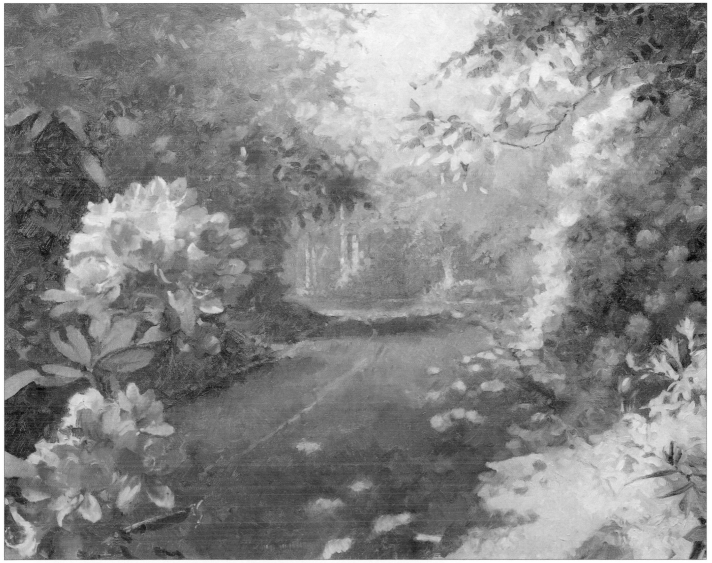

Water Lily

I have chosen a single water lily as the subject for this first step-by-step demonstration. Apart from being one of my favourite subjects, the water lily is made up of very simple shapes and the petals contrast well against the natural background. A strong light source, giving plenty of shadows, is essential for this type of study, as subdued lighting will make the flower appear flat and difficult to understand. The tonal contrast between the background and the flower head is also very important. Looking at the subject through half-closed eyes will emphasise this contrast.

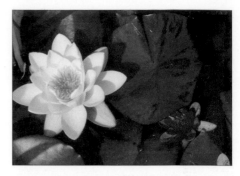

I painted this demonstration under the artificial lights of a photographic studio, so I used a photograph for reference. Notice that for the actual composition, I rotated the flower slightly.

1. Use a weak colour and a small brush to draw in the overall shape of the flower head, sizing it to fit the canvas. Keep everything as simple as possible.

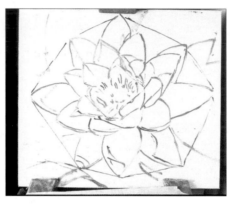

2. Now draw in the outlines of individual petals and any leaves. Do take time to ensure that you size everything correctly.

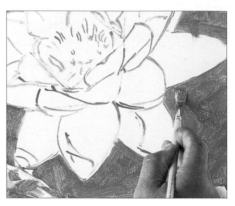

3. Use viridian, with touches of ultramarine and burnt umber, to block in the background.

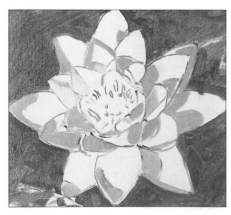

4. Add titanium white and a touch of cadmium red to the green mix, then block in the shadowed parts of the petals.

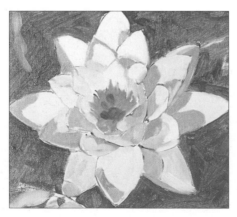

5. Mix cadmium yellow and cadmium orange, then block in the flower centre. Add titanium white and a touch of cadmium red, then block in the petals.

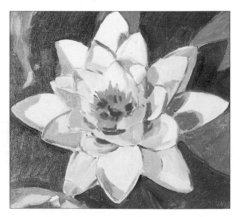

6. Introduce touches of ultramarine and ivory black to the mixes on the palette, then use these tones to establish the dark areas of the painting.

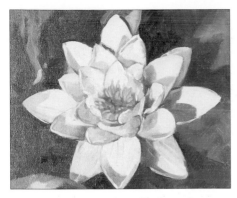

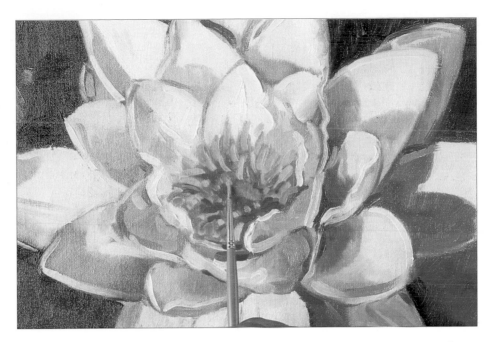

7. Now blend and work the colours together, correcting the shapes as necessary. This stage can take a considerable time to complete, and you may need to add more touches of colour to redefine some shapes.

8. Finally, use a fine round brush to add fine detail to the flower centre, and small highlights on the petals.

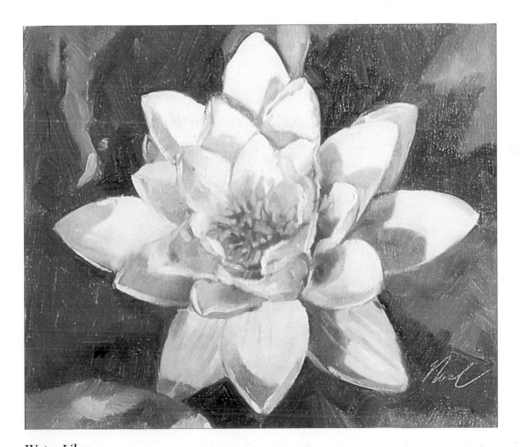

Water Lily
Size 25.5 x 21.5cm (10 x 8½in)

The finished painting. Simple uncluttered flower head studies such as this often produce the most exciting paintings. They can be great fun to do, especially if you paint them much larger than life.

Cyclamen

For this next demonstration I have chosen to paint a plant with multiple flower heads – a composition where the background and environment have to be taken into consideration. This cyclamen in a pot is an excellent subject to paint, but rhododendrons, hydrangeas and lupins are all suitable subjects.

When setting up your subject, always try to keep it and the canvas in the same line of vision. This will minimise the movement of your head and body, and you will find it easier to transfer the shapes on to the canvas.

Reference photograph.

1. Draw in the rough outline of the whole group of flowers to fit the canvas, then add detailed outlines for the petals and leaves. Here, I have deliberately used one colour to show the rough outline, and another for the detailed drawing.

2. Block in the basic shapes of the petals and leaves.

3. Work up the background area of the composition.

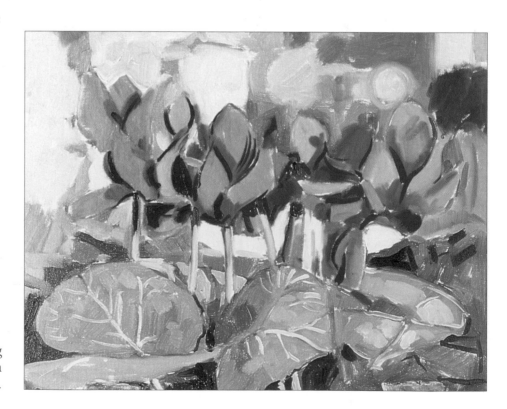

4. Start to redefine shapes, adding more colour and mixing colours on the canvas.

122

5. Accentuate the highlights, mid tones and shadows.

6. Finally, add small details with a fine round brush.

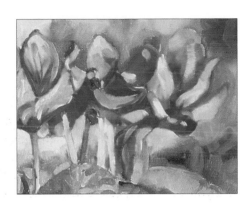

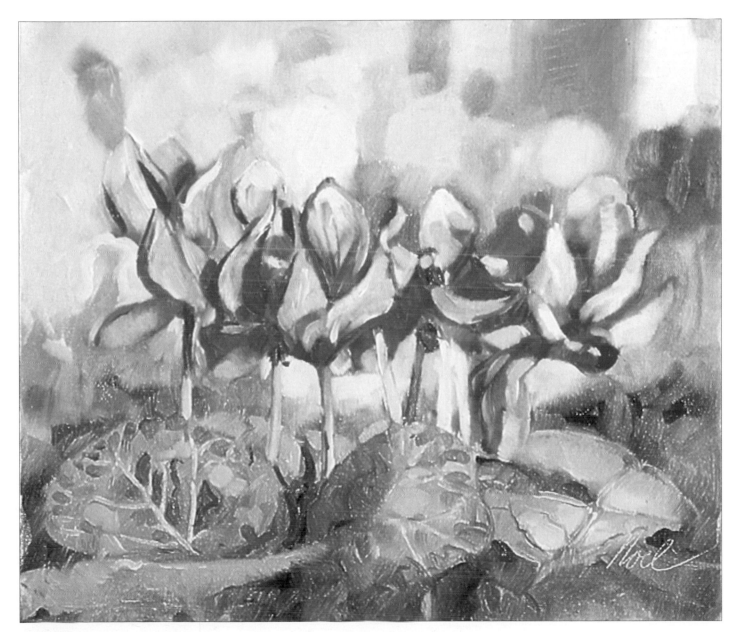

Cyclamen
Size 25.5 x 21.5cm (10 x 8½in)
The finished painting.

INSTANT OIL PAINTING

by Noel Gregory

It is possible to produce immediate results with oil paints. Quick methods can be exciting and challenging, and with practice you will soon be able to master a range of techniques that will enable you to build up beautiful paintings of which you can be proud. The delight of working in a spontaneous and intuitive way is achievable whatever your skill level, and it is also highly enjoyable. Imagine the pleasure of capturing the freshness of an early morning seascape, the splendour of a dramatic mountain scene, or the peacefulness of a sun-drenched landscape. What could be better than to re-create the magic and beauty of the world around you?

In this section I show you how to paint in a spontaneous way. I have used the word *instant* in the title, but really only a photograph could be called so. Photographs, however, do not always capture the intensity of light, the subtlety of tone, the shadows, depth or texture. A painting can portray all these things and more. 'Instant' in oil painting terms means being taught how to master quick techniques, how to develop skills and build up confidence, and how to maximise the effects of simple brush strokes.

If you work through the chapters in this section, you will discover that painting is indeed fun, and the more fun you have, the more you will like to practise. You will discover all sorts of secrets and tricks that go towards making great paintings.

Whether your style is realistic or loose, you will soon be experiencing the rich pleasure of oil paint. Eventually you will be choosing your own colours, developing your own compositions and creating unique pictures full of feeling and atmosphere. Above all, you will be having fun. I hope this section achieves everything I talk about and that it inspires you to take instant action!

Spanish Villa
75 x 65cm (29½ x 25½in)

Here, the mass of branches and leaves has been simplified to create an impression of foliage. Take your time when planning your painting, and practise applying quick brush strokes. You will soon learn how to capture complex subjects.

Still life

Almost anything that does not move can be placed into a still life painting. With a considered use of the spotlight it can be painted in the comfort of the studio, and started and stopped at any time without change of shadow.

I have purposely included fruit in this section, because like flowers it can be painted without great detail and still remain recognisable.

It is less complicated (though not necessarily easier) to produce a still life than some other forms of painting. This is because once the object has been placed, there is no movement, and therefore, unlike landscapes, animals and plants, the reference will always be the same. So it is up to the artist to choose objects that relate well to one another in subject, or in colour, or in shape; and place them in an inspirational way and with good lighting, so that the final painting will have a strong impact.

Basket of Tomatoes
50 x 40cm (19½ x 16in)

8 Hours

Strictly speaking, this illustration is not an instant painting because it took a good day in its making. I have included it to show the development from a few tomatoes into a full still life group. The basket is the frame of the composition, and the different colours of the fruit together with a good lighting source make for an excellent finished picture – one that I really enjoyed painting.

Helpful hints

The following hints will help you with your choice of subject matter for still life paintings.

Choose objects that have some connection with each other, either in colour or nature. For example, the picture opposite has a selection of squash shapes.

Limit the number of objects to avoid complication. This will not only increase the speed of your painting, but it will make for a better image.

Fill the canvas with the subject and not background.

Limit the colours of the objects and the background. Too many can be confusing. Simple choices using related colours give better results, as below.

Be aware of the shapes between the objects. I show this on the opposite page.

Do not include heavily decorated objects, such as cut glass. This removes time spent on detail.

Light objects from one side with a spotlight. This will give good shadows and a greater three-dimensional image.

Paint the subject from a close up angle – as near as you can get, eliminating the need to make up detail by being too far away.

I Hour

The Two Pomegranates
25 x 20cm (10 x 8in)

The pomegranate has a simple round shape and, cut in half, is extremely interesting to paint. In this composition I have used a strong side light to give me my shadows. Similar hues are used for the pomegranates and the background, giving colour unity. This idea can be tried with any fruit such as oranges, apples, tomatoes etc. and it will help to develop an understanding of three dimensions and tone.

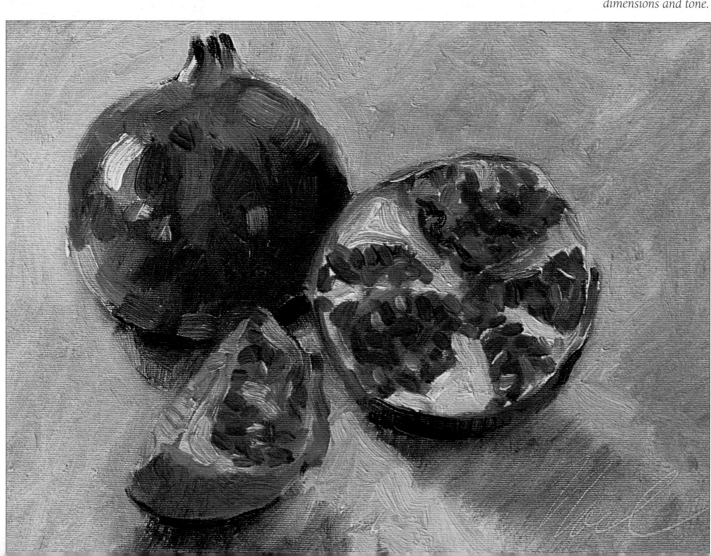

Looking at shapes between objects

Seeing objects by spatial shapes was the vogue in my art school days. Although this left me with less than a complete understanding of the subject, it is a valuable way of looking at things. You are no longer concerned with whether your subject is a landscape, portrait or still life, you are only aware of the shapes that objects make in between each other. If you are painting several objects, as in the picture below, it is important to look at the spaces around them and the way they relate to each other. Try squinting your eyes at this illustration and looking at the blue areas. It is the shapes in between that need to be drawn correctly, and not necessarily the objects.

Squashes
30 x 25cm (12 x 10in)

 2½ Hours

In the pomegranate picture opposite, I limited the colours to create a feeling of unity. Here, I have used contrasting colours. Notice how the red squash is enhanced by the use of blue in the background, the colour opposite it on the colour wheel.

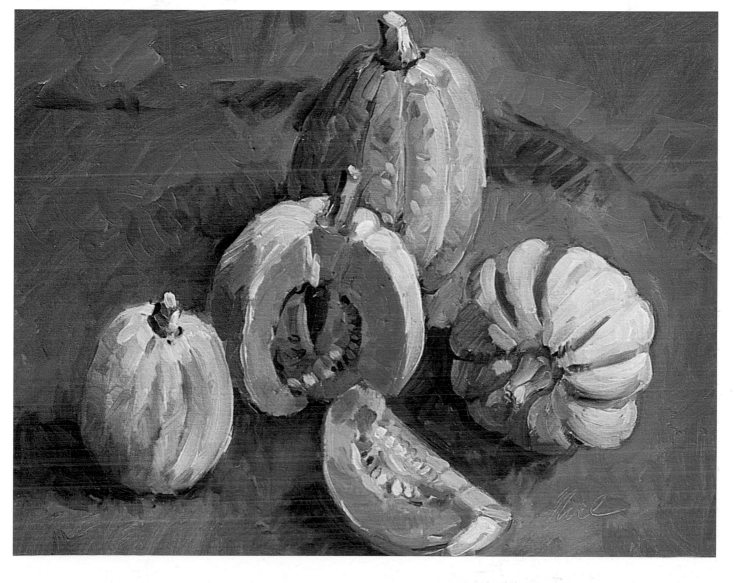

Painting Metal

2½ Hours

One of my students brought a pewter jug to a class to add to a still life composition. He also brought pewter spray paint to use in the picture – an obvious mistake: a spray will only give a completely flat pigment areas, and this will look very unlike what you need to achieve to get realism. Metal reflects its surroundings, just like glass. It is the painting of these reflections that gives us our object. In this demonstration I have chosen three objects that are made from very different materials – copper, pewter and brass.

You will need

Canvas board, 41 x 33cm
(16 x 13in)
Brushes:
 Filbert size 6 (large)
 Short flat size 2 (small)
 Sable size 1 (detail)
Linseed oil
White spirit

Colours

Cadmium yellow

Cadmium red

Alizarin crimson

French ultramarine

Burnt umber

Titanium white

Viridian

Cadmium violet

Useful mixes

Brass bowl
Alizarin crimson, cadmium yellow and titanium white.

Copper plate
Cadmium yellow, cadmium scarlet and cobalt violet.

Pewter tankard
Alizarin crimson, French ultramarine and a touch of titanium white.

This arrangement has been lit from one side to bring out the dark tones and highlights of the metal objects.

1. Using a small, dry brush, lightly paint in the outlines of the plate, tankard and bowl. Fill the canvas with the subject and not the background.

Tip

When you paint the initial outlines, use a dry brush with only a touch of white spirit and very little paint.

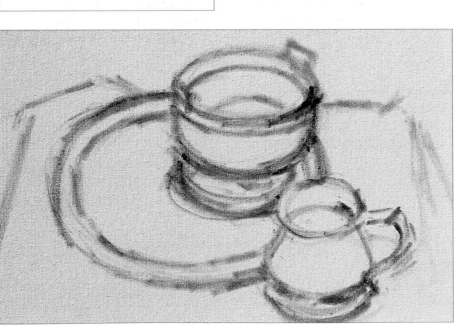

2. Use the suggested mixes to paint in the main shapes with flat colour. Squint your eyes to evaluate the darker areas, add small amounts of French ultramarine to your mixes and add the darker colours to the relevant areas.

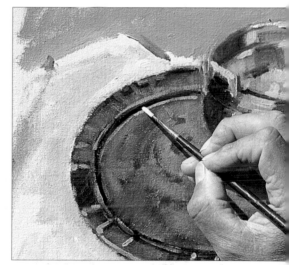

4. Continue adding colour by observing what you see. White highlights are added to the copper plate to represent reflected light.

3. Highlights should be added using pure white. Darker tones should be added using a mix of alizarin crimson and French ultramarine. This will blend with the wet underpainting. Notice that the orange hues on the brass bowl are reflected from the copper tray. Small amounts of cadmium red and cadmium yellow will help you with this.

Tip

Keep the tonal areas simple when you are painting a still life like this, and study the reflected colours, light and shade from each surface. It is this that gives the impression of metallic surfaces.

5. Keep correcting and adding to the colours: oranges, browns, reds and greens. At this stage, you can redefine and adjust the shapes of the objects by repainting the background.

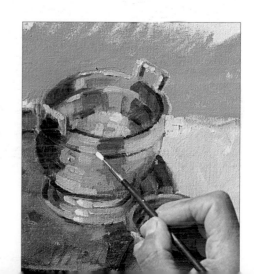

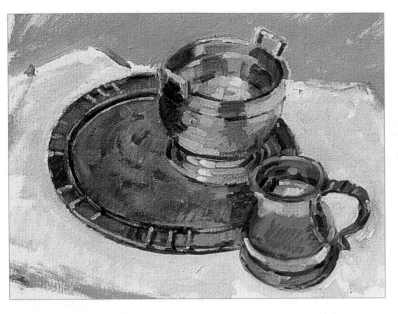

6. Using a thicker version of the copper mix, paint the copper reflections on the tankard and bowl, then the brass reflections on the copper plate using a thick brass mix. Blend cadmium violet into the copper mix for the shades of the plate.

Tip

When working on fine detail with a sable brush, it is useful to steady your hand by using a mahlstick.

The finished painting
41 x 33cm (16 x 13in)

The painting was allowed to dry for two hours, then the colours were blended with a large dry brush to create a softer image. Notice that the original brass bowl was embossed. I felt this was an unnecessary detail, taking time and adding little to the painting, so it was not included.

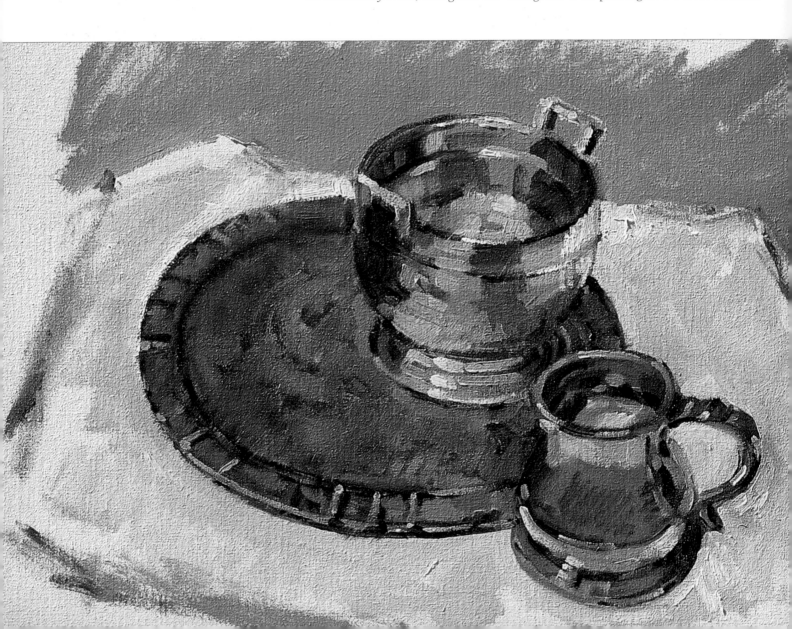

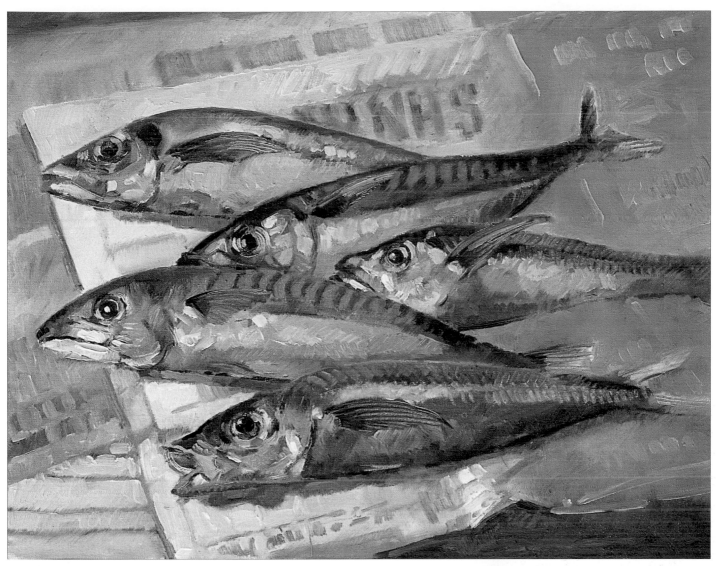

Fresh Catch
41 x 33cm (16 x 13in)

2½ Hours

It is not just metallic objects that have reflected colour. The pigments I have used in these fish are mainly blues and purples, with a small amount of viridian. These colours, mixed with titanium white, give an overall impression of silver. If the background were a different colour, i.e. red or yellow, the fish would reflect more of these colours, and they would have to be added to the palette. In the detail below, I show a liberal use of white which is painted thickly over existing colour to emphasise the tonal structure and to represent shine on the fish scales.

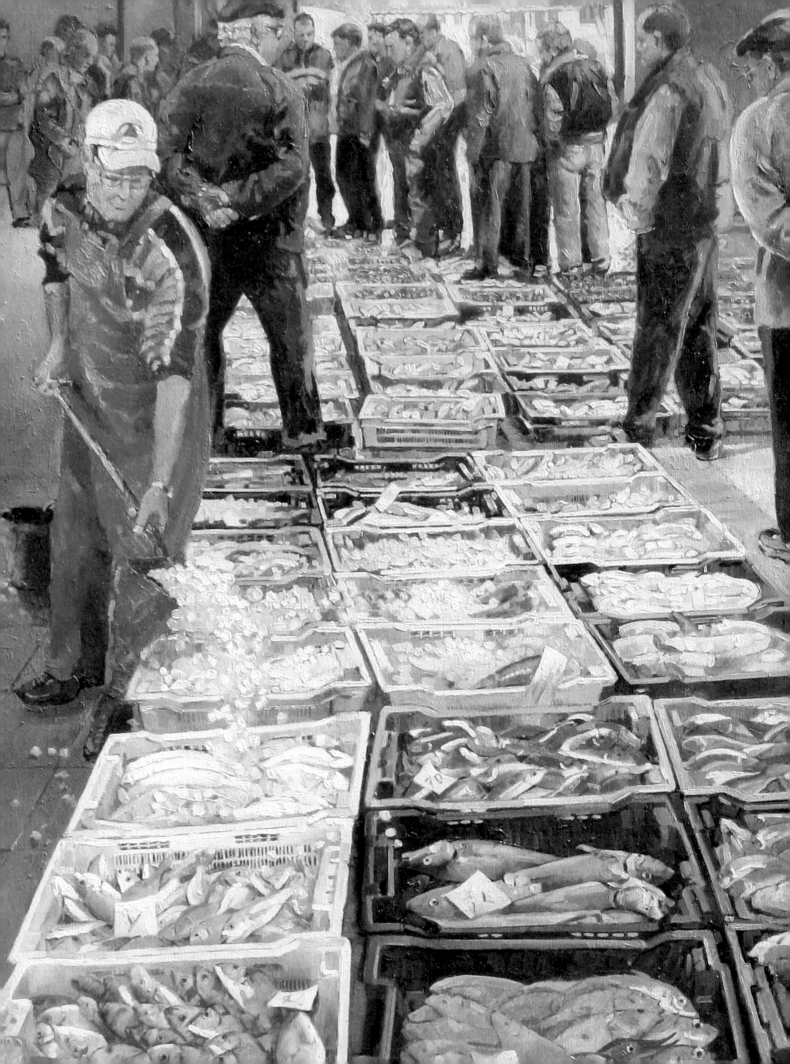

Figures

Figures can be an important part of our picture making, but they can also show up weaknesses if they are poorly executed; so it is very important that figures are drawn from as much information as possible.

Sketchbooks were the order of the day at my art school and they can be very useful. Today, the best 'sketchbook' must be the camera and with this digital recorder and a printer you can have all the information you need instantly. If I require figures in a landscape, all I do is to take as many shots as possible and arrange them together, as in this painting where I used five different photographs to make the image.

Detail from:

The Fish Market, Southern Almeria
100 x 175cm (39 x 69in)

This painting took almost two weeks to complete and so cannot really be regarded as an instant oil painting. However, this detail shows the importance of figures in a painting of a subject that would be less interesting without them. Although the figures take up the top half of the painting, they are of great importance to show scale. A knowledge of painting figures is therefore extremely important even in other sorts of painting such as landscapes.

Children in the Park

2½ Hours

When painting figures quickly, it is essential not to include much detail. It is also important, if you want a fast result, not to paint features because it is impossible to paint faces quickly without getting involved with capturing the likeness and character of the subject.

There are a few tricks you can use when you want to include figures in a scene.

Avoid too much detail in the faces and hands. Simplify them with a few marks rather than trying to reproduce features or fingers.

Always use some kind of reference – photographs, sketches, etc. Never try to make figures up. You cannot simplify with a lack of knowledge.

If you find your figures work with a few brush strokes, leave them alone and do not be tempted to fiddle.

Too much detail may give greater importance to your figures than you would wish. You may find yourself looking at nothing else when the painting is finished.

Consider painting back views; this will eliminate having to include too much detail.

If you add figures, make sure that they are to scale, for it is very easy to make them too big or too small from unrelated reference material.

Here I demonstrate how to achieve a pleasing result with a simple composition of the back view of two children. The wet-in-wet technique can be used to great effect to capture the charm and intimacy of this scene.

You will need

Canvas board, 30 x 40cm
 (12 x 16in)
Brushes:
 Filbert size 6 (large)
 Small flat size 2 (small)
 Sable size 1(detail)
Linseed oil

Colours

French ultramarine

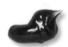

Titanium white

Cobalt violet

Burnt umber

Cadmium red

Cobalt blue

Sap green

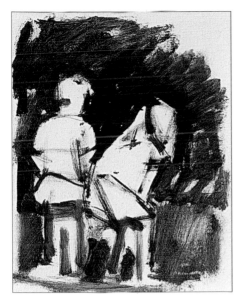

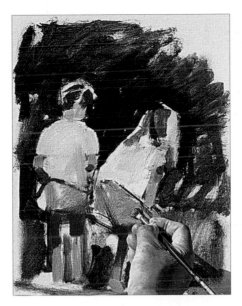

2. Using a mix of linseed oil and titanium white, paint in the light areas, rigorously working the paint into the canvas with random brush strokes. Add a touch of cadmium red and start painting in the flesh tones. Use burnt umber to establish the hair, then lay in the green areas on the clothes with a mix of sap green and titanium white.

1. Start by quickly and lightly sketching in the outlines and clothes with the small brush and a mix of French ultramarine and burnt umber. Block in the surrounding dark area. Lay in the green grass below the figures using sap green and titanium white.

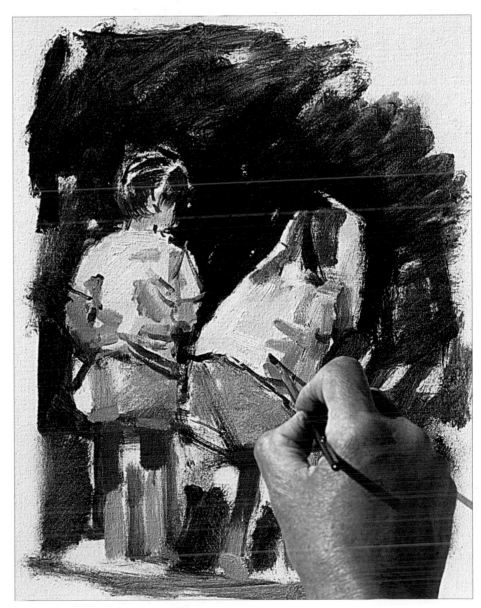

3. Using the small brush and French ultramarine mixed with titanium white, add the shadow areas on the t shirts and shorts. Work a darker blue tone into the hair and the t-shirts.

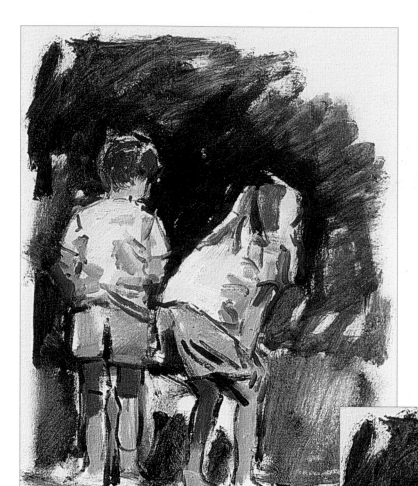

4. Carry on drawing detail into areas with a sable brush and French ultramarine mixed with cadmium red. This will give the shapes and structure which will determine where further areas of colour will be developed.

5. Build up the dark and light yellow tones in the children's hair. Do not mix the paint on the canvas too much, but lay the strokes down, following the fall of the hair. The skin areas need more form, so add more flesh tones, refining details and lightening areas. More detail needs to be added to the shorts, so mix green with a touch of white and paint in some folds, then add brown and yellow tones. Paint the lake using cobalt blue; the lighter blue tone will define the childen's legs, making them stand out against the background. To complete this stage, add the boy's shoes and socks using cobalt violet.

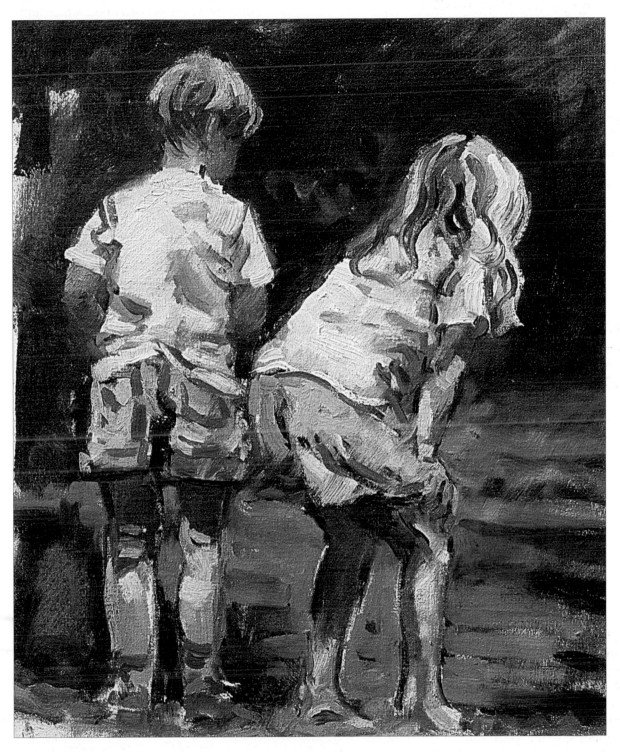

The finished painting
30 x 40cm (12 x 16in)

To complete the painting, dark blue is worked into the background around the children. The shadows and dark areas are refined in the background and figures, then more colour added to the water's reflections with dark blue and light blue using horizontal brushstrokes. Pure white highlights are mixed with the underpainting to create a feeling of sunlight. Finally, the water is softened with gentle strokes of a dry brush.

Glazing

If at any time you need to change the tonal structure of a picture, one way is to repaint that picture, but an instant way is to use glazes. Glazing and varnishing were once important techniques used in picture making. So important, in fact, that exhibitions held what was referred to as 'varnishing day'. The Royal Academy in London, for example, held this after the hanging had been completed for its summer exhibition. It was only then that it was considered that the artist could finish the work in its proper environment and light.

Colours created by glazing are stronger in depth and resonance than any colour created by mixing. The luminosity in Renaissance portraits, especially in skin tones, amply demonstrates this. Paintings can be completely changed by a wash to unify colour.

Glazing can also be useful for intensifying shadows over original colours or even heavy impasto, making an otherwise dull area more alive and interesting. Many coats can be applied to an oil painting when it is dry.

Oil glazes can be used over quick drying acrylics, alkyds or egg tempera. The most effective technique is using the glazes over a white base, which allows the colours to be reflected back.

You will need

Canvas board, 80 x 50cm
 (31½ x 20in)
Flat size 2 brush
Clean dry cloth
Glaze medium

Colours

French ultramarine

Alizarin crimson

Lemon yellow

Why glaze?

Glazing emphasises tones and improves colour balance.

You can give a new look to an old painting by glazing large areas to create a fresh tonal image.

Glaze yellow over tired areas and lighten a dull picture.

Use a blue glaze over a painting that looks flat. Make sure that the glaze covers only the areas that you want to recede.

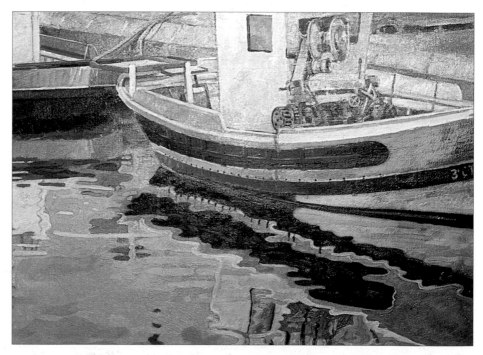

What is wrong with this picture? Well, nothing really, except it is a bit boring tonally, there is no centre of dramatic interest and the water area is slightly confusing to the eye. This can be remedied by using glazes. You could use a glazing medium, or colour can be thinned with turpentine or linseed oil, either together or on their own, to achieve the desired effect.

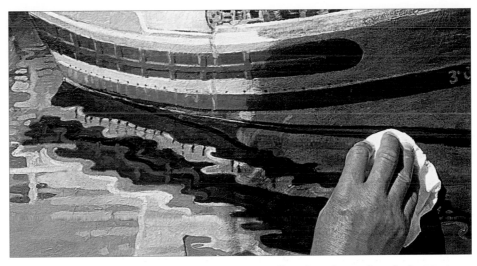

1 Using the flat brush, a mix of alizarin crimson and French ultramarine and a little glaze medium is brushed on to the bow of the boat when the painting is completely dry.

2. While the glaze is still wet, rub the colour off with a clean, dry cloth. Notice how in a few seconds the painting has more life, depth and contrast. Whole areas can be dramatically changed tonally, or unrelated colours brought together by a common hue using this method.

Fishing Boats in the Harbour 1½ Hours
80 x 50cm (31½ x 20in)

The sea is now simplified with a glaze of French ultramarine, and a lemon yellow glaze has been applied to the boat, creating a feeling of sunlight. This is the essence of instantly changing a picture. All these changes have been made in only a few minutes, instead of having to repaint large areas with thick paint to create more tone and contrast.

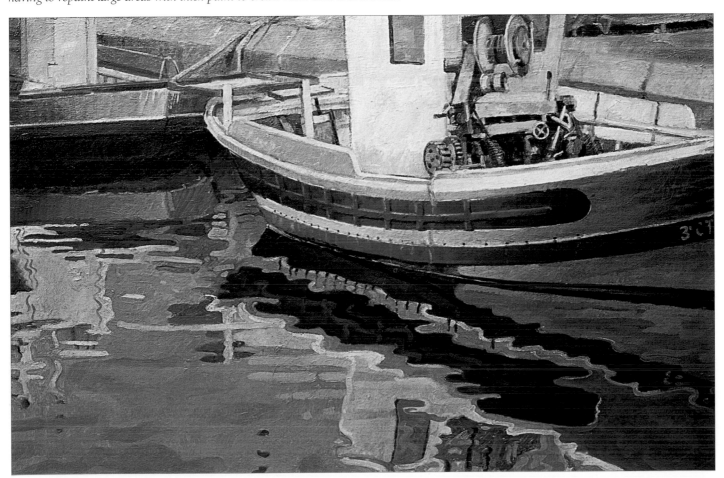

WATER MIXABLE OILS

by Michael Sanders

I have been painting and teaching art for many years, and I am often asked, 'What is the best medium to get me started?' My answer used to be, 'Oil paint'. Now it is 'Water mixable oil paint'. I then explain how versatile the medium is, how easy to correct, fun to manipulate and adaptable to many styles and techniques.

In this section I describe and demonstrate some of the techniques available to the oil painter. What you won't find is any mention of turpentine or white spirit. This is because all of the paintings were produced using Winsor & Newton's Artisan, a genuine oil paint made with linseed or safflower oil, yet which can be thinned and cleaned up with water. When I first tried these, I could not believe they were not traditional oils, and brushes left in a jar of water virtually cleaned themselves! Since then I have used water mixable oils regularly, especially indoors. The advantages are obvious: no more smelly rags or bottles of spirit; just soap, water and paper towels.

All you need to paint with water mixable oils are a handful of colours, a piece of primed board or canvas, some brushes, jars of water and away you go. Because they dry at the same rate as other oils (not quickly like acrylics), you can take time to enjoy the painting process without worrying. Corrections can be made without panic and paint can be scratched through or scraped for interesting effects, or reapplied.

Most of the techniques I will show you are centuries old and have been used by many of the old masters. Follow me through a landscape with flowers and a scene with buildings, then maybe paint a composition of your own. As you work through the examples in this section, your skills will improve and your confidence will grow. Some techniques will feel just right, some colours will appear more attractive than others. Gradually, with practice, your paintings will have a uniqueness that is yours alone. Be bold and never be afraid to experiment.

Woodland Poppies
Size: 49 x 33cm (19¼ x 13in)

This painting relies heavily on careful use of tonal values, as well as a harmonious range of colours.

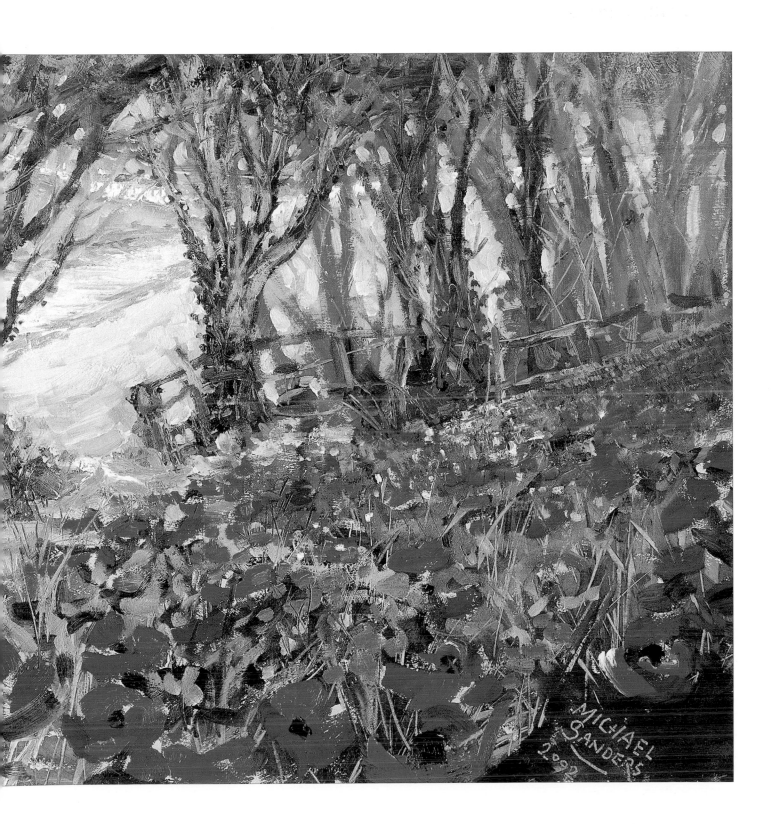

143

Flowers in the Landscape

My inspiration for this painting came initially from the colours of these marigolds and the contrast between the dark greens at the bottom of the image and the bluish tinges visible at the top. I decided to allow the composition more space at the top and, using the blaze of marigolds as a focus, I wanted a complementary colour scheme which included plenty of blues. This gave me the idea of inventing a simple, blue-based landscape that would fit in the top third of my composition but which would not contain much in the way of detail – with a distant sea.

When combining flowers and landscapes, one of the elements must be dominant. You have to decide whether you are painting a landscape which has flowers in it or a flower scene with a simple landscape as a backdrop. You cannot have both, or the painting will become too busy.

You will need

Board primed with acrylic
 gesso tinted with acrylic
 burnt sienna
Sap green
Burnt sienna
French ultramarine
Phthalo blue
Titanium white
Lemon yellow
Naples yellow
Cadmium yellow deep
Cadmium red light
Small painting knife
Paper towel
Brushes:
 No. 5 filbert
 No. 4 filbert
 Round no. 4 synthetic

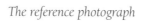

The reference photograph

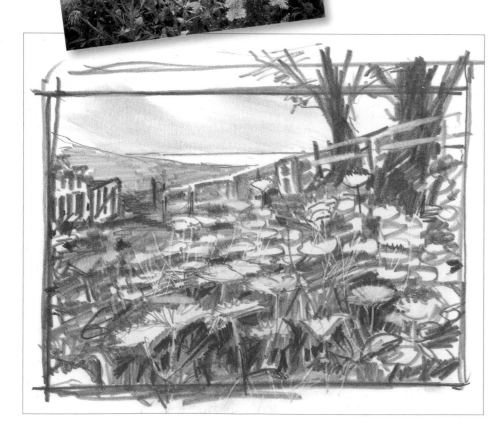

My initial sketch. The flowers are drawn tonally, as if from a lower viewpoint and more in 'close-up' than in the reference photograph. I have added a pale fence with a gate on the left as a natural break between foreground and distance. The trees were put in to give a little interest in the sky area, and the horizontal line of the sea was drawn across as a foil to the diagonal of the fence. Having completed this sketch, I made a mental note to leave the gate out as it looked distracting, and to lean the trees into the painting, rather than out.

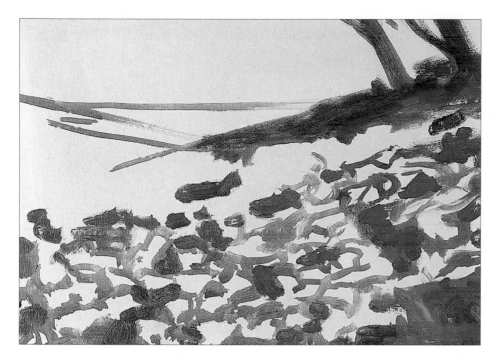

1. For the initial sketch, mix sap green and burnt sienna, and thin the mixture with water, to the consistency of condensed milk. Using a no. 5 filbert bristle brush, block in the basic shapes, leaving holes for the flower heads. As the painting recedes into the distance, cool the mix with ultramarine.

2. Block in the sky using ultramarine made greyish with a touch of burnt sienna. The mix should be thinned with a hint of water – enough to make it flow nicely. Use a vigorous brush action and keep your painting loose. Paint the sea with a hint of phthalo blue, titanium white and a little lemon yellow. Allow the background colour to show through, creating highlights on the water.

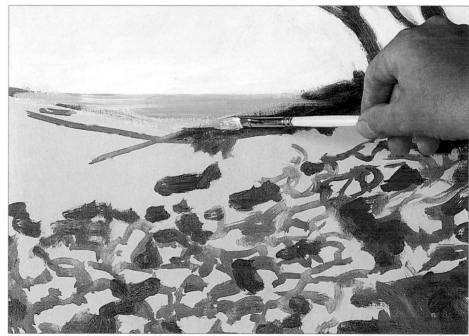

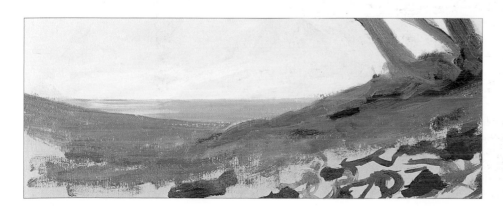

3. Block in the distant hills using a bluish-green mix of ultramarine with a little lemon yellow and titanium white. Use vigorous brush strokes. Mix burnt sienna with ultramarine and white to make a bluish grey, and paint over the background green of the sketched trees. Paint some of the background foliage using the same mix with a hint of sap green to make a distant blue-green.

4. Use a small painting knife and the sgraffito technique to scratch out foliage in amongst the flowers. The colour of the board will show through. Join some of the lines to the flowers to create stalks. Use the flat of the knife to paint broader leaves in the foreground.

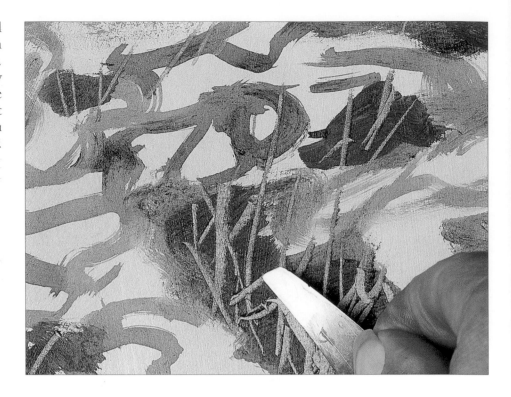

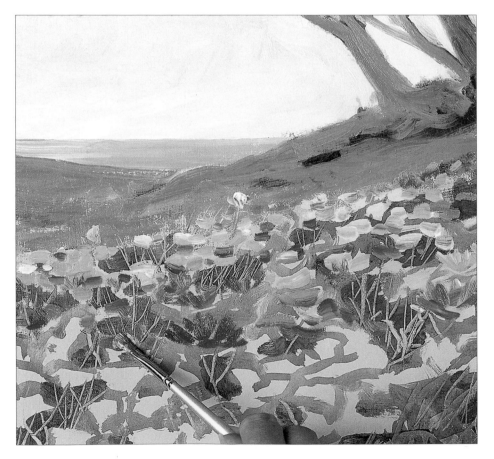

5. Paint the basic shapes of the blooms in the background in a dull orange mixed from cadmium yellow deep and cadmium red light, using a no. 4 filbert brush. Vary the colour mix to create a natural look. For the most distant flowers, add a hint of pale ultramarine. Paint in patches of flowers rather than individual flowers or petals – the detail will be added later using tone.

As you come towards the foreground, add a warmer orange. If you find that you are painting regular patterns, make sure you break these up to retain the random look of nature. If you have painted large areas of one colour, break this up with another shade.

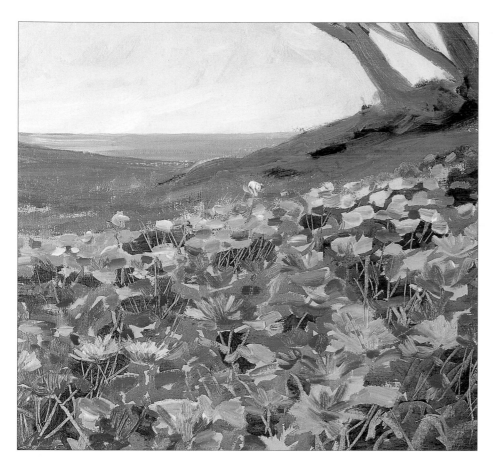

6. Block in the foreground blooms, the orange ones first. Use the sgraffito technique and the wrong end of a paintbrush to scratch out the shapes of petals. Some of the flowers are viewed from behind, so scratch out the shape where the stalk joins the flower. In the very foreground, apply paint freely to imply petals – do not make any very definite shapes, or these will draw the eye to them. Lastly, mix lemon yellow and white with a little water for the more yellow flowers. Be careful not to contaminate the yellow with the background green – you will need to wipe your brush occasionally with dry paper towel.

7. Make a pale green from Naples yellow, lemon yellow and a hint of phthalo blue. Paint it on to the distant hill on the left, making it lighter in tone than the sea. Stroke across, using a no. 4 filbert, leaving gaps to give the impression of hedges. Don't make the shape of the fields too square and regimented. Wipe your brush periodically. Vary the colour of the fields by adding more or less Naples yellow. Nearer to the foreground use warm green with a little burnt sienna.

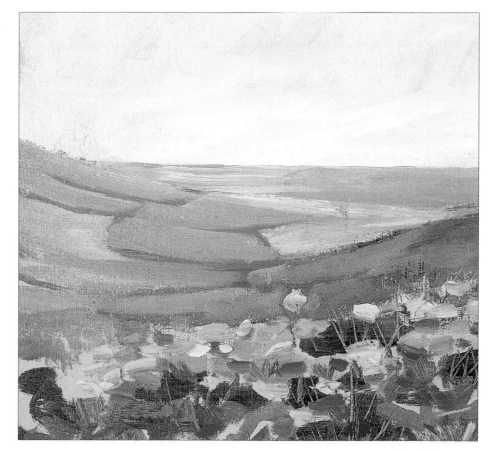

147

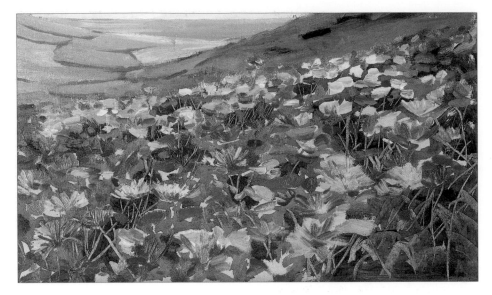

8. Mix a pale blue-green from phthalo blue, sap green and Naples yellow, and paint around the distant blooms to define their shapes. Don't add too many sharp edges. Go over the whole flower area adding definition and tidying up. I have painted out a bloom at the back, because it was too dominant and too central.

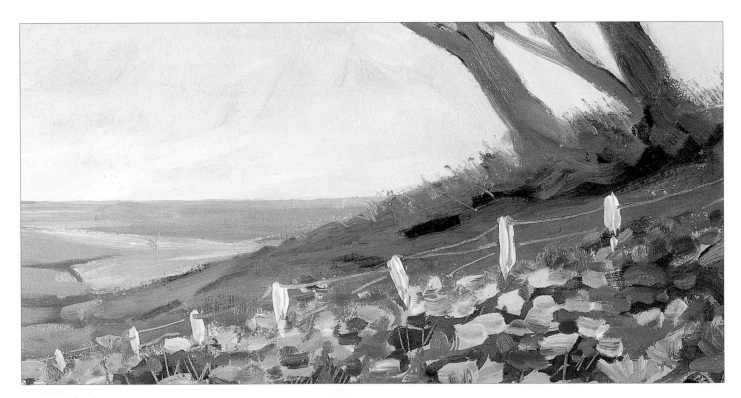

9. Mix titanium white and a hint of Naples yellow and paint in the fence posts, which lead the eye downwards to create the effect of distance. Sgraffito with the end of a brush to scratch in the wire of the fence, and to roughen the skyline beneath the trees to suggest foliage. Add darks to the foreground with sap green, phthalo blue and Naples yellow, and sgraffito stalks and leaves. Use a little burnt sienna to warm up the foreground, and to define the petals on the nearest flowers. Paint inwards towards the flower centres. Some flowers should be anchored to the ground with dark stalks. Add darks under the foreground blooms to give them form. The foreground of this painting should be darker and warmer than the middle or background.

10. Use a round no. 4 synthetic brush and a mix of cadmium yellow deep and titanium white to paint highlights on the left-hand side of some of the flowers, to show the direction of the sun. Pick out petals in very light colours.

Flowers in the Landscape
Size: 41 x 31cm (16 x 12¼in)

The finished painting. In the final stage, I have lightened and warmed the trees with burnt sienna, ultramarine and Naples yellow, which make a soft, pale grey. The effect is to soften the trees and make them fade into the background. I have also painted and highlighted additional branches. I took a fan blender and blended across the horizon to soften it, then did the same with the sky.

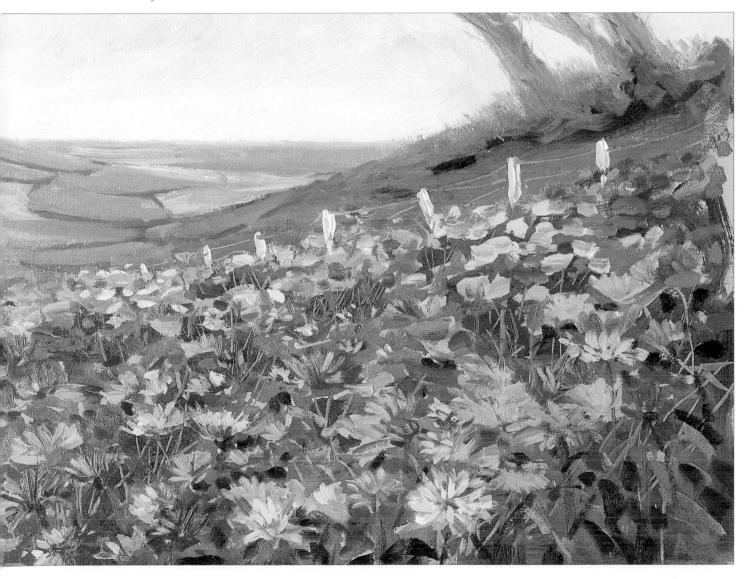

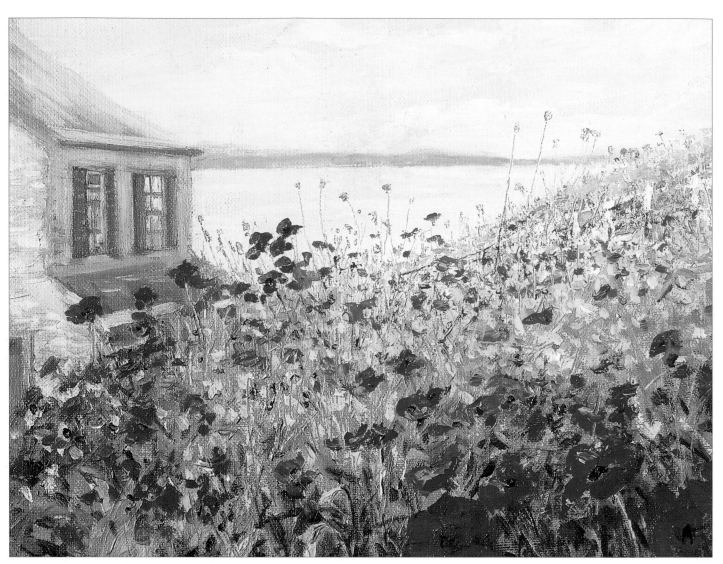

Coastal Poppies

Size: 30 x 24cm (11¾ x 9½in)

The still, quiet background makes the perfect foil for the dancing poppies, and the house on the left adds some solidity and vertical movement. The red-green combination in the foreground works well to 'anchor' the composition.

Tamar Daffodils

40.5 x 51cm (16 x 20in)

In Cornwall, where I live, the hedgerows in the spring are filled with daffodils of all shapes and sizes. They can be white, yellow, orange or any combination. For me, the coming of the daffodils means an end to winter and the start of spring. In this composition, the blooms have been placed against a dark background in order to enhance their colour, while the distant, wintery trees were painted purple-grey to complement the yellows. I've used single, isolated strokes of colour in the background to give a soft, shimmery effect. The foreground leaves were scraped back with a painting knife and the distant cottages were made in the same way. The red sail was added some months later, making sure some medium was mixed with the paint, wet on dry.

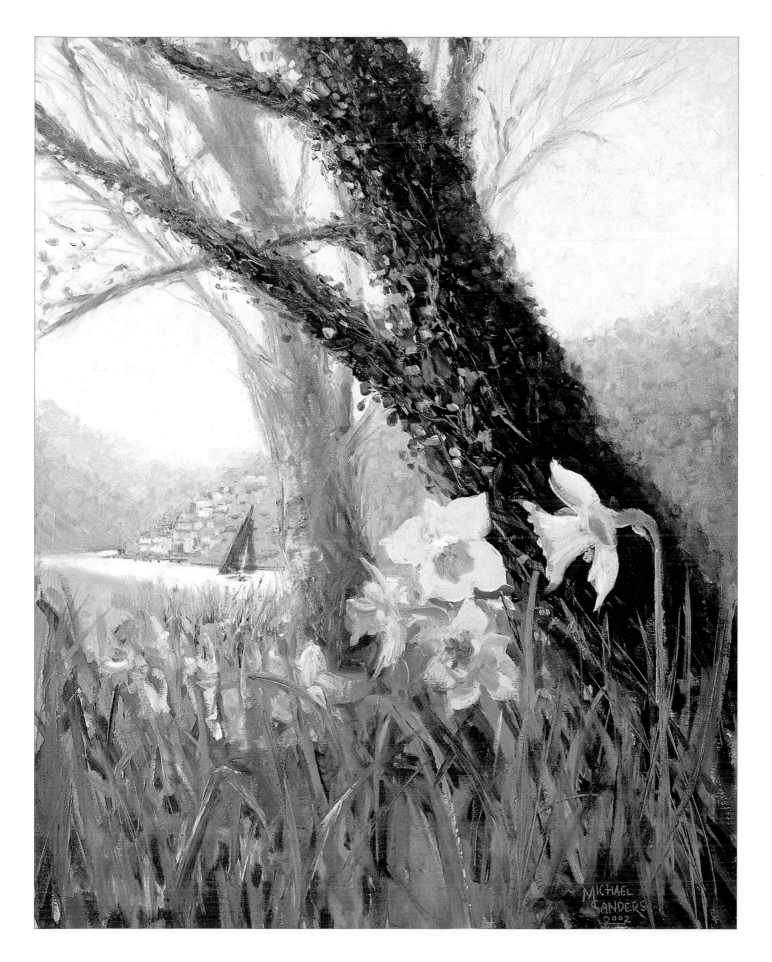

Spanish Courtyard

Knife painting is a very direct, exciting, wet on wet method of working. It pays to practise various strokes with the painting knife on a piece of primed board before attempting a painting. The application of paint is similar to spreading butter. Using the knife, spread some colour out on a large flat palette. Then scrape some paint off the palette so that you have a ridge of paint on the edge of the knife blade. With a little practice you will find that you can touch this ridge lightly on to the board and obtain a thin, crisp line of paint. Imagine masts of boats, windows, grasses, fence posts. All these can be tricky wet on wet using a brush, but are easy with a knife. Try scraping larger amounts on to the edge of the knife and applying broad, textured strokes. You can buy an *impasto* medium which I sometimes use for knife work: it stiffens the paint so that the ridges and marks show more clearly.

This knife painting evolved from a watercolour and a small figure study in pencil. As I worked on the painting, I noticed that I was making a classic mistake: I had put the focal point, the figure, exactly in the middle. This is never a good idea as it results in a static, boring composition. I should have taken my own advice and made some thumbnail sketches first, to see how the composition worked! The mistake was put right later.

You will need

Board: 3mm card primed with acrylic gesso tinted with acrylic cobalt blue
Burnt sienna
Ultramarine
Cadmium yellow deep
Cadmium yellow light
Cadmium red light
Naples yellow
Lemon yellow
Titanium white
Sap green
Phthalo blue
Permanent rose
Large and small painting knives
Cocktail stick for sgraffito
No. 4 round brush

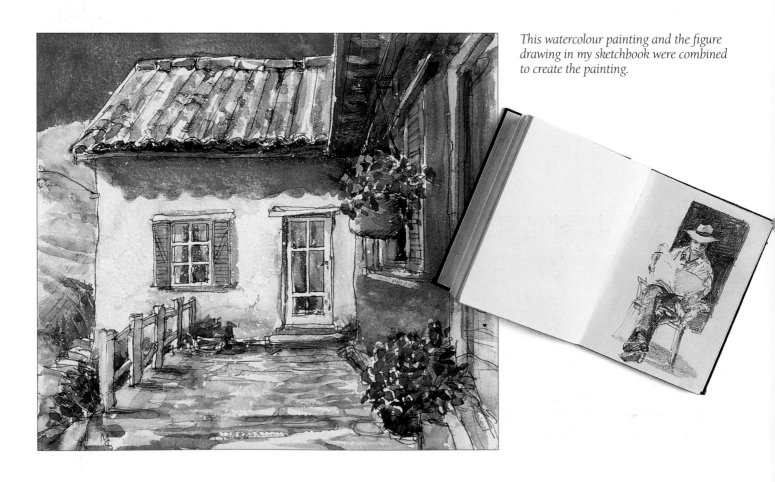

This watercolour painting and the figure drawing in my sketchbook were combined to create the painting.

1. Sketch the building and the figure using a no. 4 round brush and a thinned mixture of burnt sienna and ultramarine.

2. Mix cadmium yellow deep with cadmium yellow light, Naples yellow and titanium white, for the roof tiles. Use a large palette knife to apply the mixture to the roof in ridges. Change the angle of the tiles to allow for perspective.

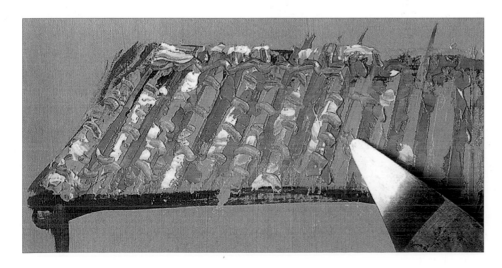

3. Modify the mix with ultramarine to make it duller for the valleys in the roof. Paint loosely and allow some background blue to show through. Add more blue to make a brownish colour for the shadows under the ridge titles. Sgraffito the angles of the tiles with the tip of the palette knife. Don't worry if the edge of the roof looks ragged – you can tidy it later when you paint the sky.

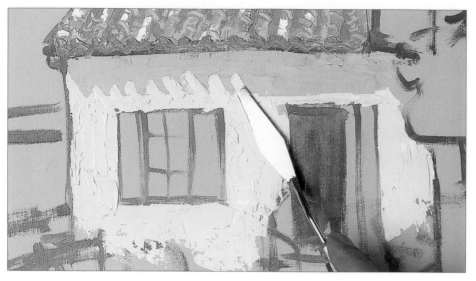

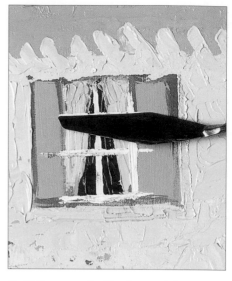

4. Use the rounded tip of the knife to put in the ends of the tiles at the edge of the roof. Mix a bluey grey from orange, ultramarine and titanium white and paint in the shadow under the roof. Paint the yellow of the house wall using cadmium yellow deep, cadmium red light, Naples yellow and white, creating a rough texture with your painting knife to suggest stucco. Change to a smaller painting knife for the detail of the edge of the roof shadow, working wet on wet. Keep the angle of the stroke the same for all the tile shadows, since this shows the direction of the sun.

5. Wipe your knife clean with paper towel. Mix ultramarine blue and burnt sienna and paint the dark of the windows. Paint the dark area inside the open door – this will make the figure stand out. Mix a pale grey for the curtains and white with a hint of grey for the window and door frames.

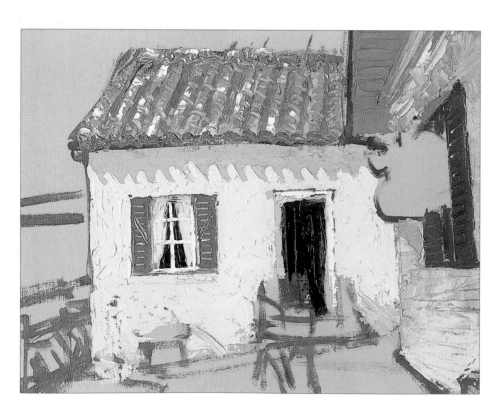

6. Paint the shutters on the left in a vibrant green mixed from sap green, lemon yellow, phthalo blue and white. Use the sgraffito technique for the lines of the shutters. Block in the dark background shadow at the top right of the painting using a mix of ultramarine and orange. As you go down the right-hand wall, lighten this mix with the orangey yellow from the first wall. The shutters on this right-hand wall should be in a darker green than the others, with more phthalo blue added.

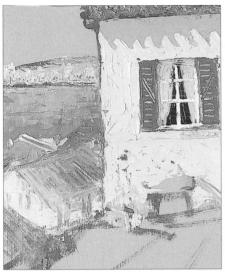

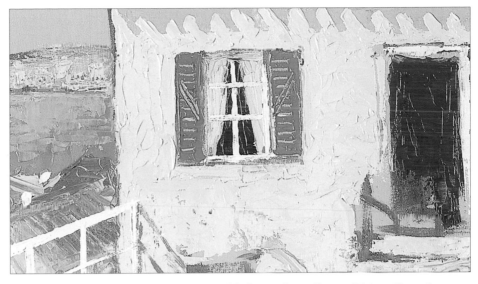

7. Paint the sea in a vivid blue mixed from phthalo blue and white with a touch of ultramarine. Mix orange with white and burnt sienna for the rooftops in the middle ground. Subdue the shade with a little pale blue for the shadows. Use the sgraffito technique to scrape back the architectural details, roof tiles and windows of these middle ground buildings. The distant land across the bay should be painted in a similar colour to the rooftops.

8. Add burnt sienna and cadmium red light to the yellow of the wall, and use it to paint the ground. Allow the blue to show through from underneath. Add suggestions of warm reds and browns to break up the monotony. Clean your large painting knife and apply titanium white with a tiny touch of Naples yellow to paint the fence. Put in the shadows of the fence posts with the edge of the knife using Naples yellow and burnt sienna.

> **Note** At this point in the painting I decided to widen the doorway by moving the wet dark blue over to the left.

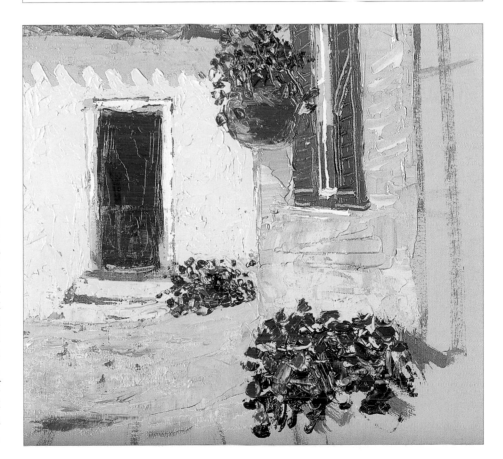

9. The terracotta of the flower tubs is a darker mix of the roof colour. Mix sap green and burnt sienna for the background green of the tubs and hanging basket. Lighten this mix with Naples yellow as required. Work wet in wet from dark to light. Touch in smaller leaves in a paler green, and darken the mix, adding less Naples yellow, for the foreground foliage. Mix the bright reds and oranges of the flowers using cadmium red light and cadmium yellow deep with a little white.

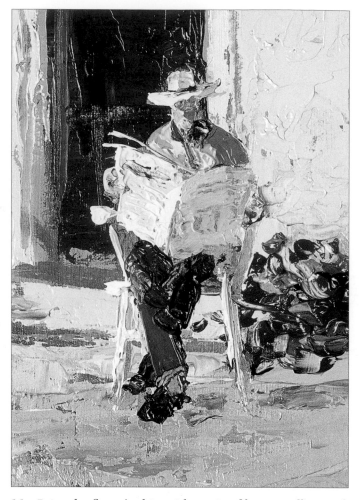

10. Scrape out the shape of the figure and his shadow using a painting knife or stick.

Note *When starting on the figure, I decided to move him from the left-hand to the right-hand side of the door, since the sketch placed him bang in the middle of the composition.*

11. Paint the figure's shirt with a mix of lemon yellow and cadmium yellow deep. Darken the mix for the shadowed side. Mix burnt sienna with white and a hint of orange for the face, and burnt sienna and permanent rose for the shaded part under the figure's hat. The mix should be darker still, with more burnt sienna added, for the neck. The hand on the left should be sunlit, and the one on the right in shadow. Paint the hat in titanium white with a hint of Naples yellow, and add a little pale blue for the shaded side. Use the edge of a painting knife and titanium white to paint the edges of the newspaper's pages, and fill in the rest of the newspaper in white with a hint of blue. Mix burnt sienna with ultramarine for the darker back leg, and add Naples yellow for the lighter front leg. The feet should be little dark blobs in the same colour. Finally add a red hatband, and white highlights for the chair.

Spanish Courtyard

Size: 40 x 30.5cm (15¾ x 12in)

The sky, unusually for a knife painting, was added last, using a mix of ultramarine and white with a touch of phthalo blue. I would usually paint the sky first, but as the board was primed with a sky blue that was tonally close to what I wanted, I was happy to leave it until later. The warm yellow-orange of the walls works well against the blues of the sea, sky and shadows: another example of complementary colours working together.

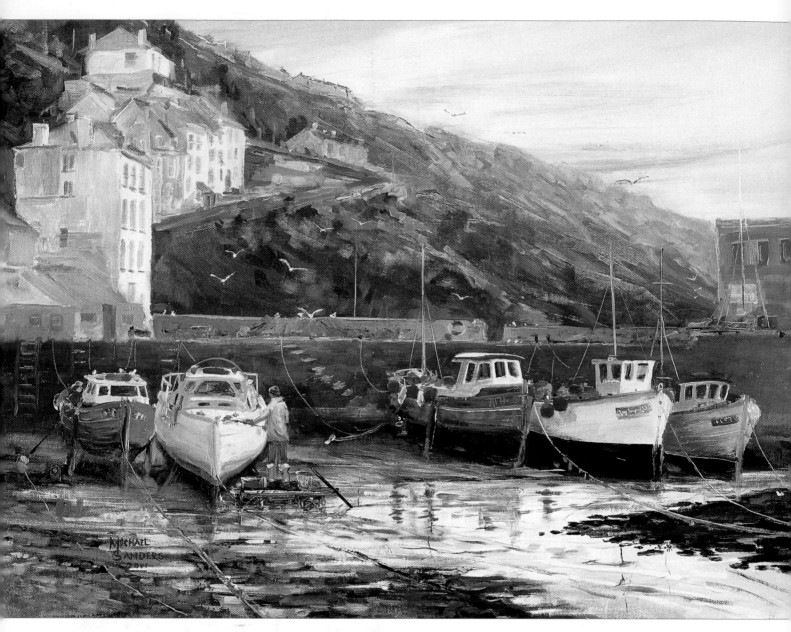

Polperro Evening

Size: 48.5 x 34.5cm (19 x 13½in)

For me, tone gives the definition and logic to a painting; line and composition give the dynamic or static element and colour creates the mood, the emotion. I took a gamble in this painting by having a static, almost horizontal line through it. It works because the line, the harbour wall, is broken by interesting colour and a couple of gaps. The seagulls lead the eye up to the background and the sky. The colour suggests the mood and time of day. There is a lot of strong purple, so the figure had to be yellow. Nothing works better then complementary touches!

Opposite
Village Gossip

Size: 35.5 x 48.5cm (14 x 19in)

This is a composite image. The figures were lifted from my sketchbook and arranged to form a group. I really enjoy putting the little touches into a painting like this: the washing hanging in the doorway, the touches of red on the figures. As with most of my work, the tonal composition is the major element, with a strong complementary colour scheme underpinning everything.

158

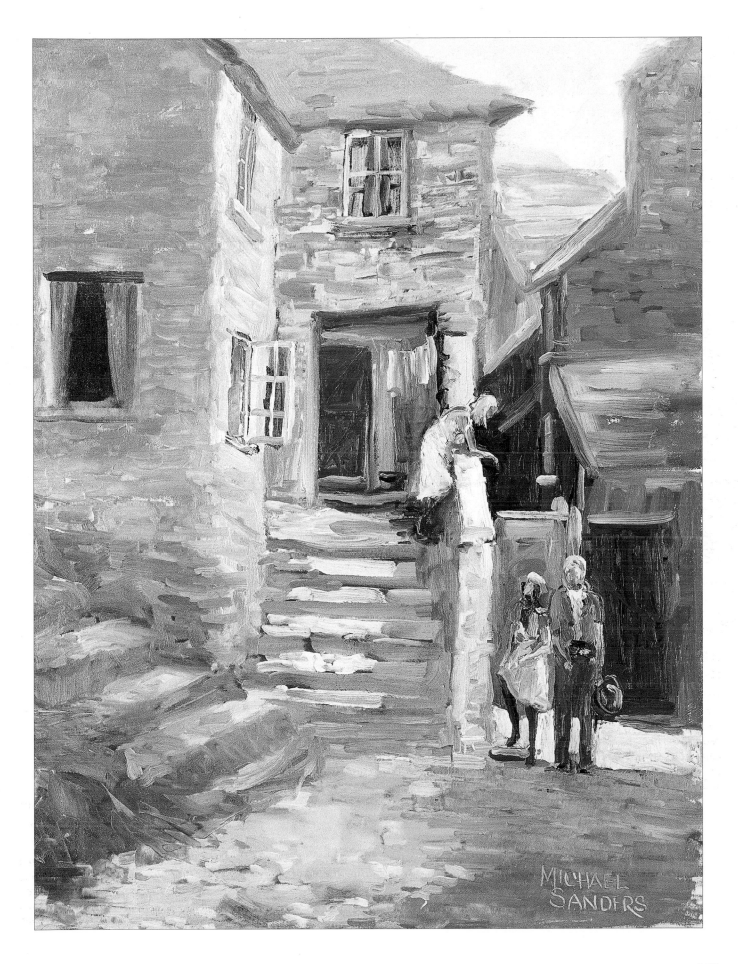

159

Index